THE UNTAMED THREAD

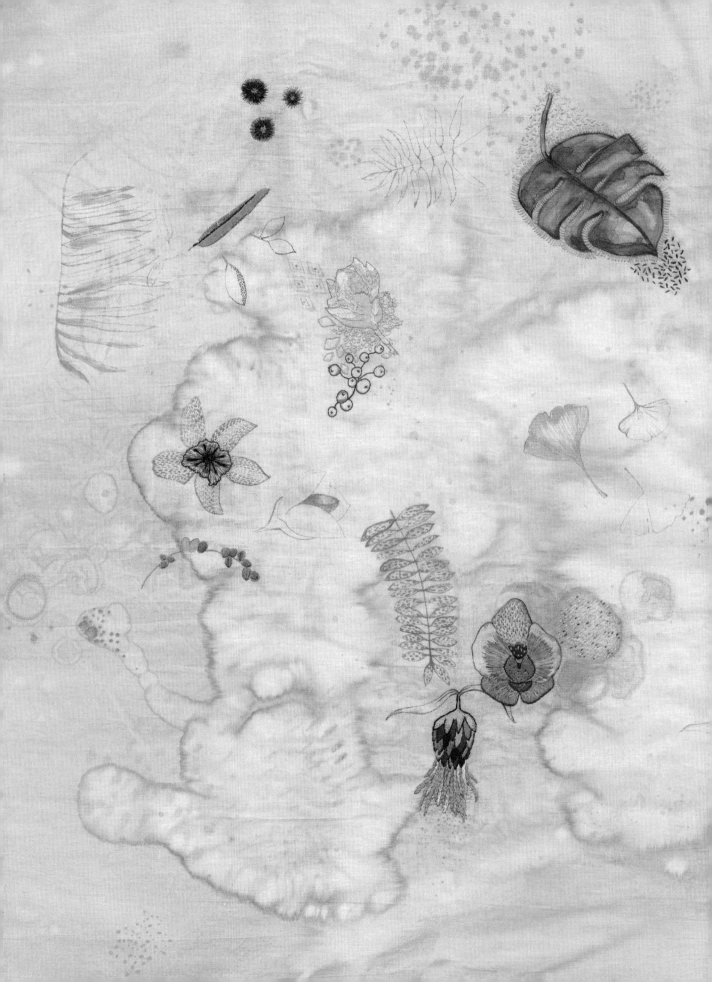

Fleur Woods

THE UNTAMED THREAD

Slow stitch to soothe the soul & ignite creativity

KOA PRESS

@fleurwoodsart

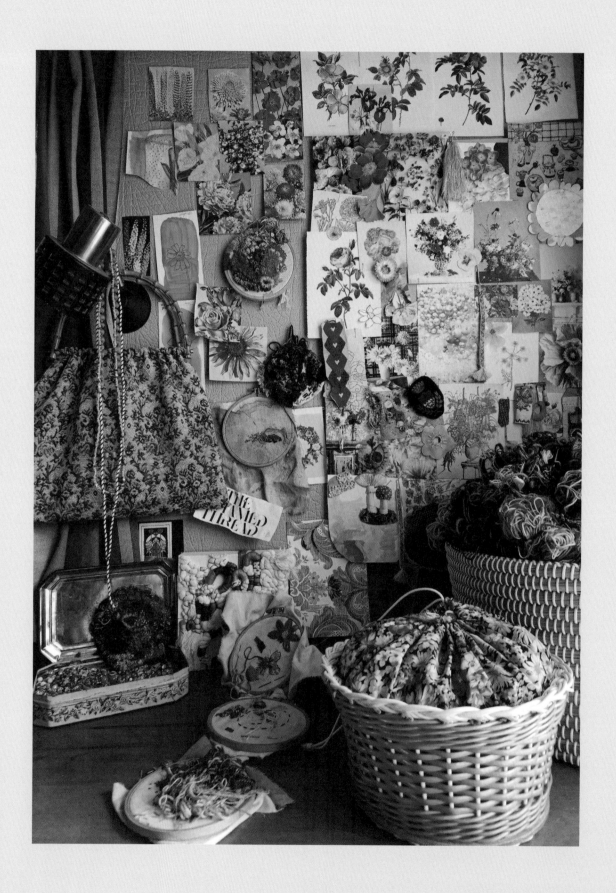

Contents

Cover: *Garden Wanderings*, 2022.
Previous: *Flora*, 2017, the first
piece I sent to Jumbled in Australia.
Opposite: My little studio is filled
with inspiration and textures.

Come with me ...

Welcome to my studio where I share my journey and processes — opening a window into my creative world while encouraging you to craft your own. I am thrilled you are joining me to explore the untamed thread of experiences that have converged to create my art practice. Stitch and nature are the two leading characters, and the pages before you overflow with the inspiration they bring.

This book is delivered with soul and a sincere desire to encourage you to engage in creativity, whether as a collector, viewer, dreamer, seeker, maker, artist or adventurer. Lovers of all things art, flora, colour, texture, textile and thread will find a safe, soft place to land here — a warm blanket of creative guidance with generous encouragement. It is a place to find inspiration; a gentle nudge to create more regularly with a free and joyful approach to contemporary stitch.

If you've ever wanted to find freedom and joy in the creative process and learn to let go of the concepts holding you back, then it is time to turn the page.

I can't wait to see what we can create together.

Fleur

Fleur Woods
Contemporary fibre artist, seeker
of joy and lover of nature

Below: A work-in-progress textile
collage. Opposite: Collected
treasures at home with screen
print *Freckles*, 2014.

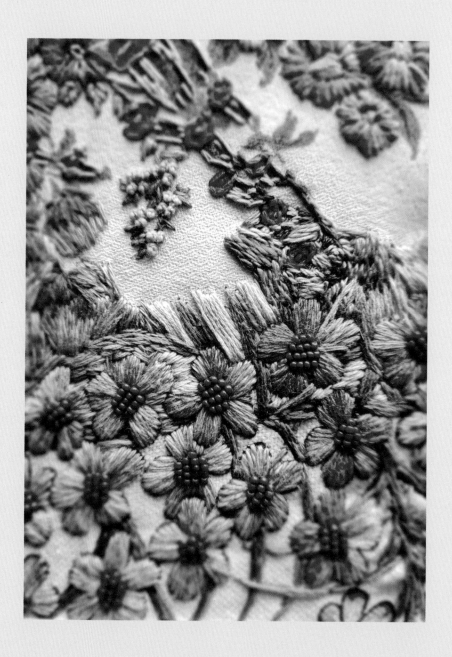

THE BEGINNINGS

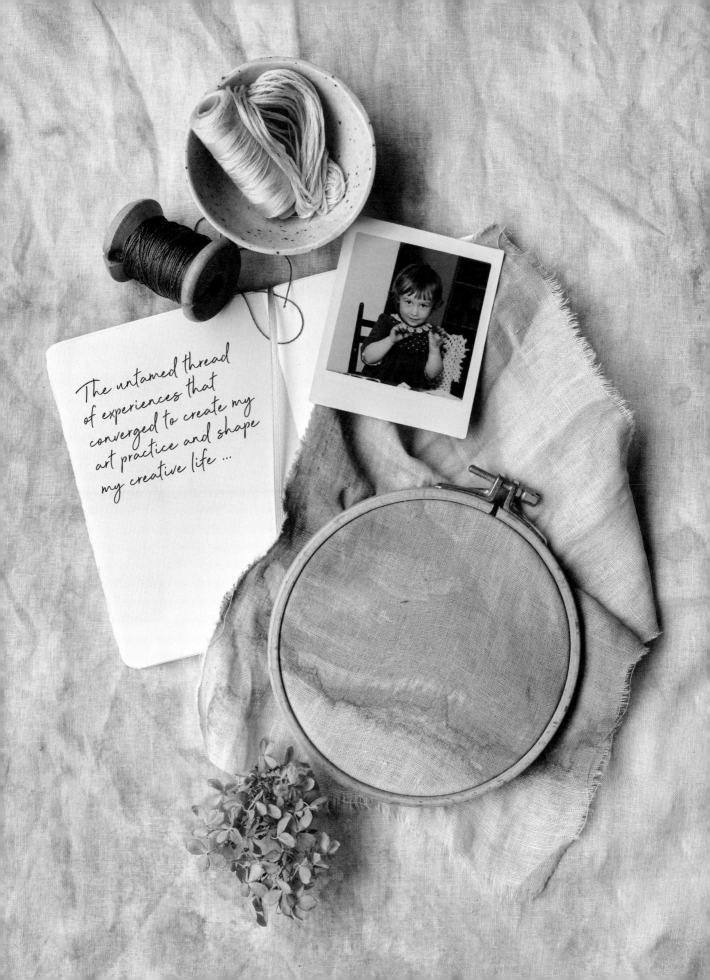

The untamed thread
of experiences that
converged to create my
art practice and shape
my creative life ...

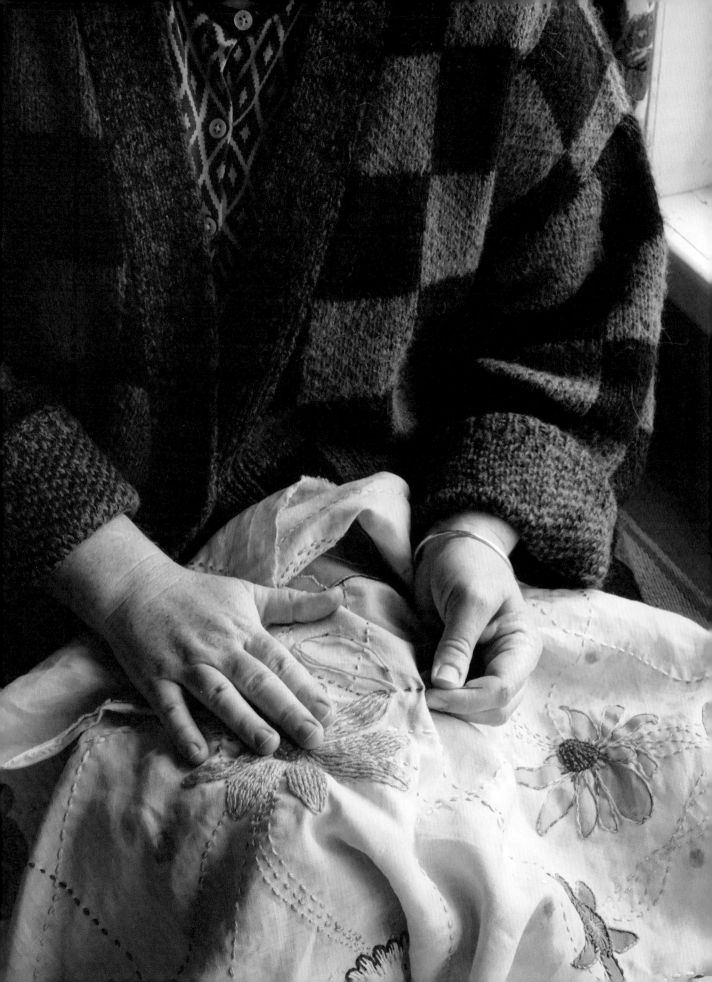

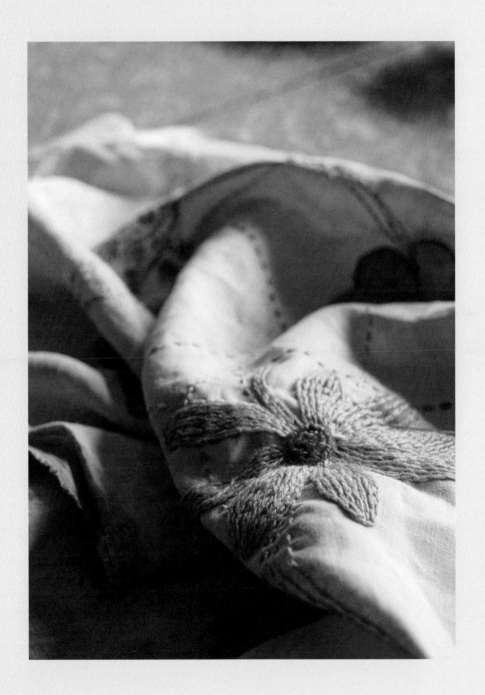

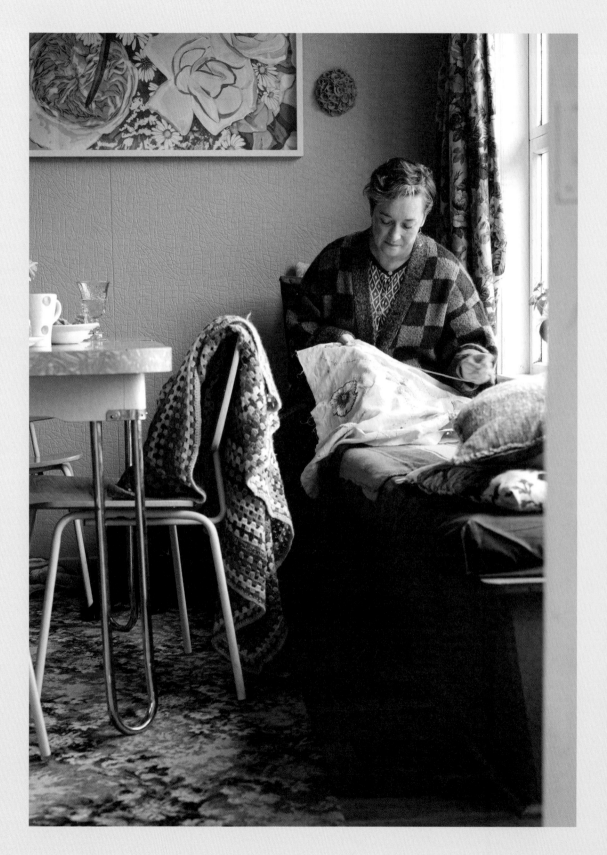

Previous and Opposite: Stitching wandering
twirls of Kantha stitch into *Leave Flowers
Everywhere You Go,* 2023, on the sun seat.

It feels essential to share an overview with you of how I got to this strange place – where I am writing a book about why it matters to find your creative home.

What it looks like as you uncover it, and how to craft it into something that serves you and your life…

Born in Brunei and spending my formative years in Hong Kong, it was the meshing of traditional Chinese and mainstream pop culture that lingers with me still. The rich silks, embroideries, carvings and temples of Hong Kong bump alongside Ballet Barbie, Whitney Houston and 1980s fashion. We immigrated to Aotearoa New Zealand in 1988, I was eight, and this shift from the concrete jungle of Hong Kong to the lush green belt and wild coastline of Wellington was my first actual connection with the natural world. I was in awe of it all.

My family embraced creativity growing up, for which I am grateful to my parents. Not so much in the sense of a messy craft table in the kitchen, but by way of slow wanders through significant art institutions, such as the Tate Modern. As an architect these spaces inspired my father and in turn my mother, who despite being creative wandered progressively further into the corporate world to avoid the roller coaster of living a creative life. This shared joy of creativity and exposure to art and beautiful spaces, through travel, added a rich tapestry to my collected influences.

Children have an innate abundance of creativity that they pursue with freedom until, slowly, over time, outside influences intervene. While I was just as creative as the next kid, I recall drawing attention from my parents and teacher at the age of six for sketching a child sitting on a chair with her legs bent; perhaps I had a 'talent'. What I knew at that stage, that no one else did, was that I noticed and felt everything deeply, sometimes obsessively and sensitively. So while to the adults it seemed like talent, to me, it seemed inevitable.

Skip forward to 1996, age 16 in the art room at St Hilda's Collegiate, Dunedin (Aotearoa New Zealand), where the notion that creativity might form a meaningful part of my life was dawning on me. I could paint, draw, relief print and photograph. At that stage, like so many teenagers in art rooms of the time, I was fighting a battle with realism. I would copy by eye images from *National Geographic* magazines and draw endless landscapes in the hopes of emulating art icon of the time, Grahame Sydney. I found it endlessly hopeless that while I tried to capture the beautiful Central Otago landscapes realistically, I couldn't find the magic he had, to produce such unique pieces. Disheartened and very much in an era of 'do something sensible with your life', I didn't pursue a place

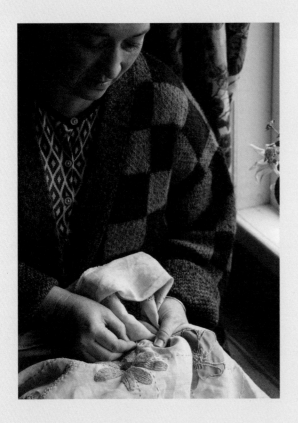

at art school (a regret in hindsight), instead rolling up to the University of Otago for a Bachelor of Nothing-much. While I mostly enjoyed it I was becoming increasingly curious about how the *real* world worked. As an 18-year-old, it was abundantly clear I had lived a privileged, curated existence and wanted to know how 'real' people lived.

The following year (1999), I was living and working in Brisbane, Australia, at a bank call centre of all things. I think this was the 'real' people's life I had been hunting for, and it was surprisingly uninspiring. While I adored exploring the cultural institutions that come with a bigger city, I could feel that my soul was left behind in my high school art room, a sanctuary of creativity that I couldn't translate into my real-world life. I had

decided because I was no Grahame Sydney, I wasn't talented enough to continue. So I stopped. I'd still visit galleries sometimes and try to imagine if I could make something deemed worthy enough to participate in those spaces.

The longer I worked in the call centre I slowly began to realise that artmaking was missing in my life. A year or more passed before I finally joined a local art course — we studied figurative painter Francis Bacon, who focused on the human form, and I made some weird paintings about bones. It didn't set my soul on fire, but the course grounded me and allowed me to invite creativity back into my life, without Grahame Sydney in the mix this time.

A pull to Aotearoa New Zealand, for the feeling of horizontal rain on my face, found me back in Wellington in

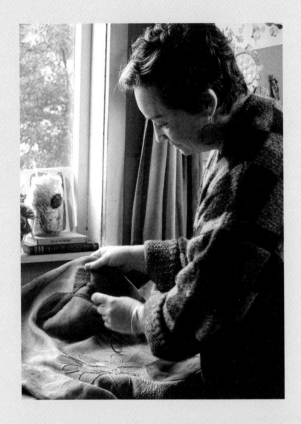

2001. The wind and the wildness were invigorating after the constant and compliantly sunny Brisbane. There was another draw too — my future husband, a fellow Kiwi, who happened to be flatting with one of my best friends in a tiny cottage in Thorndon, Wellington. Over a roast dinner and Trivial Pursuit we connected (won the game), and it wasn't long before we moved in together. I also decided it was time to give art school a go. Despite my strange portfolio of weird bone paintings and a few other self-portraits, the tutors shrugged and said why not. I wandered onto the Massey University Campus and immediately felt at home. As a mature and second-time tertiary student, I had goals aside from the intimate knowledge of local bars.

In my first class, Design 101, the tutor unpretentiously exclaimed that we (the students) were there because we were sensitive; we noticed everything; we gathered strange items that we felt deeply affected by. Our weirdness and our sensitivity were crucial for our creativity. What a sudden and life-affirming relief it was. At that moment, I knew there was a place for me. The vital elements of my character that I had for so long seen as my most significant flaw, were perfect for the job I was applying for. Artist.

The connections I made with a collection of fellow art school wanderers taught me so much. Through their unique and cultural lenses these women guided me to find *my* way. They never judged. We were all in quite different places in our lives and creative mediums, but it didn't matter.

As it turned out, art school was

terrific for the first year, but unfortunately, I became increasingly unwell as we moved through the second. I was diagnosed with Crohn's disease (an inflammatory bowel disease) after years of visits to emergency rooms and tests for everything under the sun. It became increasingly challenging to study and work. So, still unaware of how important creativity was to my being, I leaned towards work. In hindsight, the opposite would have been healthier, but this choice led me through an unofficial five-year degree working in advertising at a local newspaper.

What I wasn't learning at art school, I was more than making up for in earning my corporate stripes. Contracts, presentations, deadlines … it was a rich learning period, made all the more impactful by the most incredible boss. The most impressive and influential female I had met, she was a force for good. She understood my creativity and supported me to operate creatively in a corporate context, which ultimately gave me confidence I still carry with me into the work I do today. Proof that everything happens for a reason, who knows? I will forever be grateful to her and the team, who helped me to learn not only a bit about business but, most importantly, that the corporate space wasn't where I belonged.

My Crohn's continued to give me a pretty hard time. I tried everything, from the mainstream to the kooky, and still, progress was hard to come by. It was clear that stress was a significant

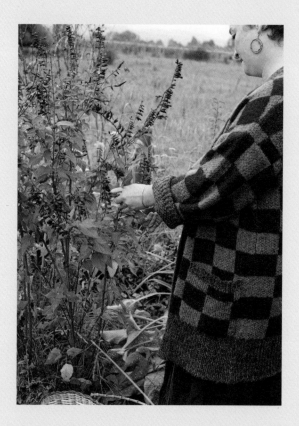

factor. When you are a sensitive person who feels the emotions of every room you are in, it can be hard to manage your reactions. For me, this manifested in my body as pain and inflammation. As it became apparent that my lifestyle needed to change dramatically to prevent me from becoming sicker, something magical happened. We discovered our first baby was on the way, and that was all we needed to push ourselves to change. We left our well-paid corporate jobs and moved to Nelson in Autumn 2008 (South Island, Aotearoa New Zealand) to be nearer to family.

Pregnancy would mark the end of my Crohn's journey and the beginning of a whole new experience — motherhood, which eventually transitioned me into a more creative life. We were blessed with baby

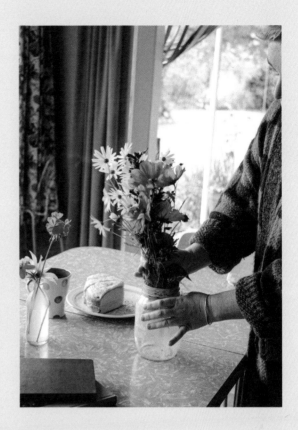

From Left: Forever foraging in
the garden; garden daisies;
garden pickings brought to the
table for creative inspiration.

number two a few years later, and I was
officially in remission. As anyone who
has had kids knows, the early years are
intense, but they were also creative and
for me, liberating in many ways. We were
a house where all the messy, creative
stuff happened; we embraced glitter in the
carpet. We crafted with an abandon many of
my friends couldn't cope with in their own
space, so their kids often came too.

You may wonder why my journey is
relevant to becoming an artist — this
isn't vanity for me. I have never shared
these parts of my story before in detail.
I now know that all those twists and
turns ultimately guide you where you need
to be. The long and the short of it is
that I had spent nearly 10 years unwell
and knew I wanted to stay home with my
kids, but beyond that, I also knew I

needed to slow down and shift my life.

It felt more important as a mum to do
so, and yet it quickly became obvious to
me that I wasn't satisfied being a full-
time mum. Becoming a mum is identity
shifting. I felt discombobulated. I had
moved straight from the corporate world
into full-time motherhood. I dearly
wanted the Martha Stewart version: a
clean home, nutritious meals, a veggie
garden. And I felt like such a failure
when I found that those things brought
me no joy. It was obvious to me that
while my health was back on track in
this chapter of life, I needed something
just for me, and I needed it quickly as
I was at risk of losing sight of what it
was that sparked my soul.

What did bring me joy, and this spark,
was gardening and creating with the kids.

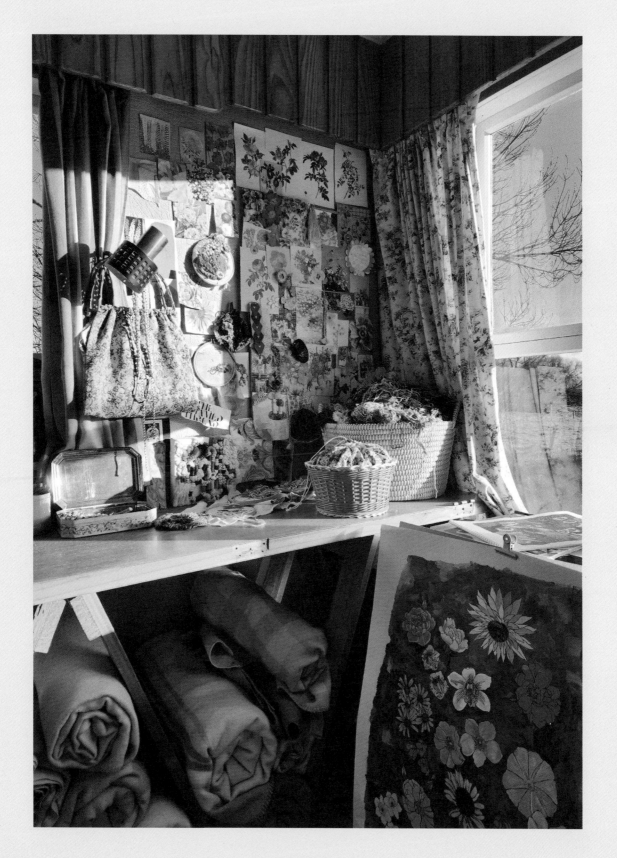

I was a much better mum when I could fill my cup and those two little girls led me, often by the hand, to the things I love. Walks in the garden, beachcombing, picking flowers, arranging flowers, making things with play dough. They led me back to my creativity. I needed to embrace my creative self with them, but I also needed it just for me. So as the girls napped or went to preschool, I painted, upcycled op-shop finds and played around with digital art. On reflection, all the elements I enjoy creating today were there then. I just didn't have the time or the practice to execute anything lovely.

I was making art again, and I can say this — it was all reasonably dreadful — but it was the missing piece. It was the thing that gave me a sense of self and this time, I played.

As the girls grew, in 2014 we moved out of Nelson to the Moutere Valley, and with lots of family support, I started to create more. Not long after we moved, a friend in our village kindly let me show my pieces in her store, The Old Post Office, and even let me curate exhibitions for other local artists. It was exciting. I knew my work was still far from what I saw in my mind, but it was slowly evolving. At the same time, the 100 Days Project was introduced to me by a fellow creative. It was the best thing for my fledgling art practice as every day for 100 days, I listened to a piece of music and responded to it. I had a maximum time limit of two hours each day to complete an artwork. If I got to 1 hour 59 minutes and hated it, then that was tough. I had to live with whatever I'd managed to make. It taught me a fundamental lesson — you are not going to create wonderful, or possibly even good art every time.

On completion of the project (early spring 2014), some friends and I had an exhibition of our work. It was part revelation, part torture. I was confronted by the 70 pieces I felt were (dreadfully) far from where I wanted to be as an artist; but there were about 30 that gave me hope. I could see a thin thread between them. Some strengths in terms of colour and mark-making that I would explore further. Hope was all I needed to keep me going.

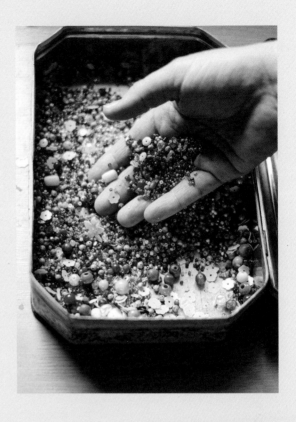

Around this time, I stumbled across *The Gap*, wise words from popular media personality Ira Glass:

Nobody tells this to people who are beginners; I wish someone told me. All of us who do creative work get into it because we have good taste. But there is this gap. You make stuff for the first couple of years; it's just not that good. It's trying to be good, it has potential, but it's not. But your taste, the thing that got you into the game, is still killer. And your taste is why your work disappoints you. A lot of people never get past this phase, they quit. Most people I know who do interesting, creative work went through years of this. We know our work doesn't have this special thing that we want it to have. We all go through this. And if you are just starting out or you are still in this phase, you gotta know it's normal and the most important thing you can do is do a lot of work. Put yourself on a deadline so that every week you will finish one story. It is only by going through a volume of work that you will close that gap, and your work will be as good as your ambitions. And I took longer to figure out how to do this than anyone I've ever met. It's gonna take a while. It's normal to take a while. You've just gotta fight your way through.

These words were transformational. They got me at my core and reminded me of a lifetime of work ahead of me.

In spring 2015 I opened a gallery in Upper Moutere village, a creative collective with friends at The Old Post Office Store. My primary goal was to give credibility to my work. At this stage, I hadn't managed to secure a solo exhibition aside from the odd café; it was very much a 'fake it till you make it' move. On many levels, the gallery worked. I'm not sure it gave me any credibility in art, but it showed collectors and exhibition galleries I was serious. More than anything, it forced me to deal with the commercial realities of earning a living as an artist. Initially, I had grand visions for a contemporary art space in our rural village and started showing other artists' work. I enjoyed connecting with them, but it quickly dawned on me that the amount of administration involved

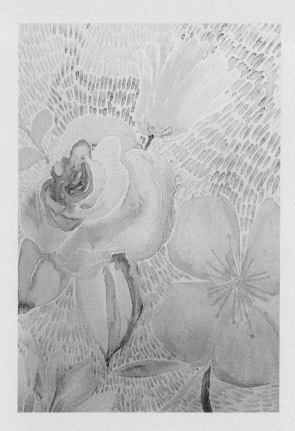

Left: A close-up of the pink wall in my gallery. Opposite: My happy place — my dining table just outside the studio.

the pink walls in the gallery space. It was my way of publicly claiming what I felt to be true. A coming out of sorts — my pink, feminine, nana craft reveal. In the tune of Ira's wise words and with a definite aim to close the gap, I started making more, bigger paintings; mixed media works; and gradually, tweaking my process brought stitches into the mix. I didn't know how to embroider, I just knew I loved the texture and had endlessly collected (rescued) from every op shop I had ever visited, little teacloths that had holes and stains but also had the sweetest stitched florals. I used only the random tools I had, an unsuitable blunt needle and whatever fibres I could find in colours I loved.

As I started stitching into my work, it was as if the women of past generations gathered behind me in the studio and cleared a path. I didn't know the name of a stitch or even a tiny hint of the actual depth of the craft itself, but it felt like the most beautiful thing I'd done creatively in a long time, so I just muddled along, learning as I went. It was like, from that moment forward, the universe was smiling. I started doing work that brought me joy, and stitch was gradually becoming a part of the process.

My husband backed me to make art my full-time career, and to this day, whenever I grumble or have doubts, he reminds me I'd better get on with it because I'm his retirement plan. That faith was critical for me, particularly at that moment of the journey because I

in curating exhibitions, plus the challenge of selling contemporary art and the ins and outs of managing a small gallery, were not my cup of tea. The harsh reality was that I mostly survived on selling cards, and that even though I did manage to sell a fair bit of art over that time, my heart wasn't really in it. I hadn't found my thing.

So, as I tend to do, I plot twist. I stopped having exhibitions, brought in smaller works, and made the space a studio gallery for my art. A light bulb went off in winter 2016, nearly a year after opening the gallery … I was trying too hard … to be cool or clever or edgy or something. When really what I love, what I've always loved, is florals, textiles, textures and colour.

That day I painted flowers on one of

was deep in the vulnerability of finally, for the first time in my life, showing who I was as a person — a creative, a mother, a wife and a daughter.

He encouraged me to take some time to build a body of work, and I did. It was the first time I'd ever framed an extensive collection of pieces, and while he was in full support, it wasn't as though our bank account was smiling. The support feels even more meaningful when someone is willing to sacrifice *with* you, for your dream. I was also lucky to chance on excellent framers, The Framing Rooms, who, from the very start have looked after me and my work with a sense of advocacy and friendship that is so special.

I took this body of work to a regional art expo in 2016 and it was terrific;

I sold some of them, which was such a boost but more importantly, I learnt some critical lessons from fellow artists around how to describe my work proudly, how to let the viewer in, to share and be open. I distinctly remember painter Jane Blackmore doing a talk for fellow creatives and reminding us to 'put our big girl knickers on' and chat to people about our work, which inspired me, especially as she delivered it in such an open and unpretentious way. I adopted her advice immediately and it was a massive contrast, and improvement on my previous attempt at sexy indifference, which often came across as awkward ramblings.

My lovely little gallery was bringing me joy, and my work was evolving. I was slowly starting to connect the dots

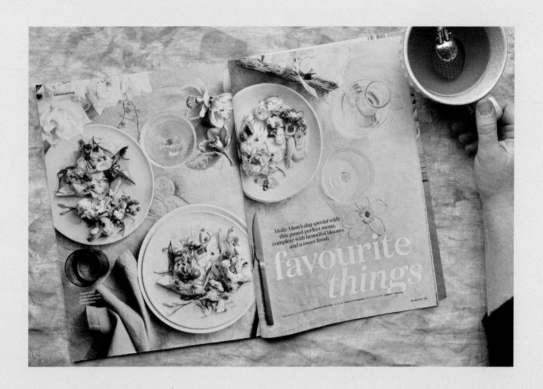

between my hand, head and heart when the stars aligned and I had a lucky encounter with Julia Atkinson-Dunn from Studio Home who came to teach a social media workshop in the gallery space. It was a turning point for my career. It had become clear to me that our little region, with its seasonal travellers, couldn't solely sustain my goal to be a well-paid full-time practising artist. The tips and tricks learnt with Julia

came at just the right time. I started putting my work more regularly and purposefully into the online realm.

A few months later in the summer of 2017, I had my first solo show at Kina Art Space in New Plymouth. I created 14 pieces and threw everything into it, financially and emotionally. This was my first show of stitched paintings titled *Bloom*. Battling the anxiety that comes with sharing and showing work, especially as I felt I was still forging a connection/finding an audience that resonated with my new stitched work, I pushed through and it was a magical opening night with 11 of the 14 pieces sold. I will never forget how affirming that was. I am grateful to continue collaborating with Kina to this day.

In the period that followed, Julia wrote about my work on her popular art

~~~~~~~~~~~~~~~~~~~~~~~~~~~~~~~~~~~~~
Above: *Inside Out* magazine spread with original artwork *Flow*, 2017, used as a tablecloth. Opposite: Many of my favourite things — clay sculpture by Sophie Holt on books I love, vase by Kate Mitchell and wall basket by Heartstone Baskets, as well as collected crystals, vessels and blooms.

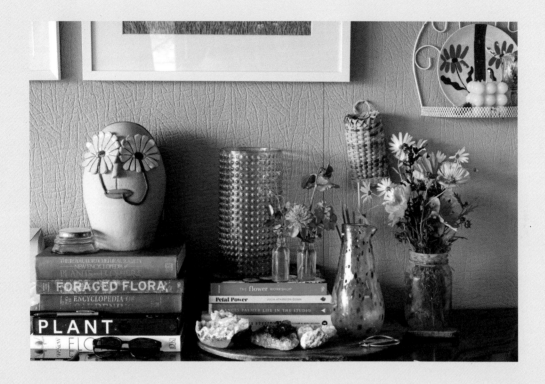

and design blog Studio Home, which further gave me a boost to continue along this path. I also had a small mention in a home and garden magazine and recall feeling so excited, then ultimately deflated as the stampede to my work I had anticipated didn't happen. It felt as though everything slowed off the back of my solo show. I couldn't get support from other art spaces, and my gallery was hobbling along as I tried to split my energy between it and creating.

Everything felt so confusing — I'd had this successful show, and my work was published, but I couldn't get any further traction. I was diligently posting to my Instagram, hoping for discovery and approaching galleries more confidently, only to be repeatedly rejected. Had I misread the signs? I am a resilient soul, but my enthusiasm was drained. I constantly looked at job websites and wondered if I'd made a big mistake — was my internal dialogue of not being good enough, talented enough, or resourceful enough, true?

Then one morning in March 2017, sitting in my humble inbox full of rejections that I couldn't even be bothered to delete, was a curious email from a stranger — Jessica Hanson, *Inside Out* Magazine Style Editor. I read it three times to check that it wasn't a scam. Jessica contacted me to see if I could create something for a Mother's Day shoot they were doing in Sydney in 10 days' time. She'd found me via Instagram. I honestly had no idea if this was something that artists did or how I would make it happen, but it was the only opportunity I had, and I decided I would make it work no matter what.

Opposite: The happy mess on our dining
table. One of my favourite original
paintings, *Daisy, Daisy*, 2019, hangs
alongside a ceramic wall bloom by
Katie Gold. Next: *Flow*, 2017, stitched
painting created for *Inside Out*
magazine feature, 2017.

The brief was to create a large piece of linen in a specific colour with scattered hand-painted and embroidered florals. I imagined it would maybe form a tiny part of their overall shoot but regardless, I was compelled to give it a go.

The challenge was not for the faint-hearted. The timeline was intense, but through that came some creative evolution that was truly career-changing for me on many levels. My process expanded as I had to create *just* the right colour of linen, as I couldn't source what I needed locally. I'd painted smaller pieces of linen, but working on a large scale was a challenge that transformed my process and taught me so much. Jessica's brief also required floral clusters scattered across the work to give them styling options in different areas. So, I worked 16-plus-hour days to create this piece, and biting my nails, couriered it to Sydney. It arrived the morning of the shoot. It was so exciting that day sitting with my friend in our kitchen drinking tea as the kids played, knowing that my art was being seen, experienced and hopefully being photographed by some stylish humans in a stylish place. I had no idea what role my piece would play in the shoot, so when the magazine came out in May 2017 and my art was the backdrop to the five-page Mother's Day feature, I sat down and cried. I was grateful that someone loved my work enough to share it this way, and humbled to see it in print.

What happened next completely changed the game for me. Pip Brett, the owner of a beautiful art and design store in Australia called Jumbled emailed me as she had seen the *Inside Out* magazine spread and wondered if I would like to send them some work to sell in the store. And they would purchase it outright! You could have knocked me over with a feather. She had no design brief in mind, just told me to 'create whatever you want, big is good'. What a contrast to the feelings of defeat only a couple of months earlier. I felt a surge of hope and ran with it. Thank goodness I didn't quit.

In fact, Pip's invitation to exhibit with Jumbled led to another exciting opportunity with fellow Australian art powerhouse, Greenhouse Interiors, and before I knew it, by winter 2018 I had to close the gallery because I couldn't keep up with the demand and get any work on the gallery walls.

Since then, there have been so many wonderful, encouraging, challenging, weird and beautiful moments. Many that are shared in the pages before you. But now, here at this pivotal moment where things truly began for me and my work, it feels right to pause the journey, and delve into the creative process in the hope my experiences can help you to explore your own creativity.

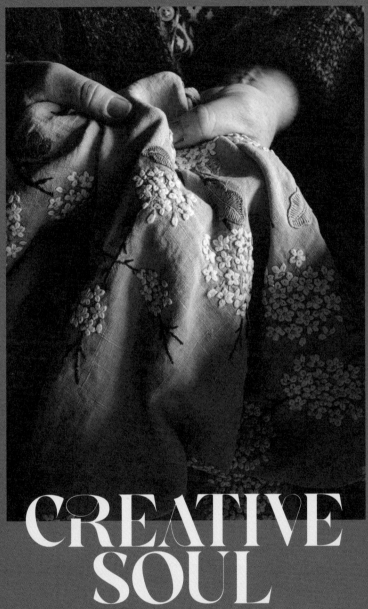

# CREATIVE SOUL

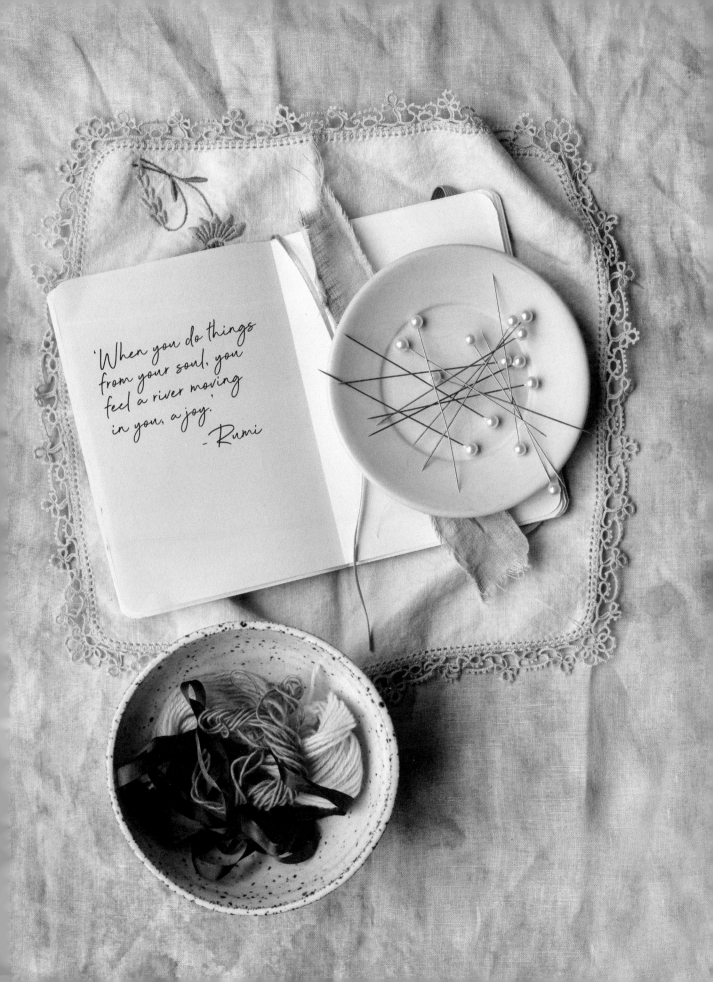

'When you do things
from your soul, you
feel a river moving
in you, a joy.'
- Rumi

The source of inspiration — my
great-grandmother's tablecloth
(left) and a piece I created
in response.

# We all have creativity within us. As children, we create so freely with such a sense of joy and reckless abandon.

Progressively as outside influences come into play, as rules start to govern and we care more about pleasing people and wanting to do the 'right' thing, our creative instinct becomes smaller, more cautious and often squashed all together. But even as the process gets less enjoyable, we are still drawn towards creativity. It is in us, and we need it to express ourselves and make sense of this wild world.

A light-bulb moment on my path to becoming a practising artist was realising that much of what I needed was already there. For a long time, I looked externally, wanting to emulate the skills and talents of those I was inspired by but the work didn't land. I was so focused on becoming a practising artist, I didn't take the time to explore my own creative voice. Until that magical day when I finally realised that *play* might help my process. Play without connection to an outcome. It allowed me to tap into my creative instinct, leading me directly to my creative soul: stitch. It is in my creative DNA.

When I started stitching it felt like the women of past generations were guiding me. I'm not talking about ghosts, although who knows, but a sense of deep knowing, despite not having the essential information in front of me. Stitch felt natural. I didn't know how to do it, I wasn't skilled at it when I began, but it felt like my body could guide me, intuitively. It felt right, I felt excited by the possibilities it offered. Then the penny dropped — both my grandmothers were very creative.

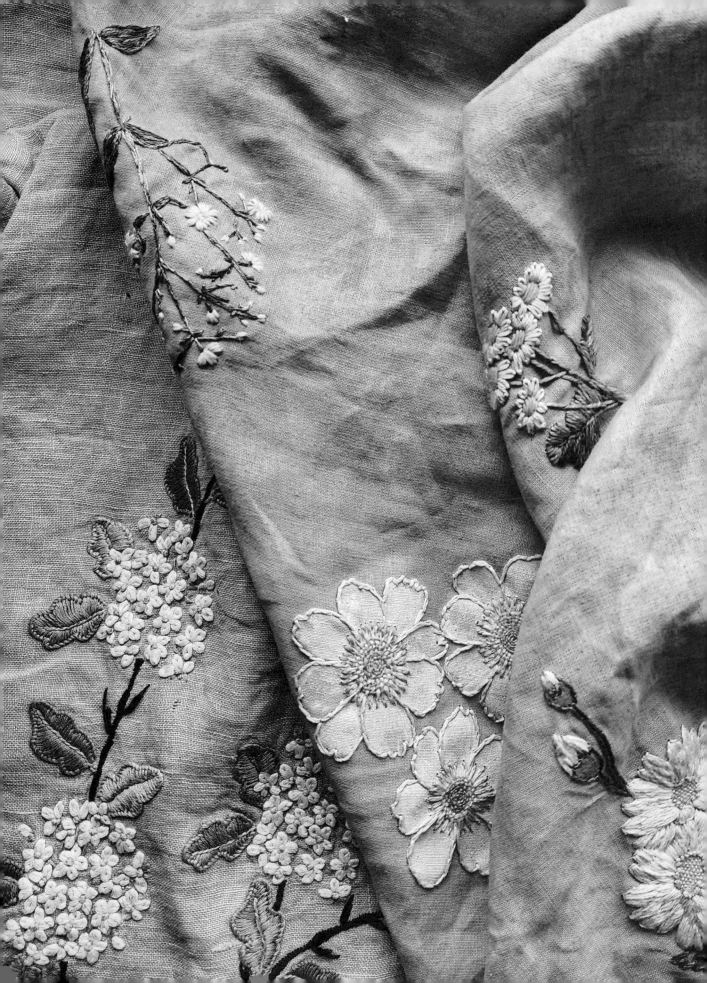

One was an artist due to study in Paris
before the Second World War broke out.
The other could hand-stitch a quilt
with her eyes closed. While I didn't
grow up with these women passing on
their skills, I grew up surrounded by
the things they had created. I also
grew up with my mother in the garden;
her love of flowers and passion for the
environment was a constant in my life.

These concepts felt comforting and
helped me understand why florals and
stitches felt so relevant, but it wasn't
until I got my great-grandmother's hand-
stitched tablecloth from the cupboard
that I understood what a creative soul
is. This tablecloth and the many vintage
textiles I was forever collecting were
already in my life. I'd been actively
collecting them for years. I'd always

From Left: Treasures in many forms;
a wildflower, colourful crochet
blankets and garden roses.

felt a deep appreciation for them as
objects, and yet I hadn't realised that
within their fibres was my calling. It
was with me all along, my creative soul.

It is important not to confuse your
creative calling with being immediately
good at it. It's not a magic bullet,
but I promise that finding your missing
links will naturally bring you closer to
a creative process that feels like home.
Imagine that, like our physical traits,
intergenerational knowledge is passed
unknowingly through objects. You might
be thinking, *that's lovely, but how on
earth do I know what it is for me?* Well
here are my thoughts on how you could
approach finding it.

First stop on your journey … look
around you. We are all naturally drawn
to objects that resonate with us. I'm

not talking about your beautifully
styled lounge that follows trends or
inspiration from elsewhere, I am talking
about the tiny item that feels special
when you hold it; the painting that
brings you deep comfort; the texture
that you can't help but touch whenever
you pass it; the weird thing that others
wouldn't choose, but to you, is perfect.
Those things are your treasures. Your
creative soul resonates with them,
and they can give you clues. It might
be worth gathering those things and
surrounding yourself with them when you
create — you will be surprised by the
power of the subconscious to gift you
the information you need.

Research and talk to your family about
your history. You might discover that
your great-grandfather made objects with

wood, which you are always drawn to, or it could be simply that generations of your family lived in a forest. This is not an exact science. I can't guarantee that the answer will be here for you, but I suspect it could be wonderful to explore who in your past might have created and what it was that they crafted. Ideally, if you can, it would be incredible to see, touch and connect with something they made.

Clues can also be in the era of creation. I have always been an old soul, and my house has always been filled with crochet blankets, vintage textiles, found objects and flowers. Handmade fibre objects feel like treasures to me. I used to say I was born in the wrong era, but I wasn't. I now understand that my purpose is the continuation of skills from the past, bringing them into modern life.

For a long time, I was trying to control the story, plan how everything would look, and how cool and successful I'd be. Holding on too tight to your dream can often result in climbing the wrong ladder. Being softer and gentler with yourself, and your creativity, can allow for much more learning and growth. Release all expectations, gather the materials you love, and play with them to create things that have no purpose other than to allow you to explore their qualities and function. There are ways to activate your creativity, and the key to working this stuff out is taking a moment to reflect after you've created, or notice how you feel *while* creating.

If you're unsure where to begin or don't feel close to identifying your unique creative soul, here are some simple, playful activities that you might like to bring into your creative practice. The key with these little tasks is not to overthink your actions — just do it, and set a time limit if you need to. But most importantly, notice how you feel when you do them. Did it spark a little joy? Was it boring? This is the information we're looking for.

If you are time-limited, these little activities can be a beautiful way to bring more creativity into your

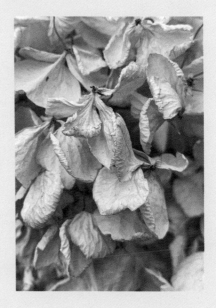

Colour and texture inspiration
found when exploring nature and
noticing the details: billy
buttons, dried hydrangea and
autumn leaves.

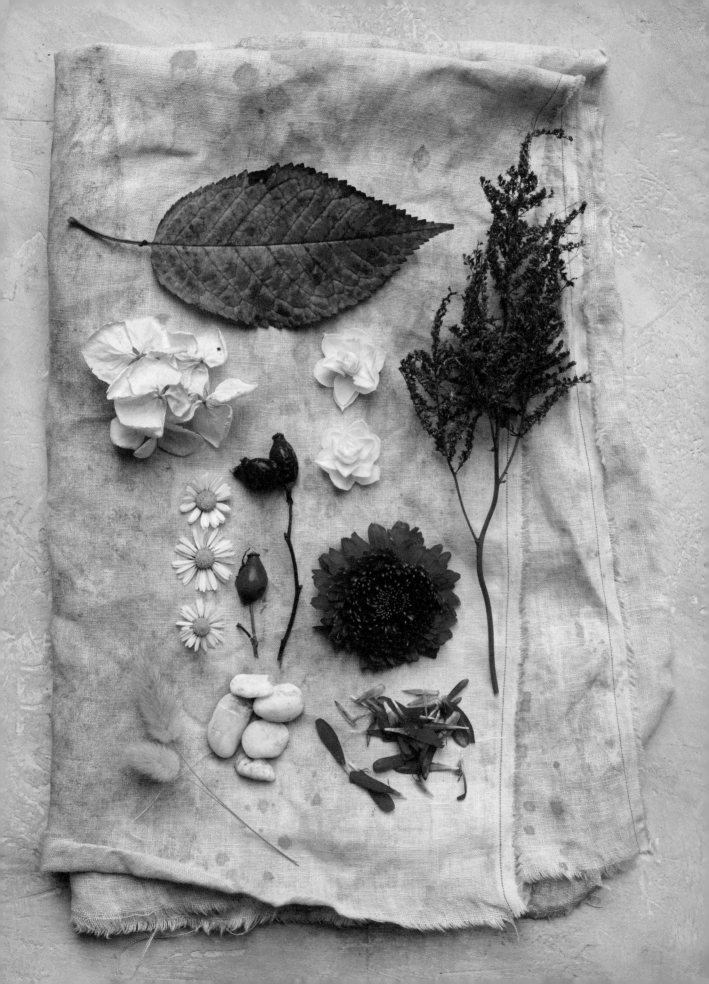

From Left: Create a 'nature' or
'foraged' flatlay then capture the
details with your phone for easy
future reference. Next: Making
organic air dry clay forms that often
find a home in my rock pool pieces.

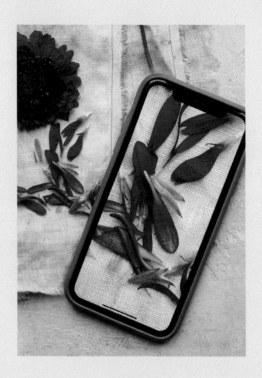

life without needing it to become
anything more. You may find you become
particularly drawn to one that you can
keep exploring over time. It's all in
the noticing. This is not about being
masterful and feeling good because
you made something lovely, it is about
noticing if the process of creating
felt good. Remember this is not about
the outcome; the outcome comes later.

### Play

Play is taking an approach to materials,
concepts or processes without any
attachment to outcome.

When children play they are present
in the moment and deeply curious about
everything they engage with. Bringing
out a little of your inner child can
open a path for your creative instinct
to feel more accessible as you create.
It doesn't matter what the activity is,
simply choosing to be playful instead of
results-focused is enough to allow space
for more learning and happy accidents.
The more you play the more you will
reconnect with what actually brings you
joy when you are making.

### Forage

Go for a walk outside, gather 5-10
things that interest you and create
a flatlay of them on a surface you
like. Photograph them with your phone.
Consider taking some close-up shots of
the elements of each object you are
drawn to, be it a texture, colour or
detail. This is a great little exercise
for warming up your creative sense of
play, but it can also provide you with
a visual resource for future projects.
If you want to follow this with another
action, go with it. If not, move on.

### Create

Roll, mould and model. Air dry clay is a
wonderfully simple substance available
from most craft stores, it's relatively
affordable, and you don't need any
special equipment. Use baking paper as
your base and find some tools — a knife

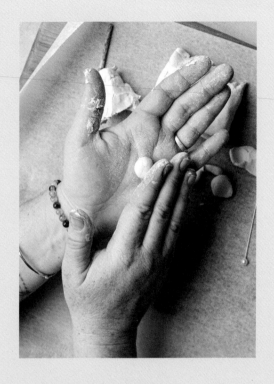
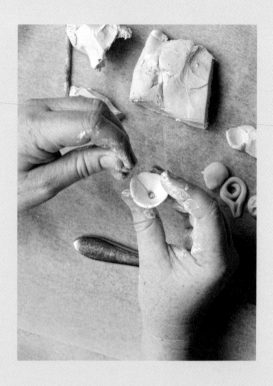
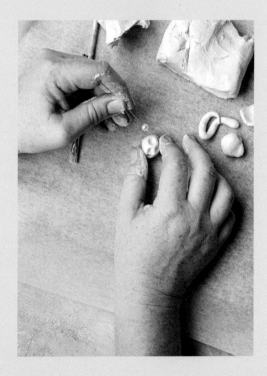
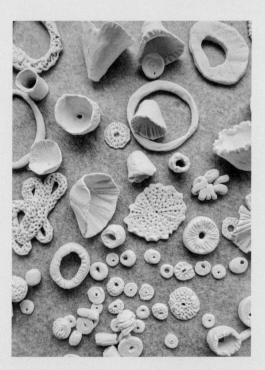

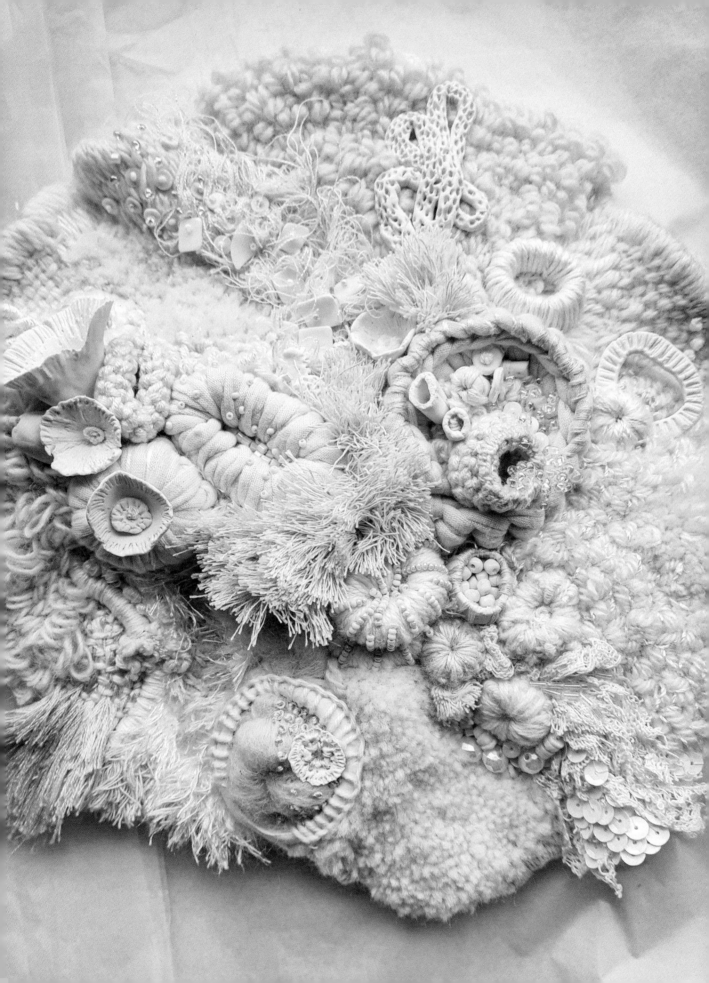

and fork are enough. Working with our hands is so comforting, and sometimes it's lovely to roll simple little beads, or perhaps you are inspired by your foraging to explore some of the forms or textures you've found.

Remember, we're not making a product. It doesn't need to be practical, usable or have any end purpose, though you may find that magically, what you make will eventually find its place.

I came to air dry clay for my work by playing at the kitchen table with my kids during school holidays and making shapes alongside them. It was lovely.

By the end of our session, I had created a large tray of tiny organic forms. A few days later, I was pondering the dried objects and decided they would be perfect little lightweight additions to my fibre rock pools.

## Favourite Place

Whether it is the beach, a garden, a café or your bedroom, visit your favourite place and write down three things that appeal to your senses: sight, sound, smell. Keep writing if you want to, about how the place makes you feel. The more we can take time to

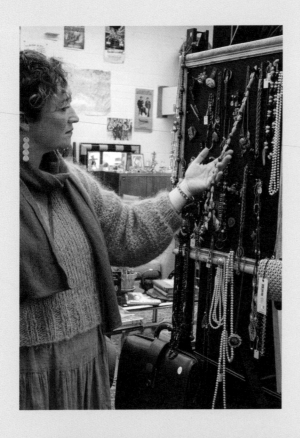

Second-hand store wandering
and creating with friends.
Next: My great-grandmother's
tablecloth with some hand-
stitched mending added by me.

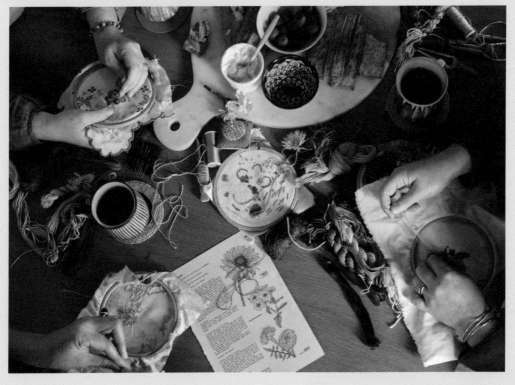

understand who we are, the more we can feed our creative soul and encourage it to reveal itself in our creation.

## Upcycle

Go to the second-hand store (or if you're like me, go to multiple), and find 3-7 things that you are drawn to, bring them home and nut out a way to make something with them. Again, not something beautiful necessarily, but something that feels fun and interesting.

## Stitch to Music

A piece of soft easy-to-stitch fabric, a needle and your favourite thread is all you need for this. I like a bit of wool blanket, a size 18 chenille needle, and an arm's length of 4ply silk merino wool. Use any stitch you like and wander around the fabric as the music plays. Pay more attention to the music than your mark-making. You can play the song on repeat or on a playlist if you want to do this for a while. It's interesting to see what marks you make when fuelled by the music and you aren't trying to control the outcome so much. It can be fun to try this to different styles of music that make you feel different ways, and see what it does to your mark-making.

## Draw to Music

Take a piece of paper and a pen or pencil. Try not to look at the paper too often as you listen to the music. Make whatever marks feel right in the moment. This is not about creating a masterpiece, it is about allowing creative energy to pour out and for you to become more familiar with how that feels. It will help you recognise the feeling when you hit on another process that brings you a similar sense of freedom and elevation.

## Join a Project

There are many creative community projects that are often free or affordable to join. For me, the 100 Days Project I completed in 2014 was a crucial part of learning about myself and my mark-making, and more importantly, I learnt a lot about who I wasn't as a creative.

## Create with Others

Sign up for a workshop, join your local craft group or gather a group of friends for creative sessions. In a later chapter, **Create Together** (page 238), I dive more into the magic of creating in the community.

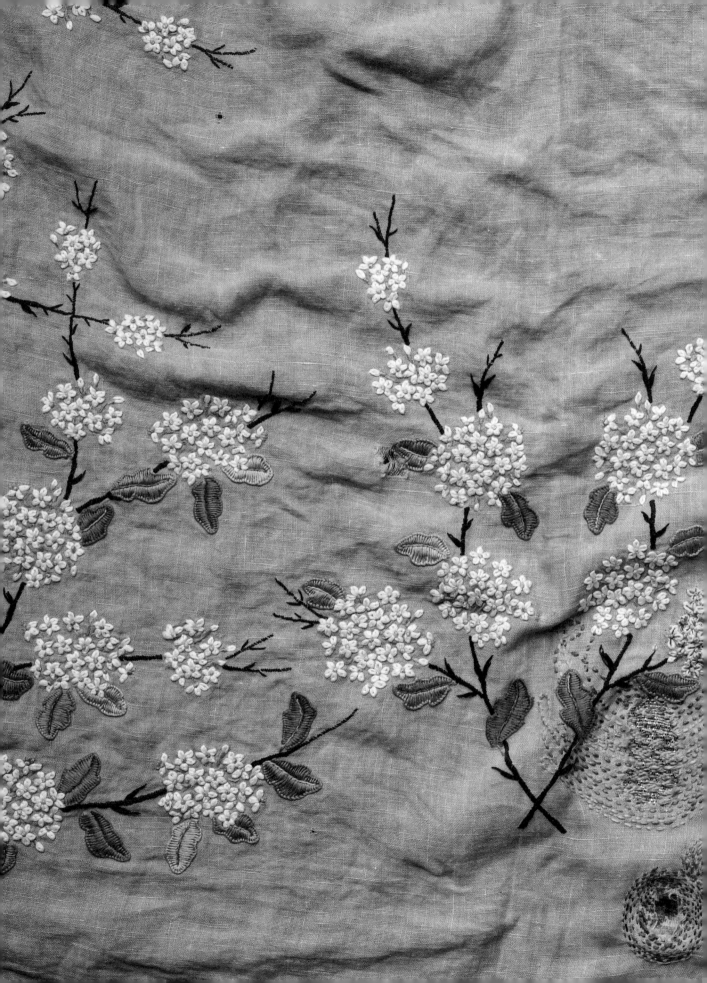

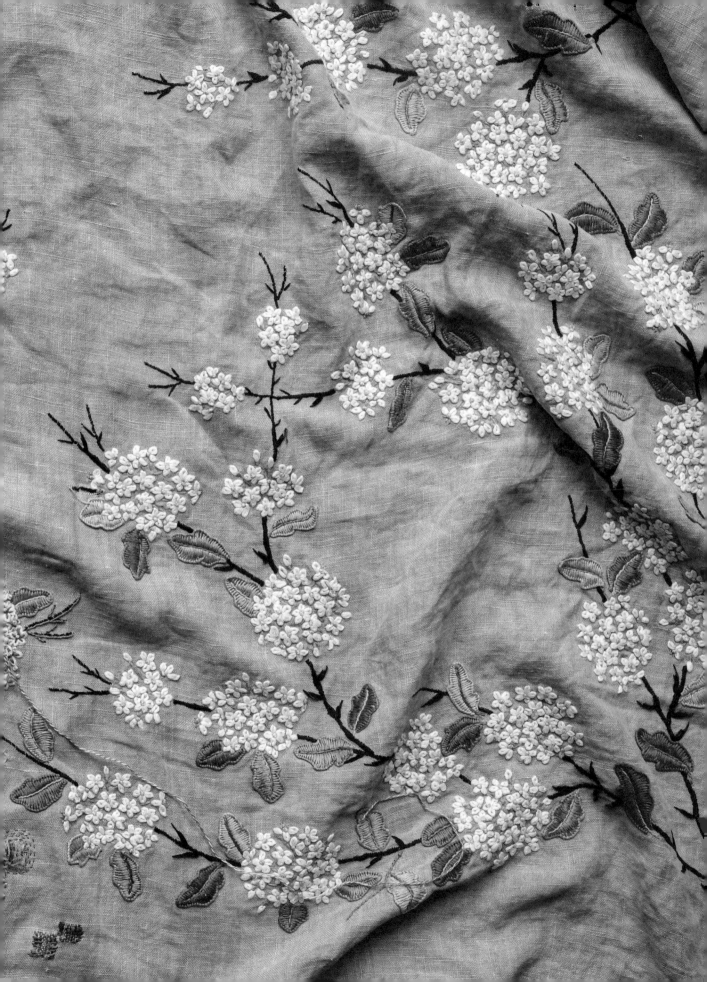

# TREASURE HUNTING

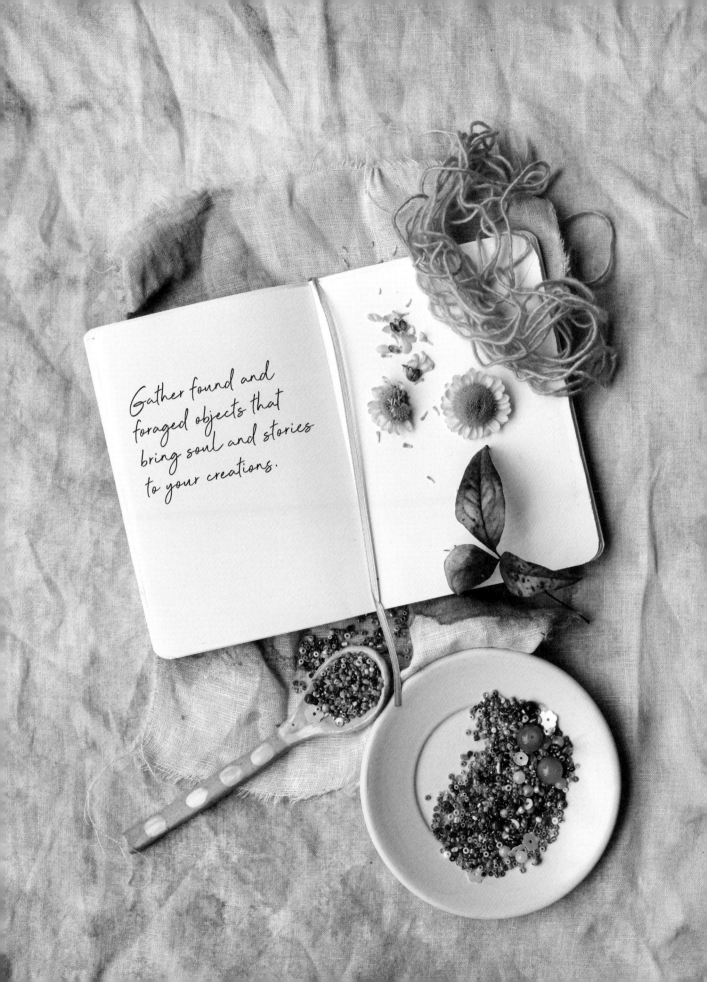

Gather found and
foraged objects that
bring soul and stories
to your creations.

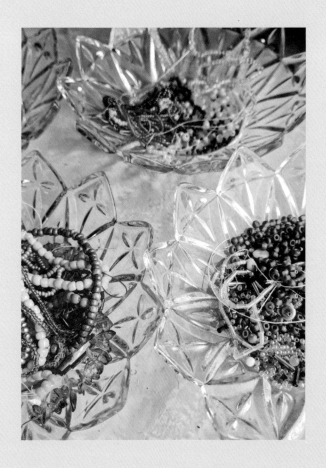

Beads bring texture and
sparkle to your work while
adding another dimension.

52 ～ THE UNTAMED THREAD

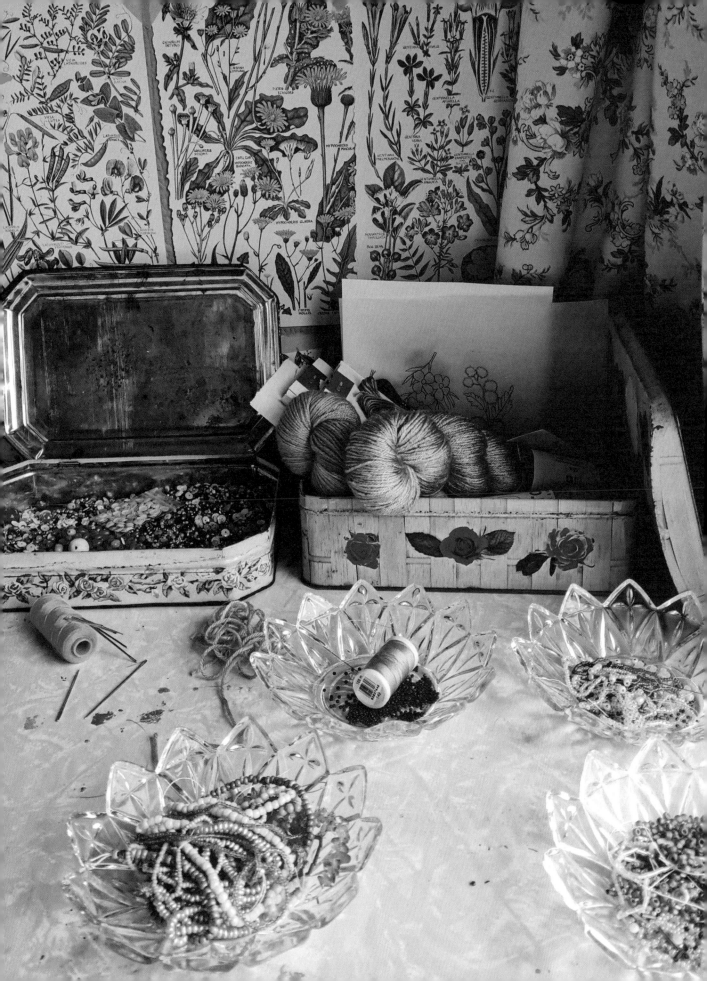

Combining my two loves, nature
foraging and second-hand store
treasure hunting.

# Are you someone who collects things?

Years ago, I started to collect vintage
textiles and embroideries from second-
hand stores. This was long before I
started working with them in my art
practice but I could never resist
rescuing them even though I had no
apparent use for them then. The sweet
little flowers stitched lovingly by hand
into a now slightly stained or holey
teacloth enchanted me. I had to rescue
them from the loneliness of the under-
appreciated basket of 'old cloths' at
the op shop or second-hand store. I gave
away my entire collection, more than
once, because I was unsure what purpose
they served in my life.

Back then, I didn't know it myself
that those collections were full of
treasures. You see, the things we are
drawn to, whatever they are, are our
treasures, and this sense of curiosity
about an object you collect can give
you vital clues to who you are as a
creative. The same goes for the other
things you intrinsically value, like
places, colours and objects. It doesn't
necessarily mean you need to be very
literal about it. For example, you may
find yourself drawn to textiles, but
your exploration of materials doesn't
need to stop with making a cushion. What
it means is that it could be worthwhile
researching and exploring textile art
forms as a medium for your creativity.

What can also be true is that you may
be drawn to a particular textile, but
the patterns on them or the weave of the
fibres are what resonate with you. It is
about digging into what makes *you* stop
and pick up that particular object. What
is the essence of it that draws you in?
It's not certain that the objects you
collect will translate directly into art

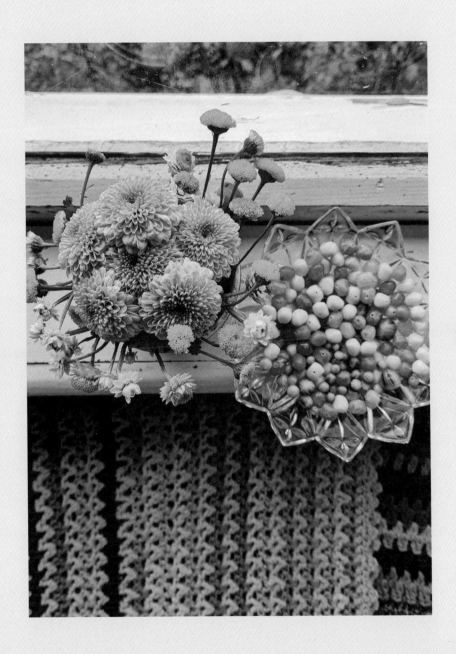

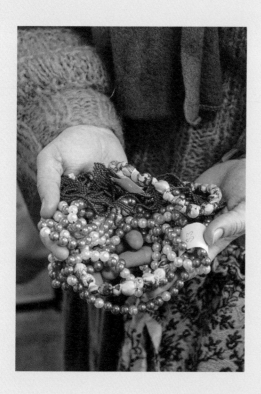

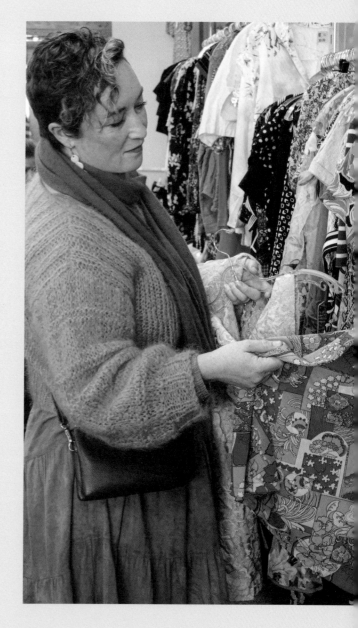

practice, but if you want to create with more joy, more regularly, these little clues might, at the very least, give you a jumping-off point.

I love collecting old books with beautiful floral illustrations, often gardening books. If I were to look literally at this, I should be a gardener as my creative outlet. On further investigation, I realised that the simplicity of the illustrated imagery, the colour palettes and the types of flora captured, are what appeal to me most. Interestingly, even though I've always collected these little books, it wasn't until I started stitching into the painted flora I'd created, using them as a reference, that I realised what a perfect alignment it was for both paint and stitch.

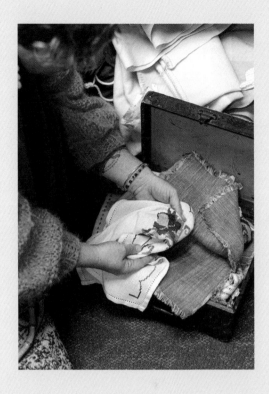

Second-hand store shopping often involves a keen eye and a few laps around the store to find beautiful treasures. Next: My bead tin filled with every kind of bead you can imagine. I love sifting through to find *just* the right ones.

Following my curiosity I regularly scour local antique and second-hand stores for textiles and fibres to use in the studio and am guided by my aesthetic when selecting them. I don't think of a particular project as I gather. Usually, it's just about picking things that spark my interest — colour, texture, pattern, sparkle. It's fun to gather and repurpose creatively. Sometimes an out-of-date shirt or dress in a great linen can be perfect to cut up for your creative work. Equally, knitters often donate their ends of balls that are too small to knit a project with but perfect for a fibre artist to use for stitching. This part of the process aligns with my values and gives me all the more joy. During a frustrating hunt for beads in the craft section of the second-hand stores one day, it occurred to me that there were a lot of quite interesting necklaces hanging there, with the most beautiful beads on them. They'd had their moment in fashion so I ended up

getting the necklaces, cutting them and collecting the beads.

It is not only the repurposing that appeals; it's the sense that this object, fibre or textile has a story. If you can learn more about the textile, the manufacturer or even the process used to create the object, you might find that your little treasure can reveal endless stories and deliver multiple options for creative projects. I like to imagine that the residual energy left from the person or people the object lived with continues into the new artwork, helping form new creativity.

The biggest obstacle for most people that prevents creating with a joyful purpose, is second-guessing their weirdness. Let your weird and wonderful ideas out. These little things are

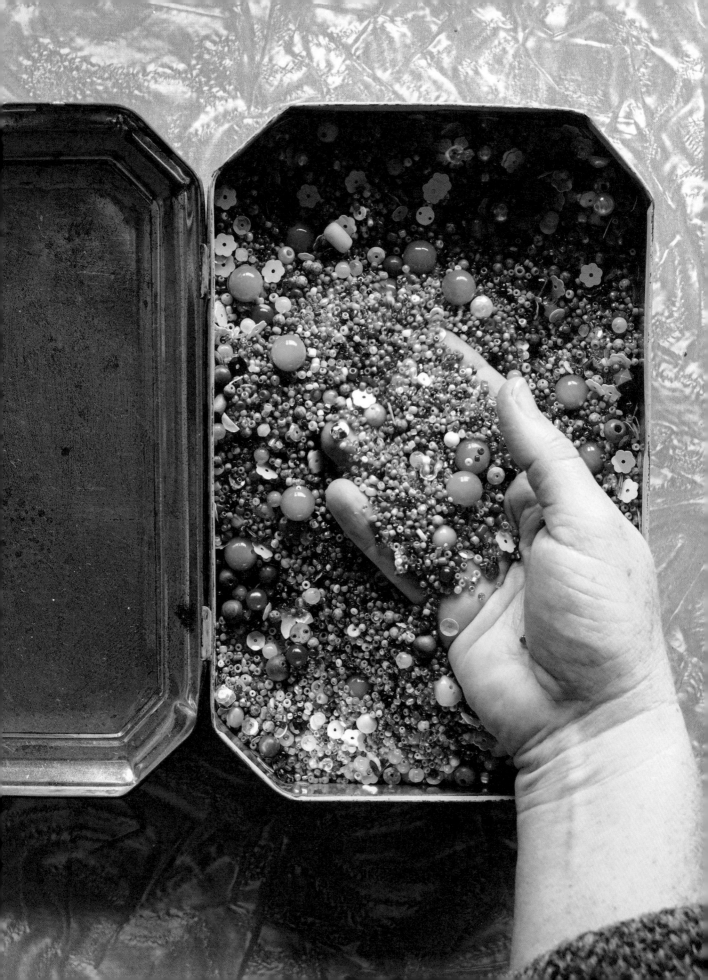

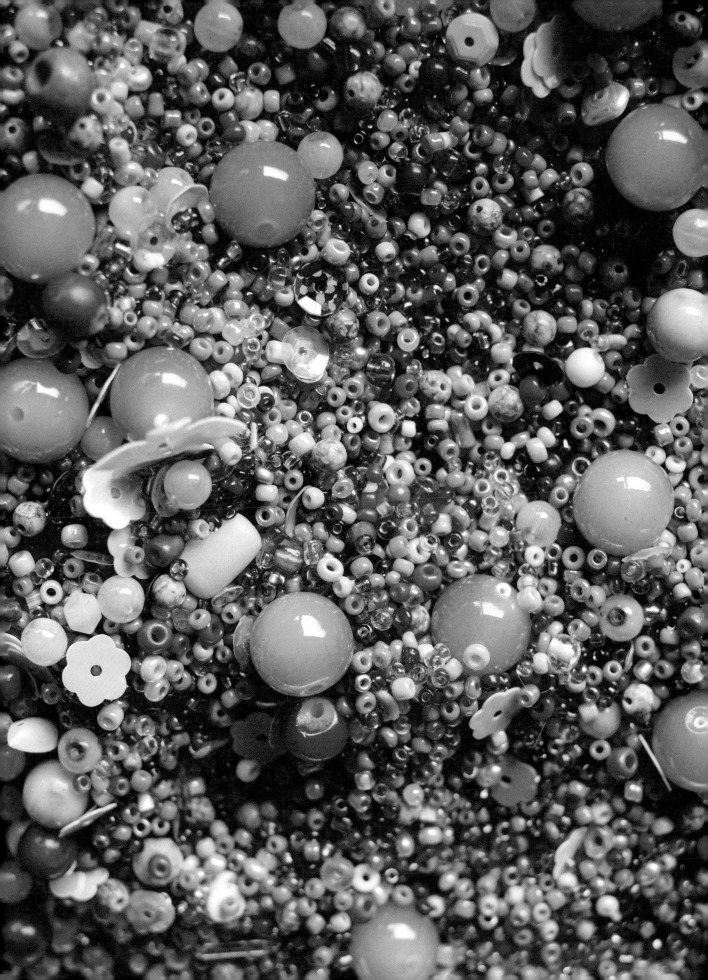

Bringing new treasures home
and having a play by creating
a flatlay is a wonderful way
to connect with each piece.

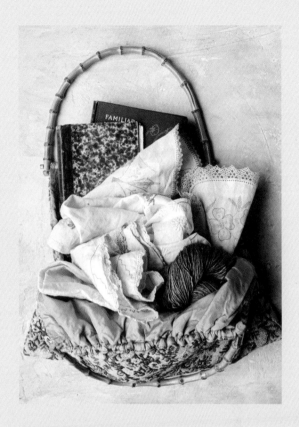

part of your story and will gift you
the ability to tell your own creative
stories. If you just let them.

At this point, we are not pursuing
a result, we are hunting. Hunting
for treasure is a slow process. When
there are paths with dead ends, we
turn around, retrace our steps and
turn towards the light at the end of
the tunnel. The thing is, everyone's
light and tunnel are different, so this
process cannot be illuminated by trying
to hunt for someone else's treasure. It
is time to get out of your own way and
let these little gems guide you.

So, I encourage you to go on a treasure
hunt. That could be in your existing stash
of collected objects, a second-hand store,
beachcombing, or even capturing photos on
your phone. Select 5-7 things that spark

your interest. Explore each object and
consider the key things you are drawn to:
is it the colour, the texture, pattern or
form? Perhaps your collection will inspire
an obvious jumping-off point to explore
further, so go for it! But if not, here
are some ideas to get you started:

**Create a Flatlay**
This is a simple process of choosing
a flat surface and displaying your
collection to be captured from a
bird's-eye view.

1. A table (or even the floor) with a
good natural light source is perfect.
You can use the existing surface or add
something as your base — a large sheet
of paper, some wrinkled linen or perhaps
even one of the elements you've collected

Select a few of your favourite finds:
cut, bundle, scatter and arrange
them as a flatlay to photograph.

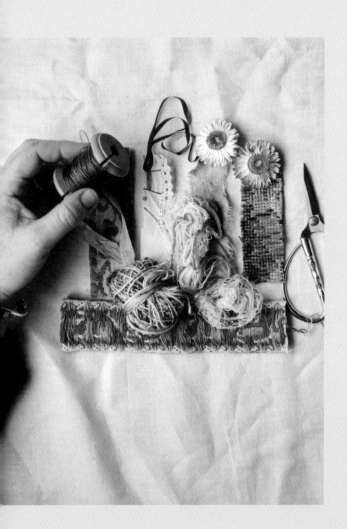

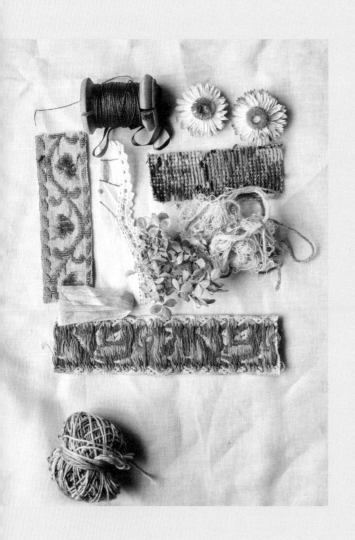

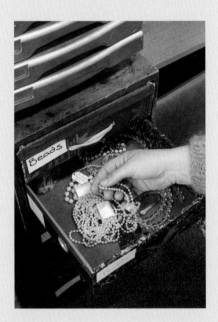

Florals in all the forms. I
love finding reference imagery
and inspiration in art, books,
jewellery and textiles.

can perform this task. Then decide on
your framing, for example, a square
shape, and arrange your collected objects
within this. Position yourself above the
arrangement, with the camera parallel to
the surface, and take some photos.

2. Play around with different
arrangements — turn, fold, roll, flip
and explore the objects. Notice what you
like about these treasures as you play
and examine various layouts. This is
important information about what sets
your creative soul on fire.

3. Flatlays can be a fun exercise to get
your creativity going, or they can inspire
further work. If you love the image you've
created, you could consider printing it as
artwork or drawing/tracing/painting over
your printed images. You can also have
images printed digitally onto fabric that
you can stitch into it. It's also possible
to stitch into paper.

## Sketch & Write
This is about transcribing your
collection onto paper. The goal here is
to give yourself a simple brief and do it

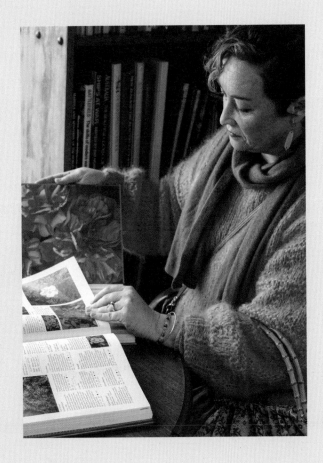

quickly. Try not to overthink it. This
is purely for you and doesn't need to be
shown or shared so can be wild, weird and
rough; as long as you can decipher what
you were thinking later. Remember this is
an exercise and not a test — there is no
right or wrong; simply exploration.

Here are a few ideas to get you started:

+ Write down three words inspired by
each object, and make marks representing
those words. You could use any medium,
including stitch, for this.

+ Use a timer and give yourself 30
seconds to stare at each object. As
soon as the timer finishes, write
and/or draw what comes to mind.

+ Put them on display — create a
little shrine or vignette of your
collected objects. Sometimes simply
acknowledging that they are unique
to you and elevating them to a place
of pride will subconsciously sow
a knowing in you that permits you
to work with those things as your
inspiration in future.

Treasure hunting at second-hand
store Stuff, in Christchurch.

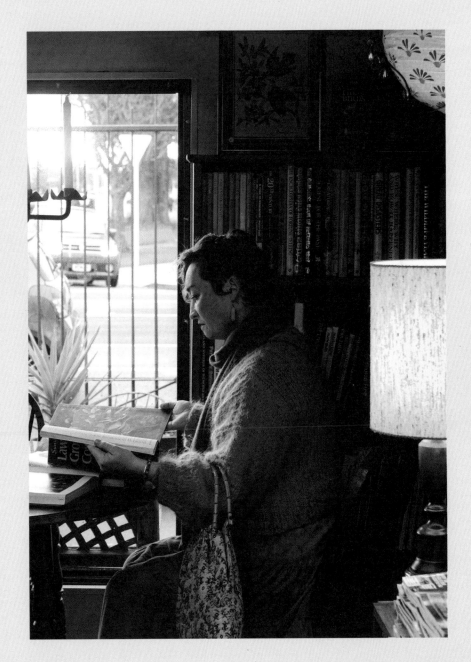

# NOTICING NATURE

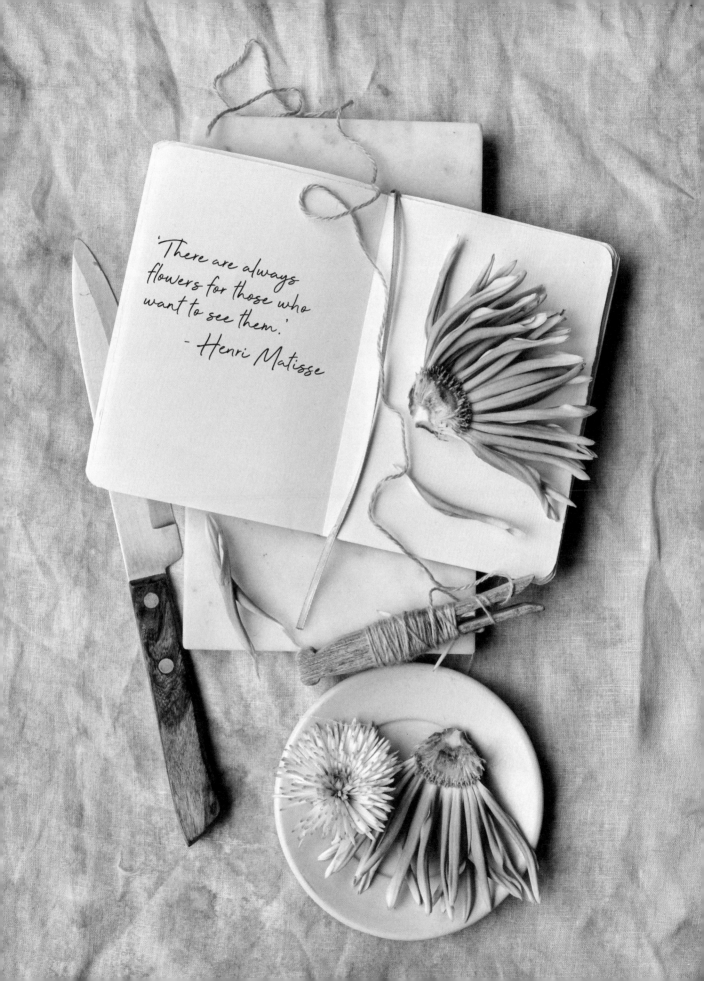

'There are always flowers for those who want to see them.'
- Henri Matisse

Previous: Iridescent Irish
strawberries (left) against the dry
grass and the golden lichen against
the stone — forever noticing the
contrasts in nature. Here: Look up,
down and up close, to capture the
intricate brilliance of natural forms.

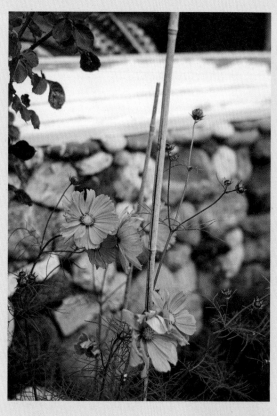

Growing, gathering, arranging and observing. There is nothing nicer than letting the flowers fade and returning them to the garden to begin to seed again.

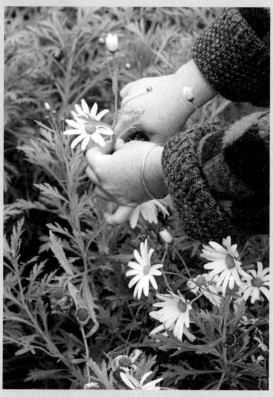

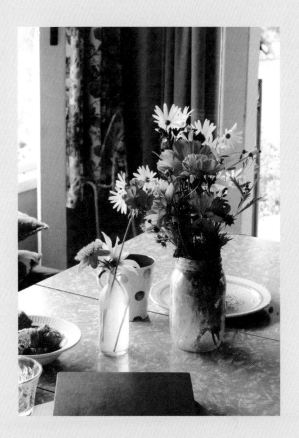

# Once I began to understand that my creative process needed to be infused with joy, I turned towards nature.

Aligning nature as a source of guidance for my practice felt natural, as it had always brought me an immense amount of joy. Whenever I feel creatively stuck, my recipe for success is time in nature noticing the intricate flora, mixed with play without a purpose. It never fails to ignite my inspiration. I am incredibly privileged that where I live in rural Aotearoa New Zealand I have access to nature in abundance. It is my daily playground.

Creativity was such a lifeline for me, and it felt so important to get it 'right', that I found myself pushing hard in directions that didn't serve me. As part of my letting go of 'being cool', I let my inner nature lover back out. When I couldn't find that state of joy and flow as often as I would have liked in creativity, I always found it in the garden or at the beach. Nature gave me a sense of inner peace that I wanted to

Every part of the flower can
tell you about its form; it is
beautiful to observe it from
bud to bloom and back to seed.

experience in my art practice. When we
moved to the Upper Moutere Valley from
Nelson in 2014, my husband built me a
little studio in the garden. My parents
often looked after the girls when they
were little, so as they played and fed
the chickens with Nanny and Grandpa, I
started to slow down … to drink my whole
cup of tea, and watch the trees change.
Everything we need is generally right in
front of us, but life is often so full
and demanding that there is no space to
gather knowledge of it. During this time
I was able to pause for breath, with the
support of my family. It was a turning
point in my career.

I didn't set out to intentionally
spend time in nature to enrich my art,
but rather to pursue the peace I sought,
to soothe my soul and, in doing so,
found immeasurable gifts to feed my
creativity right on my doorstep. This
happened in many ways but in its most
simple form, it was about walking and
looking. Walking through the garden
and allowing myself to become truly
immersed in what the colours of the
trees were doing in a particular light,
how the leaf veins differed from plant
to plant, and how the roses shed their
petals — rather than just gazing around.
I slowly wandered remembering to look
up, down and all around me, allowing my
eyes to linger in a silent homage to

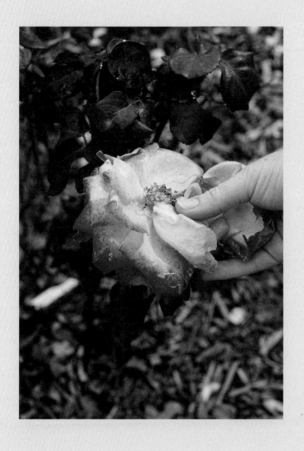

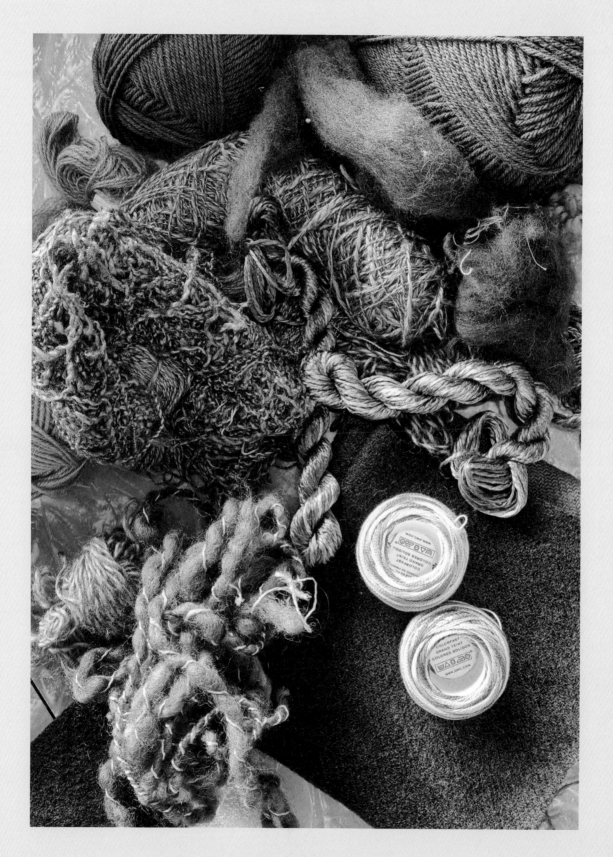

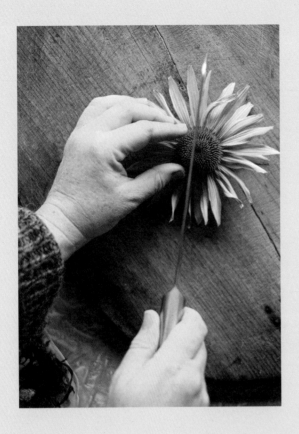

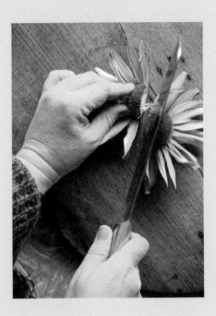

Previous: Take inspiration from nature through tones and textures. Here: Dissecting flowers is a wonderful way to understand their shapes and helps when it comes to drawing or stitching them.

forest floor, the vines in the canopy… anything that captured me. These photographs were invaluable.

Not only has this regular practice of walking and looking brought me untold wellbeing, it has informed my understanding and appreciation for the forms I love. To be inspired by the natural world, we need to experience it. Take the time to cultivate a familiarity with the aspects of nature that resonate with you. The time you spend noticing will give back to you so generously when it's time to create because your brain will be much more ready to communicate the forms and details of the subjects you love.

every form that caught my gaze. Other times I gathered a light basket or tote bag and some secateurs for a wander around the garden or forage along the roadside, where permitted — collecting anything that sparked my curiosity: seed pods, flowers, grasses, leaves, twigs, a feather; lots of little things can be found when you look. In places where I couldn't gather flora, like public gardens and national parks, I would wander and photograph, capturing the inspiration — the texture, the connection between plant and host, the centre of flowers, the mosses on the

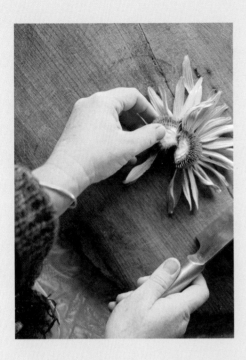

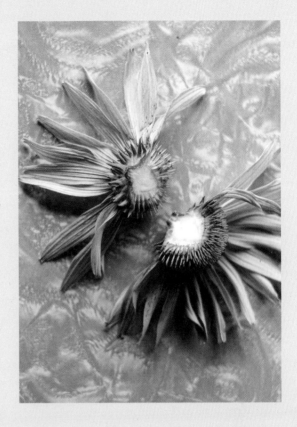

Getting to know my favourite flowers by noticing them while watering the garden or arranging them in a vase has helped me communicate their form and gather that essence into my mark-making. It has also profoundly redirected my process from a creative who gave up in the pursuit of realism, to someone who has such reverence for nature now that I understand it is my life's work to celebrate its essence, its quirks. The triumphs and sheer resilience of nature that I have experienced haven't come from simply observing, but from really taking the time to smell the roses.

Here are some simple prompts to connect with nature:

**Gather, purchase or grow some flowers.** Arrange them in a vase and watch them bloom and fade. Collect the dropped petals and explore the sprinkling of pollen on them, or how their ends curl. Allow them to dry and see the colours change.

For those you have grown, let seed pods form and dry before redistributing them into some seed mix and growing them again.

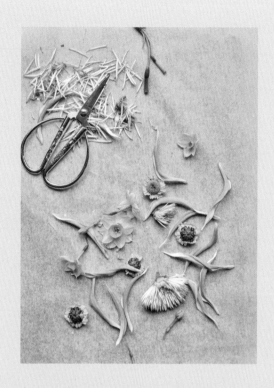

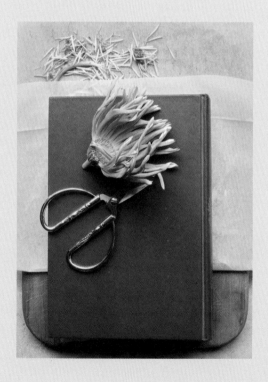

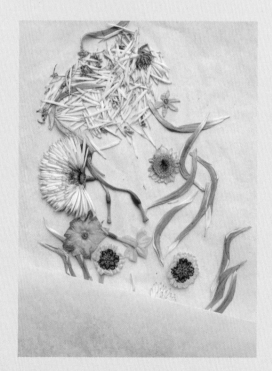

Floral flatlays are a beautiful
way to play with blooms. Sandwich
them between baking paper and
stack books on top to have
pressed dried flowers to use in
a month or so.

**Grow something you love from a seed
or bulb.**
No space is too small in which to try
this as it can be done from a balcony
or windowsill or the garden.

**Get to know the life cycle of the
nature you love, be it a river, a tree,
a rose bush or coastline.**
Visit the same place often throughout
the year, take notes, sketch it,
photograph it.

**Make friends with nature, and be
really present *in* it.**
The more you practise being present
in nature observing, you will gain a
deeper sense of understanding.
From the time spent noticing nature,
your instinct will grow. For the
colours, the energy and the forms that
you love. When it comes time to create
you will really benefit from the time
you've spent observing nature and it
will show in the sensitivity of your
mark-making as you express its essence.
   While being intentionally slow and

quiet in nature can be a beautiful way
to actively relax and ground yourself,
remember observation doesn't need to
be quiet and serious — it can be messy,
fun, whimsical and rewarding. Grab a
chopping board and a sharp knife and
dissect the nature you've gathered. Take
cross sections, carefully open up seed
pods, pluck petals, and play as though
you are an explorer gathering the most
important knowledge you'll ever need
to know. As you did with your treasures
(in the previous chapter), you might
like to explore flatlays or extend this
into a pressed flower arrangement. To do
this scatter your found flora on paper
(baking paper is ideal) and gently place
another layer of paper over the top. Add
a few heavy books to sandwich it together
and revisit in a week or a month, or if
you're like me, when happily remembering
why you stacked those books on the shelf
that way. Once the flora is dry you can
play with creating a collage with it or
painting it in different colours, use
it to press into clay to make natural
textures … anything your heart desires.

# CREATING WITH THE SEASONS

Connect and create with nature's cycles.

THE OBSERVER'S BOOK
OF
WILD FLOWERS

**Now that we've immersed ourselves in nature and taken the time to begin noticing that which makes us curious, sparks joy and feeds our inspiration, we can explore how our creativity can ebb and flow along with the seasons.**

As I write, frost is sparkling on hardy Queen Anne's lace seed heads. As nature curls into itself to brave out the cold, under the surface much is waiting to bud and blossom. Without winter, there is no spring. This is true for our creative practice too. It can be abundant and flourishing with all the hope and joy of spring, while other times it is transitioning like autumn, and can be quiet and wintery. It is rare to experience the long warm days of summer all year round. The seasons are a beautiful metaphor for our practice. If we align ourselves with them a little, it can remind us of the need to be constantly resilient and patient. As in nature, the seasons of our creative work will change, grow, wither, fade, reemerge, bloom and flourish.

I've learnt over the years it is just as valuable to draw things close and stay quiet for a while, as you learn and practise. Meanwhile, breakthroughs brew gently by the fire and just as the first buds start to form, so will your

concepts. This can be a tricky balance to strike if you are trying to live a creative life and earn a living. It generally means that you might need to diversify what you offer to protect your creative process and allow it to be both abundant and slow.

I used to believe that if I only worked hard enough, I could create anything I wanted. I now understand that our relationship with our creative soul is a much more nuanced and delicate balance. It doesn't mean you don't work hard at it sometimes; flowers have to work very hard to bloom, but it is essential to remember that there are times when it is critical to work underneath the surface, to prepare for blooming.

The more I align with nature and the seasons, the more I find inner resilience and appreciation for the different phases of creativity to enable me to ride the seasons of growth. This alignment has allowed me to observe some interesting things about how I create to nourish my creativity physically through its ebbs and flows. Allowing myself to lean into the energy of each season reminds me that, as with nature, our creative process evolves slowly.

The seasonal suggestions which follow are customisable to you, your lifestyle and your surrounds. I suggest these alignments because they resonate with me; your work is to explore what might be a good fit for you and the seasons of your creativity.

Each season has a different
energy that can inspire and
guide our creative process.

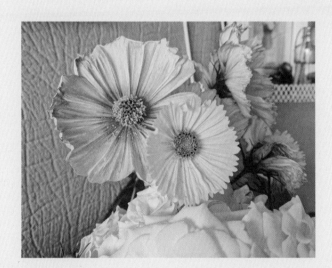

# Winter

cosy + wool blanket + books + warm socks + hot tea

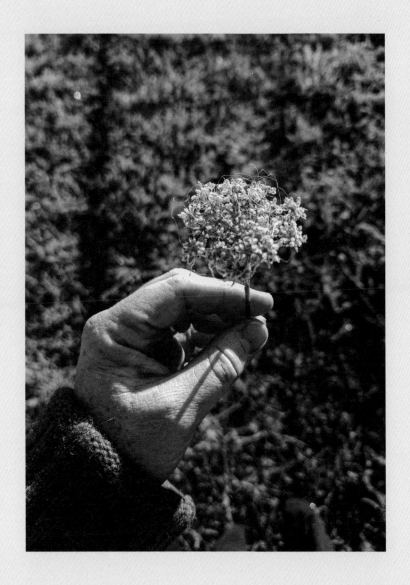

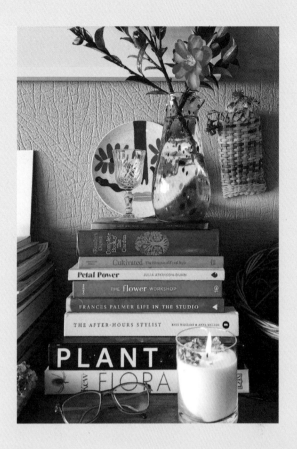

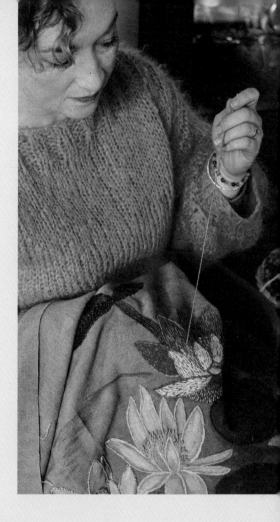

For me, winter is a time to work on longer, larger stitch projects. Things that can slowly evolve as I drink tea and listen to podcasts. There is an energy to each season and for me, this translates into my creative process with small rituals that I set up for myself before I begin. My winter ritual runs along the lines of lighting the fire, making tea, lighting a candle (a nice smelly one), adding a blanket or warm socks to my attire, bringing my lamp a little closer. I also surround myself with books about flora, art and interiors that inspire me.

There is something nice about how the cold weather draws us to cosy spaces and often my materials become softer, woolly and more comforting. I bring a lot of colour into my work in winter as colour feeds my spirit, so it seems natural that when it is more muted outside, I turn up the volume on my colour palette.

A few of the books that inspire me in winter when the garden can't offer the same inspiration...

+ *Flowers for Friends*, Julia Atkinson-Dunn
+ *Life in the Studio*, Frances Palmer
+ *Cultivated*, Christin Geall
+ *The Land Will Hold You*, Mary Walker
+ *Flora*, Royal Botanic Gardens Kew
+ *Complete Book of the Garden*, Reader's Digest
+ *Plant*, Phaidon

From Left: A stack of my
favourite winter browsing
books that sit alongside me
as I stitch by the fire. A
patchwork of weaving stitch.

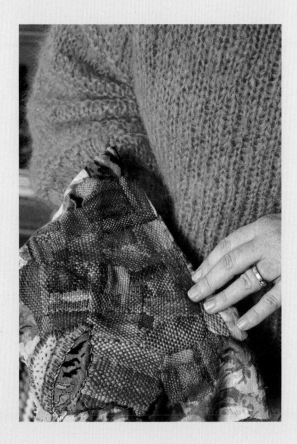

Of course, there are many more, but
these are my staples, stacked on the
table or near my chair, often all winter
long, ready to be pored over.

Creating a stitch sketch page is a
beautiful winter project that allows
your practice to quietly and steadily
grow. This could be any size and
involves practising a variety of stitches
repetitively all over the 'page' of
fabric. A woollen blanket or felted wool
is a lovely soft surface to use, or select
a linen or patterned fabric that takes
your fancy. This sketch page is purely
for practice, and the more you play with
each stitch, the more you learn how to
use them for mark-making purposes. Try
using different threads and colours from
your usual ones. Play with direction,
distance, frequency and texture. Layer
different stitches on top of each other
to see the effect. Sketch with stitch.

This relaxing process gives you regular
but simple practice over winter to hone
your skills. Have a basket beside your
favourite spot to stitch so that your
supplies are always at hand when you
have a few minutes to sit and sketch
with thread.

You could commit to this over an
entire winter or add it to your current
creative practice, spending 10 minutes
repeatedly using a stitch at the start
of your creative time and choosing a
different stitch or fibre each time you
do it, expanding your skills further.

# Spring

new life + green grass + fresh breeze + spring blooms + create + forage

Print your imagery black and
white, then bring in colour
to reimagine the scene.

I feel such a sense of joy as winter gives way to spring and buds start to burst. Colours explode back onto the scene, and while the weather fluctuates and is unpredictable, I forgive everything for sweet blossoms. My books often get put back on the shelf in spring as I venture outside to explore and have the garden inspire me in the flesh.

My creative habits shift again with this new season, and my ritual evolves into making tea to sip while wandering around the garden before getting to work. Ten minutes of noticing the new growth and celebrating the bravery of hardy plants pushing through the still cold and often frosty soil into the sun … it is a triumph that humbles me deeply. I sometimes snip a few blooms to bring to my studio to enjoy and observe. There is a sense of urgency in spring to capture the glory of it before the blossom petals blow away and the blooming bulbs return to the earth.

This is a time for drawing, painting, floral flatlays and photography. While I have other embroidered work on the go, I release my spring enthusiasm on quick sketches and observational drawings, which add to my ability to conjure up the forms when needed. My colour palette often lightens, inspired no doubt by the pastels of the blossoms and the lime freshness of new leaves. I transition away from my armchair to the table where I can view the garden and soak up every

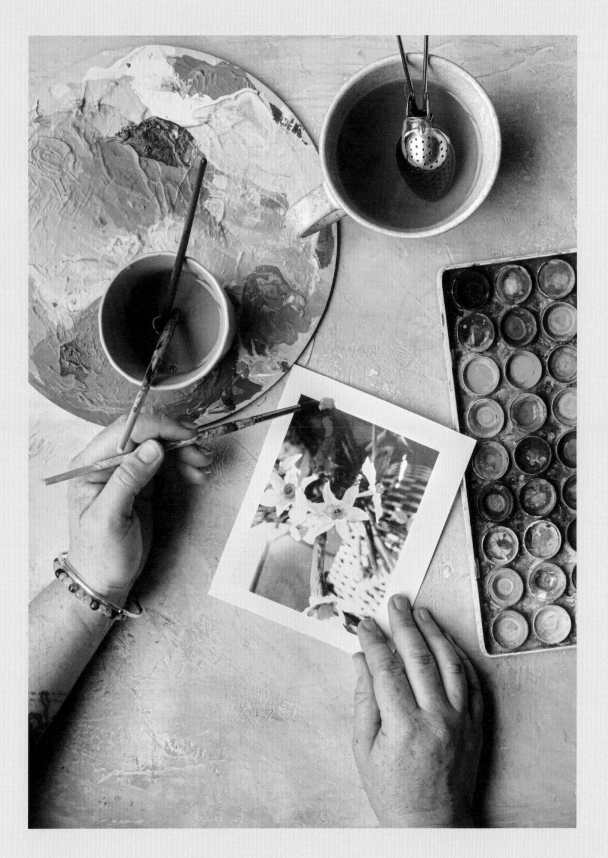

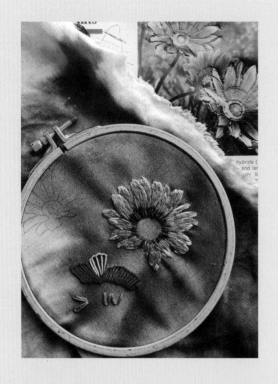

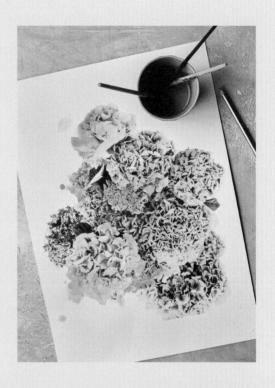

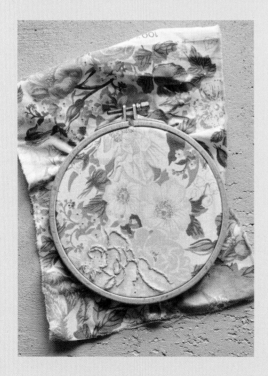

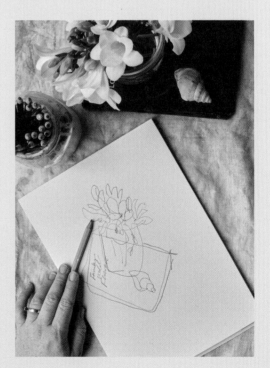

second of its abundance. The slow and
steady practice over winter helps me feel
prepared for this quicker, more vibrant
time that generally results in new ideas.
Ideas that I feel more ready to execute
because of my steady winter workflow.

Spring is a time for playfulness and
enthusiasm. Partaking in bite-sized
projects is an excellent way to embrace
the energy of the season and remain
less attached to the end outcome, for
remember — this is all about practice.

## Floral Flatlays

Forage, pick or purchase your favourite
spring blooms for a flatlay. Arrange
and photograph to your heart's content.
Print this in black and white on card
stock or watercolour paper and add
colour, line work or any medium you
like, to bring colour back in. Or have
the digital image printed directly
onto textiles. I like to use linen or a
cotton canvas blend, but there are many
options. Ensure there is at least 10 cm
of plain fabric around the entire image
to give you the option to display the
work stretched like a painting canvas

later if you choose. Layer the work with
paint, stitch, or whatever your creative
soul guides you to.

## Spring Still Lifes

Create a simple floral arrangement and
take time to draw it. I find it's best
to put a timer on for a minute or two
and sketch quickly so as to capture the
information and not overthink. Do it
quickly and often, and you will see your
skills of observation and attention to
detail improving along with your drawing
skills. Drawing isn't for everyone and
we are not aiming for finished artwork
but sketches; this is practice.

## Collage

Collect and gather old garden books
from second-hand stores and find spring
blooms, cut them out and paste onto
paper as a collage. You can do the same
with fabric, and then stitch your floral
cutouts to a piece of fabric. I love
using wool blankets as a base for my
collages, but any material can work as
long as it is easy to stitch through.

# Summer

bare feet + daydream + beachcomb + cool drinks + sunshine + warm evenings

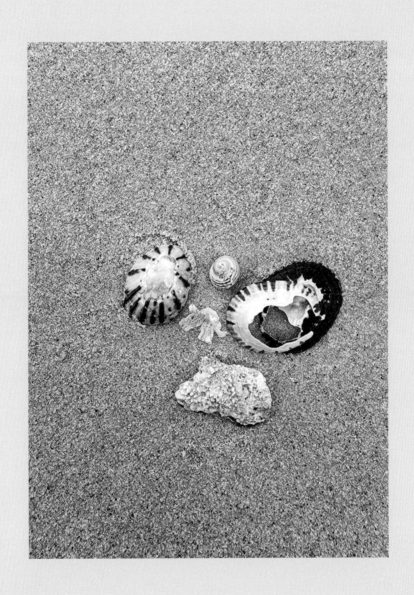

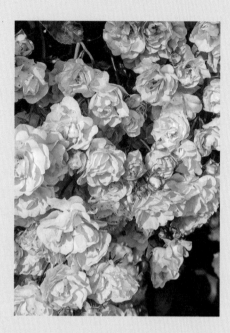

In the Nelson region, at the top of Te Waipounamu (the South Island of Aotearoa New Zealand), where I live, summer often equates to stretches of settled sunshine, lighter, longer days and yet another creative shift. My enthusiastic springtime antics have settled into steadily pursued concepts, and my colour palette is influenced by the seeds that I sowed the previous autumn that are now flowering in the garden — sweet peas, straw flowers, dahlias and roses. It's a riot of colour, a painter's palette riot that demands to be noticed and enjoyed.

The routine now moves into early-morning or late-evening watering and wandering. I spend time noticing and gathering blooms and filling the house with a nostalgic mix of dahlias and roses, daisies and hydrangeas. As my family and I seek to cool down, we are pulled towards the beach and the forest of the national park on our doorstep. Beachcombing at our favourite spot near Kaiteriteri (about 40 minutes away) led me to explore rock pools in my fibre work; while bush walks along the coastline informed my forest moss works. Capturing detailed reference photos as we embark on school holiday day trips of exploration allows me to bring this inspirational richness to my work when I return to the studio. I am grateful for the technology that allows our phones to capture such high-quality imagery — ensuring we are never without a camera.

One undervalued aspect of summer is the all-important time spent daydreaming

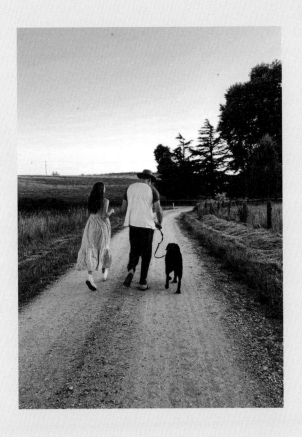

on the beach or in the bush — the peace this daydreaming brings in turn spawns so many beautiful ideas. Reading a book, sipping iced tea, or having long lazy lunches … these activities aren't disconnected from your creative soul, they feed it.

After my initial commercial success in Australia with my work front and centre in renowned publication *Inside Out* and the resulting emergence of stockists over there, I was so driven to keep my art career moving forward I became a bit of an art factory. I bought into the idea that if I paused even for a second, it would all fall away. I lost sight of the value of play, rest and self-care for about two years. On the outside, my career looked successful, but internally it was a tough grind that wasn't even really earning me a living. It resulted in burnout, and for the first time since the children were tiny, I took an entire summer off to rest and regroup. I learned to nap. My mind and body forced me to stop, which was the greatest gift I could have ever received.

It was hard to stop, practically and emotionally, yet that summer gave me back what I believe is the essential recipe to living a joyful, creative life: the ability to stop and smell the roses. Even just for little moments. This concept is still a work in progress for me, but every summer I make sure I have beach days, bush walks, and ensure that I set aside time to lie in the shade with a book, to stare at the

clouds, notice the night sky and swim in the sea. It sounds romantic, but really, it's essential. Our creativity is a practice, but the practice is also the way we live.

We become so attached to the idea of *outcome* that we forget everything we do daily can inform and enrich our creativity. My summer creative ritual is all about stitching in the shade in the afternoon, with a cold drink, and lots of cut flowers around me. I tend to stitch smaller works that are easier to transport to the beach, that aren't draped over me in the heat. I spend time on a blanket, under the tree, daydreaming. Give it a go … keep a sketchbook or journal of the ideas that pop into your head after a nap, during a day trip or celebrating with family and friends.

**Painted Linen — A Summer Garden Project**
One of my favourite summer stitch sessions involves painting linen outside, often in the morning before it gets too hot.

1. Cover the ground or a table with a waterproof drop cloth that can get messy. Lay your selected fabric (mine is usually linen) flat on top of the drop cloth and wet with water. I use my garden hose on low to sprinkle water and soak the fabric. You could also pre-wash the material and use it when wet straight from the machine.

2. Mix acrylic paint gradually with water. Or put a couple of generous spoons of acrylic paint into a bottle, fasten the lid and shake. You want the colour combined with the water so there are no lumps. Grab some brushes and some extra water.

3. Pour, brush and splash paint over the already wet fabric, ensuring there are no thick bits of colour as once dry it is hard to stitch through. The aim is to colour the material, not paint it. Allow the watery paint to puddle and leave it flat in the sun to dry. You will be left with beautiful random splashes of colour as the water evaporates. If the colour isn't as bright as you hoped once dry, you can always work over it again, being careful not to add thick areas of paint that may stiffen the fabric too much. I find the painted linen a fantastic starting point for a new work — the fabric is no longer a blank canvas which can make starting a piece feel more accessible.

4. Once dry, I tend to draw (or you can trace) summer florals onto the painted linen before stitching.

# Autumn

slow days + gather seeds + sip chai + stack + stitch

If I had to pick a favourite season, it would be autumn. There is something gentle about this season, as if it knows we are in need of a slow, kind transition into winter. Where still, warm days sit side by side with the turning colour of leaves. Amongst collecting seeds to re-sow, or seed heads to use as reference, I start to gather supplies and projects, as if I know it's time to prepare for long hours stitching by the fire when winter descends.

It has become an autumnal ritual to gather textiles and curate supplies for various projects, which often sparks ideas that require further exploration. With a large latte and a mix of fresh and dried flowers on the table, I spend time sorting and stacking supplies, almost as a warm-up to the start of my studio sessions. This involves dividing items into projects to live in its individual basket with associated threads and tools. Having several projects on the go always allows me to follow joy in the process. This settled, calm and kind season inspires me to harvest everything I need from the studio and organise it into multiple options. The minute I feel unsure, frustrated or bored with a piece, I can move to the next.

Autumn is about something other than finishing for me, rather a transitioning from one creative story to another and back again, happily. Full of the energy from spring and the vibrancy of summer,

~~~~~~~~~~~~~~~~~~~~~~~~
Savouring the steady abundance
of autumn blooms.

I am now calmed by the slow shift of the season and find I can settle into multiple projects.

One of my favourite activities in autumn is collecting seeds from the garden and wildflowers as I walk. Collecting and re-sowing reminds me that good things take time. It also inspires me to see how a tiny seed evolves and brings so much life and joy. It is good to remember that this is also the case when we create. Not every seed germinates, but those that do have to go through a slow, sometimes awkward, and often fragile process before they bloom into a flower.

I think it's the sheer resilience of nature that inspires me the most — that inside that tiny seed is everything it needs to become an incredible, intricate flower. The growing process is challenging, and tiny seeds need to be nurtured to bloom fully. We are that tiny seed. We have everything we need to grow and bloom creatively, but it's not going to happen without lots of nurturing.

Here are some creative activities for autumn that are like water and sunlight for your creativity:

Curate Collections
Gather a small stash of things that inspire you. Place them in a basket ready to start as a project. Have more than one basket of items. For example, you could collect a piece of painted linen, a pencil, some images of flora,

a selection of threads and beads, needles, a hoop/frame and scissors. If you pop them somewhere easily accessible, you might be more likely to pick them up and begin. A basket next to your favourite armchair perhaps. To make the experience even more enjoyable, add treats to your basket, like your favourite tea and chocolate. It's incredible what we will do when we know there is a reward.

Stitch away until it is unclear where to go next, and rather than give up in frustration, put that piece away and start working on one of your other project baskets. This means that even if you only have an hour to create, you are using your creative time productively and enjoying the process more.

Be Entertained
Line up some juicy or inspiring podcasts, audiobooks or music to listen to while you create. It may seem a little frivolous to sort out your entertainment, but I find it worthwhile to help my creative time flow. Often if I'm engrossed in a podcast, I'm less inclined to overthink my work.

Grow from Seed
To celebrate the season, try creating a project with some design rules. Not unfair rules like being tidy or creating a masterpiece, but simple rules that give you a jumping-off point. Sometimes I like to stitch in only one colour or

use only one stitch. Just begin, and like a seed, your work will grow slowly and organically.

Create Together
In the spirit of nurturing, this could be an ideal time of year to seek out other people to create alongside. There may be a BYO project group at your local café or library; a group of friends who fancy a craft night once a month, or you could seek out your local embroidery guild (ask for the contemporary group) or creative fibre arts group. Making in the company of others can nurture both your confidence and your skills and is often profoundly comforting. Sitting around a table sharing stories, tea and creativity is food for the soul.

Creativity Tea
Lastly, invest in some creativity tea — this is not a brand, but rather finding a drink to add to your ritual that is nurturing. I love a turmeric chai in autumn, or a delicious rosehip, lemon and ginger tea; either way I brew, add a drop of honey and pour a cup when it's time to create. And only then. This isn't about being precious, but I have noticed that as a daily practice, this little ritual can bring such a sense of honouring to my routine, that reminds me it is valuable and that creativity matters. Even through small things like brewing tea, we can make our creativity feel gentler, less intimidating, and more available.

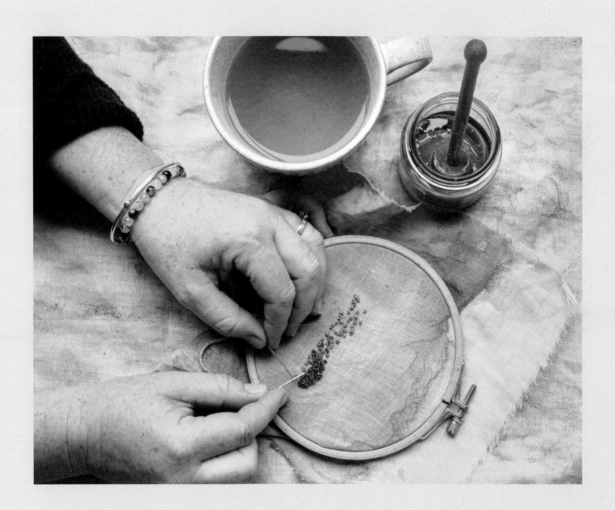

Choosing a special tea (or coffee)
to brew before you create is a
beautiful little ritual to add to
your creative time.

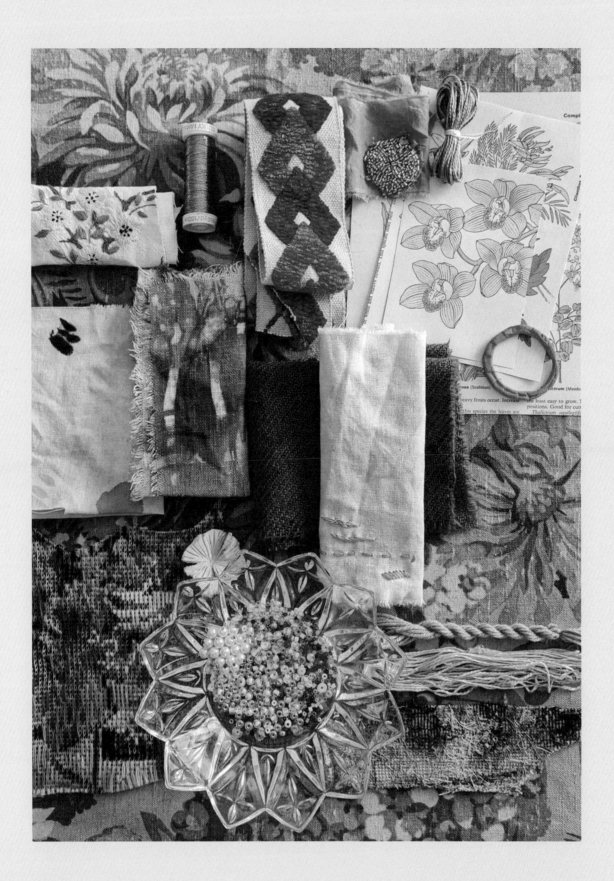

EMBRACING THE SLOW

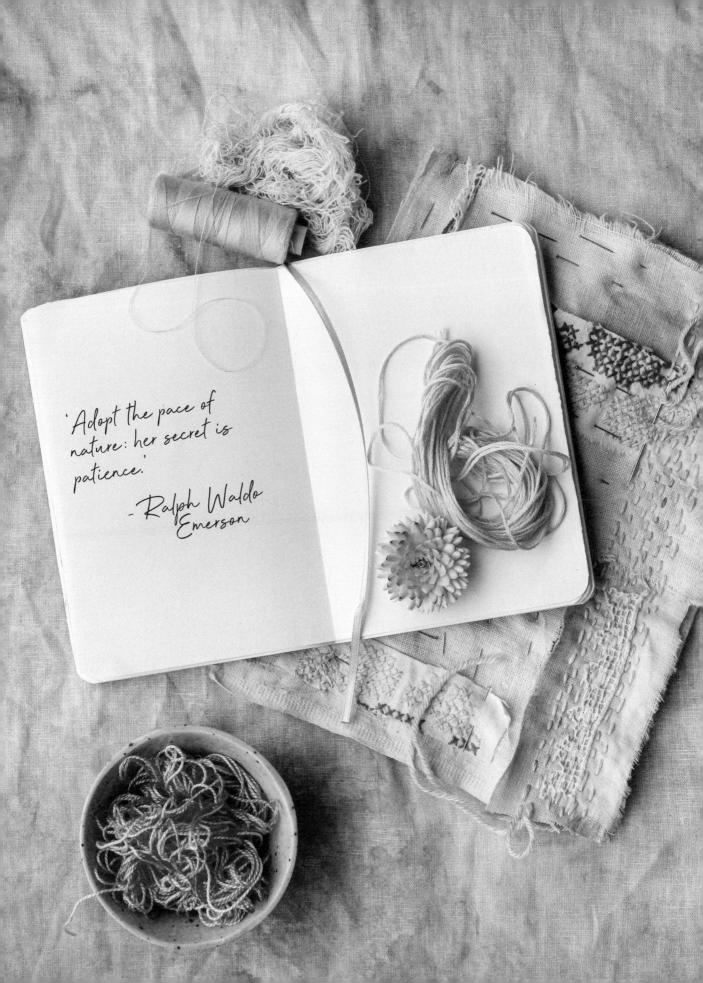

'Adopt the pace of
nature: her secret is
patience.'

- Ralph Waldo
Emerson

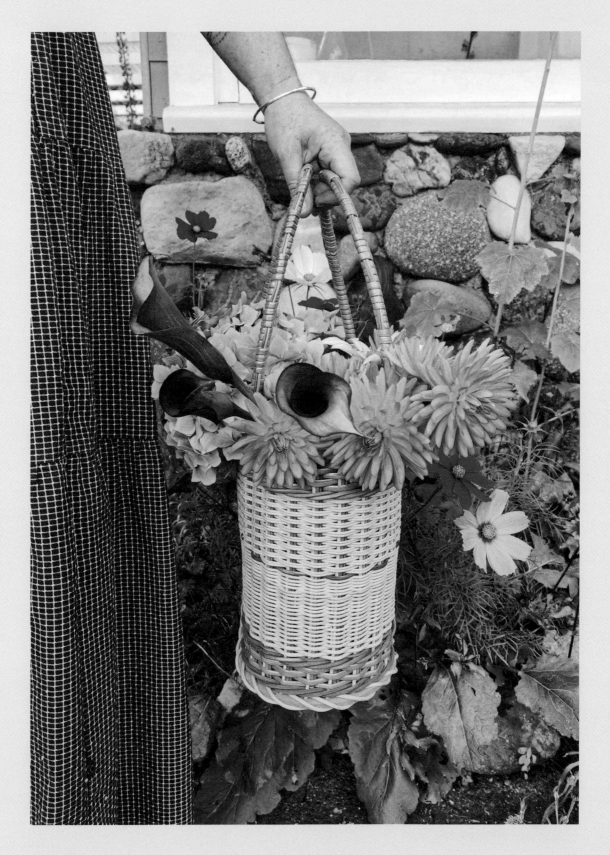

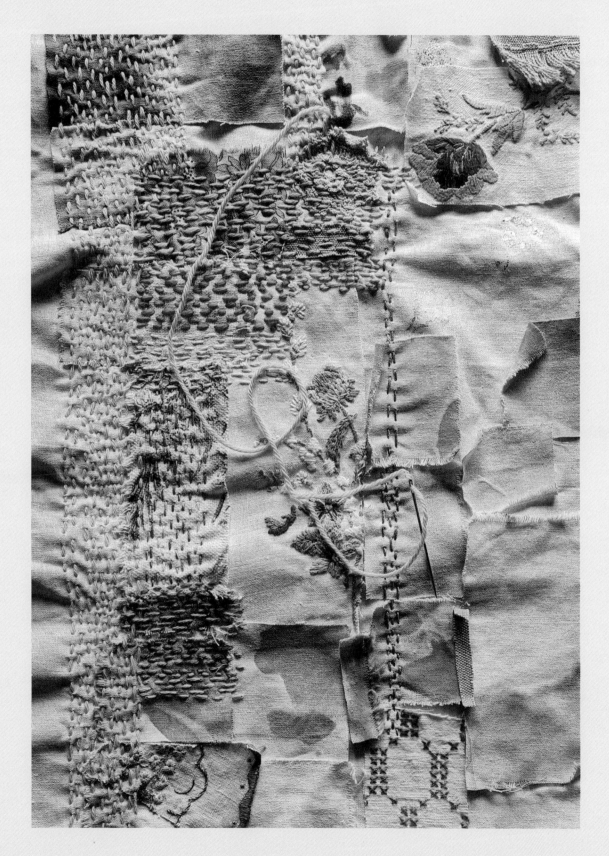

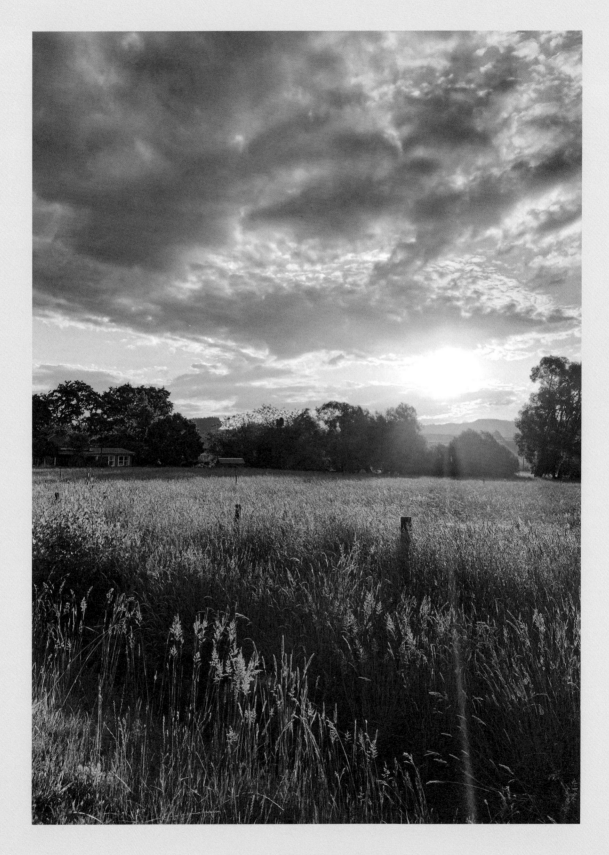

In a world that values things being done quickly, it can be tricky to embrace a slow process.

It is one of the reasons embroidery feels so nostalgic. It recalls a different time, when being slow was commonplace. In today's world doing anything slowly feels like a revolutionary act, and actually it is. When I first found stitch I was overjoyed by what it brought to my creative process, but I also felt confronted by the hours, days and weeks it took to make tangible progress. It was tough to get my head around the fact that good things take time. It is so rare in life that something extraordinary evolves quickly without much preparation, and it is time to embrace this.

One of the significant obstacles when it comes to creating is finding the time amongst life's many demands. And that so often, when we take the time to develop and hone our skills, it doesn't feel like progress, or what is created isn't good — putting us off making regular time for it. What we need is a change of approach. If you think about the time spent creating as training rather than a pressure cooker to achieve something awesome, you will find you forgive yourself more when the work doesn't meet your expectations. If we understand creativity is a practice, and embrace the fact that progress will happen at an undetermined speed, we can trust that we will get a step closer to making the work we desire every time we create.

Time spent doing work you aren't happy with is essential; you can't keep closing the gap and improving without it. There is simply not a fast track for this. The more you create, the more time you spend, and the more quickly your hands, eyes,

Previous Left: Vibrant garden blooms are a constant inspiration for the art I create. Previous Right: Kantha stitch on a textile collage. Opposite: Sunset in the Moutere Valley overlooking the fields to our little home.

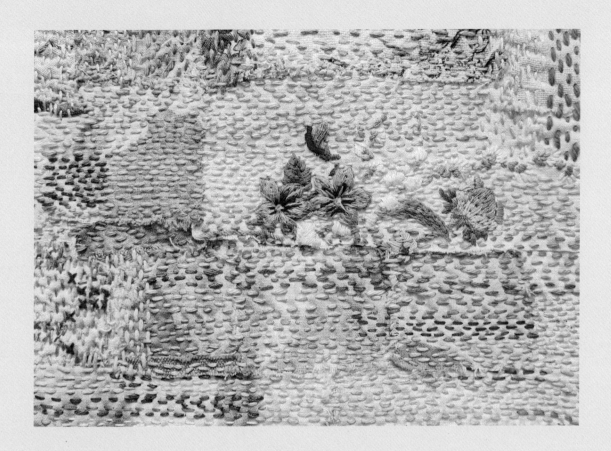

head and heart can connect to make work that represents what's in your mind's eye. The reality is that time is simply time, and progress is only achieved by doing something, however small, in the time you have available.

We all have our inner critic already judging us and setting unfair expectations. You may also have people in your life that question you: 'Is that all you've done today?' Or 'You'll never get that finished!' We must avoid this internal and external language at all costs because if we give time too much power, mistakes feel like a disaster. Having worked on many deadlines and tried to force a slow process to be faster, I can tell you there isn't any quick or slow fix.

What I have found, is that it is essential to embrace the slow. Enjoy doing something at odds with the norm and make it a priority to create little and often if you don't have much spare time. If creativity is a regular part of your life already but you struggle to justify the time it takes, reframe your thoughts to place value on the *process* instead of the outcome, or the time it takes to achieve it.

Becoming comfortable with approaching art without rules, making intuitively and trusting the process was about shifting my perception of the value of my time. Learning that time creating even if the work is not the outcome I expect is a good use of time. It is an investment in your creative growth.

Kantha stitch is one of the
most relaxing stitches as
its simple process allows
you to get in a rhythm.

There is equal value in the wins and
the losses, so time isn't significant
overall, it just is.

There is something beautiful about
engaging in slow art and the wonderful
sense of calm and relaxation it brings
as you create. Slow stitch is about
mindfully creating work that aligns
with your values and brings you joy and
peace. You are taking time to develop
and grow your skills, while nurturing
your body and mind in the process. What
could be more important than that? It is
time to reclaim time as a natural part
of your process.

Slow Stitch for the Soul
One of my absolute favourite stitches
for relaxing is Kantha (or running)

stitch. An ancient stitch that
originated due to the creative mending
and layering techniques created in the
Bengali region. Kantha quilts are still
made today.

+ If you want to bring stitch into your
life for relaxation and don't have the
time or energy to decide what project to
dive into, this is your activity.

+ Take a piece of fabric, a long
straight darning needle or similar and
some threads of your choice. I like
a hand-dyed 4ply silk merino wool or
stranded cotton for this. Make sure your
fabric is easy to stitch through as it's
not as relaxing if you are forcing the
needle through.

+ Make your thread no longer than arm's
length, tie a knot in the end and thread
your needle with the other end. Start
at one side of the fabric and slowly run
your needle in and out of the material
to make short-long stitches with gaps
between them. Pull the thread through and
continue until you reach the other end.
Flip the fabric around and come back the
other way in rows quite close together.

+ Feel free to vary the colour and
weight of the thread if you wish. The
result is lovely long stitch runs like
those you see on beautiful quilts.
The less perfect the gaps and stitch
lengths, the more gorgeous it looks.

+ Do this for 10 minutes when you can.
It can be an active relaxation or become
the beginning of a creative project.

+ Once you're comfortable with Kantha
stitch, you can try using it to follow
shapes you have drawn on your fabric or
use a patterned textile to follow the
existing shapes. You can also make a
small collage of textiles on either a
woollen blanket or fabric base and use
the Kantha stitch to bind the layers
together. It is also a great stitch to
use for visible mending.

+ Equally, this could be done
repetitively using any stitch. For those
who enjoy stitch, spending time doing it
slowly and methodically is a beautiful,
restorative practice, slowing the heart
rate and calming the nervous system.

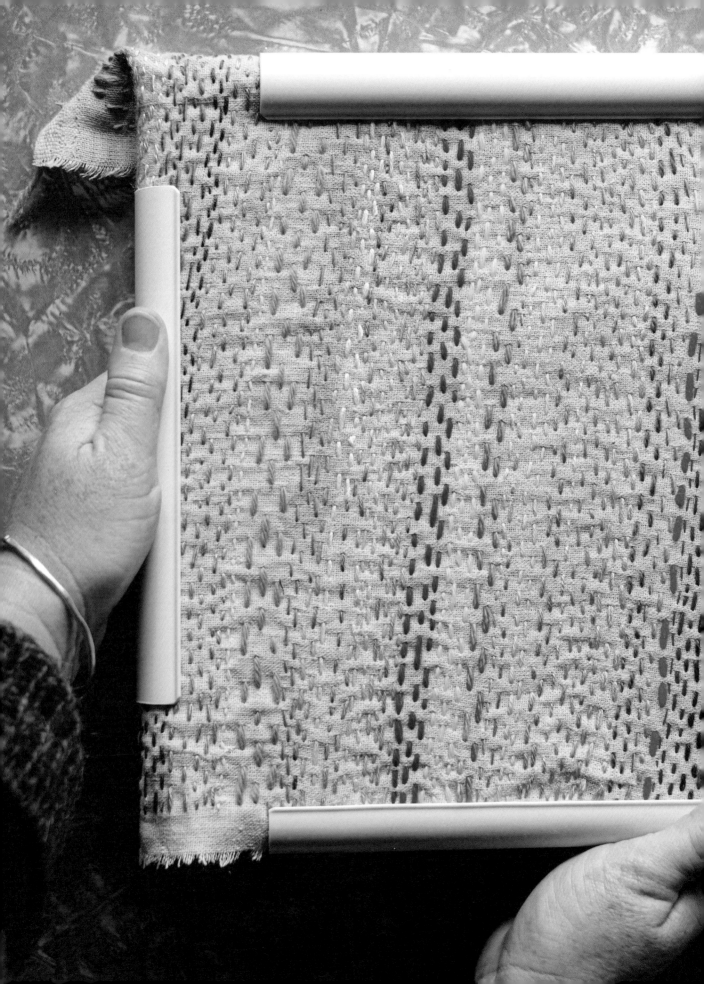

JOY IN THE PROCESS

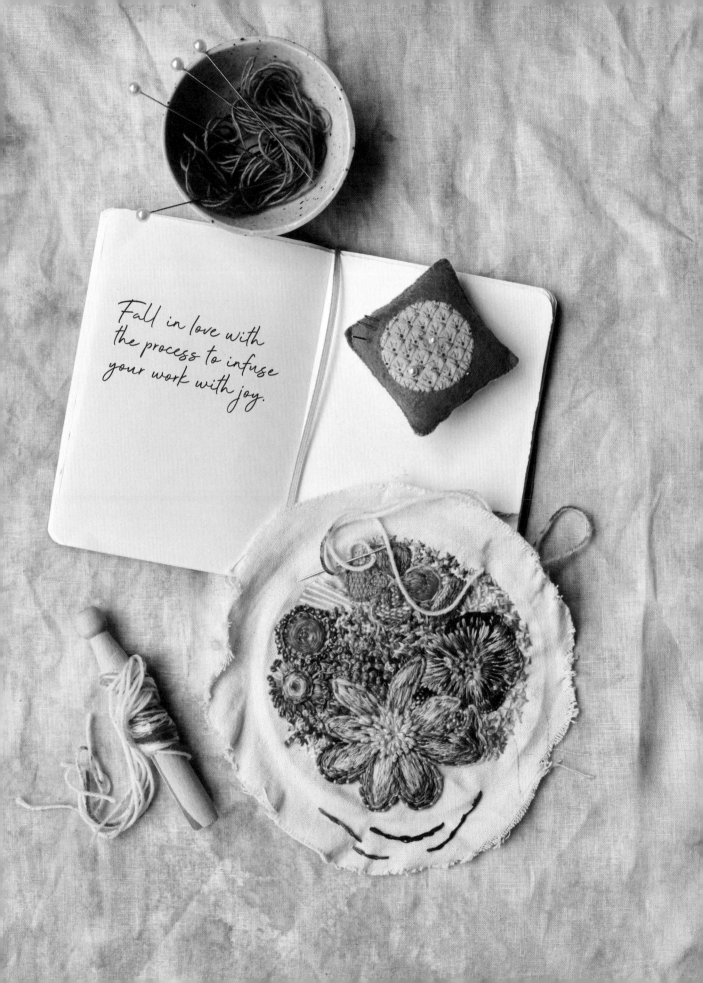

Fall in love with
the process to infuse
your work with joy.

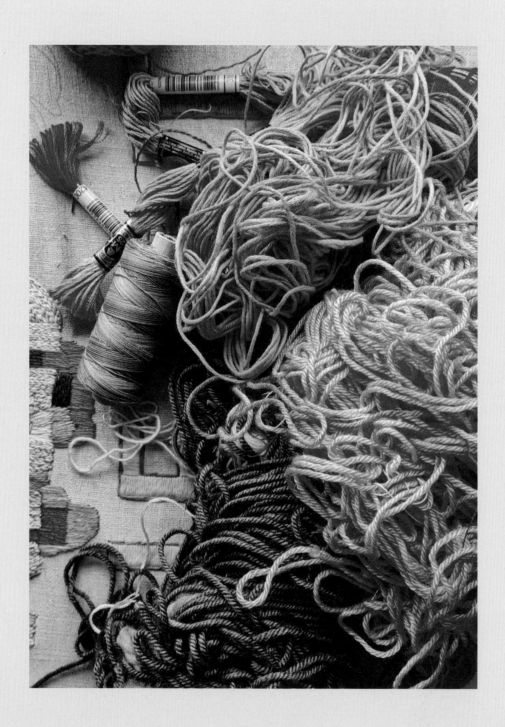

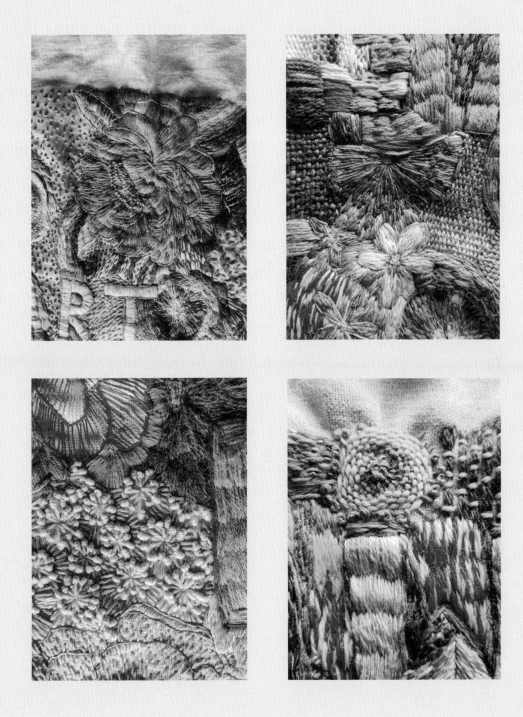

Previous: Progress shots of
Kind Heart Brave Mind, 2021,
original. Opposite: *Kind Heart
Brave Mind*, 2021, created as a
beautiful daily reminder.

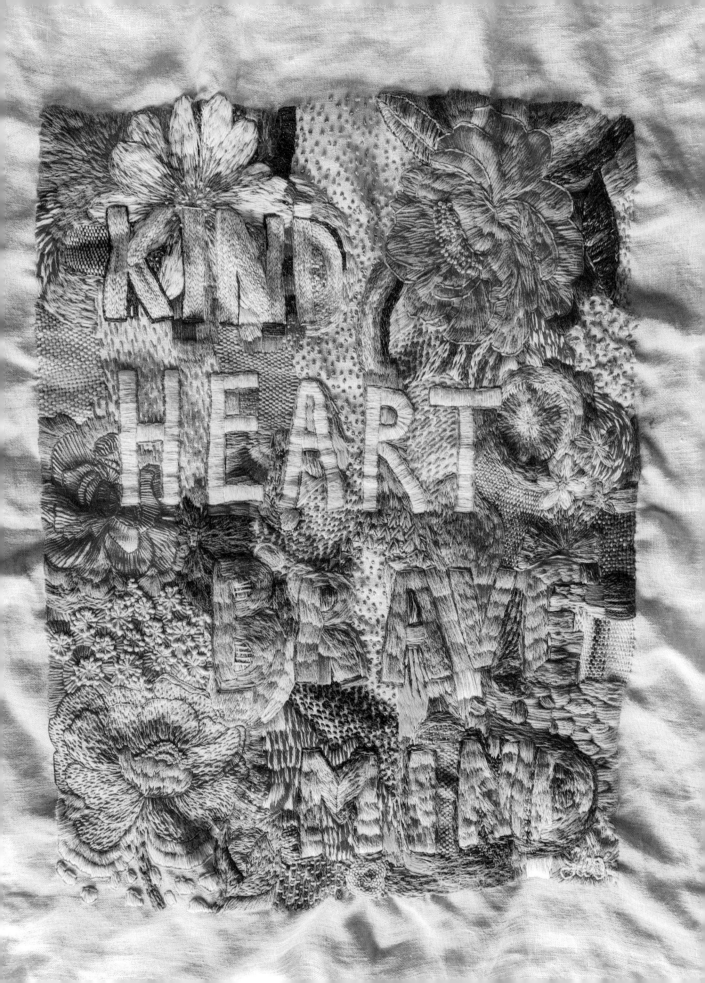

If there was only one thing I could ever share, to support and encourage, it would be enjoy the process.

It is the biggest lesson I've learnt. Find what you love and pursue things that spark your creative soul.

Joy, by definition, means to experience pleasure or delight. It isn't one big dance party with streamers and endless disco balls. It isn't a permanently heightened state of bliss. It is simpler, more humble. It is the life-changing sense of wellbeing that you experience when you do something you love. It's a choice you can make each time you create. For me, that is truly the most exciting thing about creating with joy — you get to choose what that looks like and change it whenever you want.

Sometimes you've got to go a long way around to learn lessons, other times someone can drop a truth bomb that allows you to skip a few steps. However, unless you truly enjoy the process, even the most fun creativity will soon feel like hard work, and your chance of regularly finding a state of flow is slim.

Enjoying the process leads you to better results, so exploring this aspect of your creativity is worthwhile. It's easy to find yourself compromising the process for the outcome, but I have found it is worth staying focused on the process in the long run — sometimes I will spend eight hours and only have coloured two petals. It can be a tough mindset to overcome when stitch is your chosen medium, which is why it is so important to enjoy the journey, for the stitched road is long.

Initially, even though I loved the process of stitching and the effect of the textures, I struggled with how slow it was and worried it may never be a viable practice to earn a living. I compromised my process and tried to work

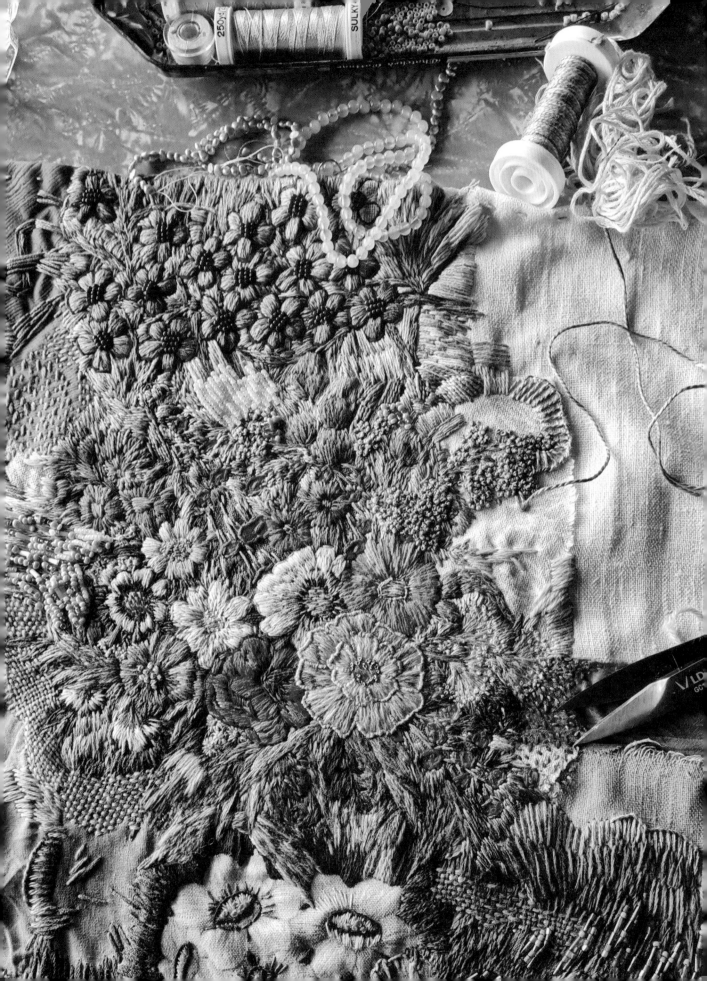

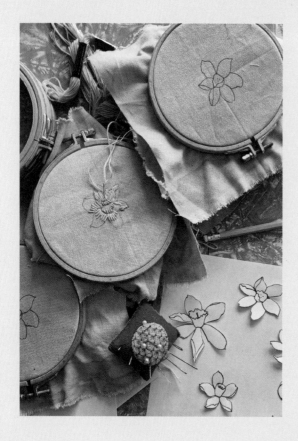

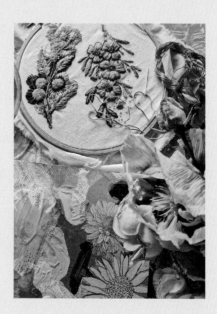

From Left: Finding joy in a process is essential, especially with stitch, as progress is slow. Next: *Lilac Wine* hand-painted linen and imagery with hand embroidery.

harder, faster and more productively. I became a one-woman art factory, and while there were moments of joy, it wasn't fulfilling or feeding my creative soul. As I strived to make my practice fit into other people's business models and timelines, I discovered who I didn't want to be as an artist.

Yes, every creative practice requires compromise, and it is always great to be open to new ways of doing things, but if joy is the thing that gets left behind, then you are choosing to change the wrong area of your workflow. Luckily there are many ways to identify the things that bring you joy, and those that don't.

Like all elements of creativity there is no magic or perfect fix, but it is possible to create a practice that feels unique, joyful and purposeful and still earn a living. It just takes time, and a bit of trial and error, to work it out.

It is important to remember we are all unique, and what is joyful for me and my practice is unlikely to be the same for you. I workshop with creatives all the time and we can all have the exact same supplies, the same amount of time, similar goals and dreams, and all create very differently and with completely individual outcomes and varying amounts of joy along the way.

The biggest inhibitor to creating with joy is doing what we think we're *supposed*

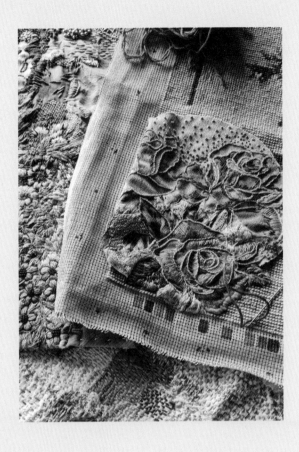

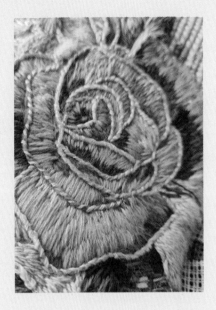

to. Nearly all of us carry around a set of arbitrary rules or ideas that can make joy hard to come by. So many tell me they are only coming to creativity later in life because they are called to do it — the preconceived notions that it had to be neat, accurate, realistic or a myriad of other unhelpful ideas had prevented them embracing it earlier. It saddens me to think of all the lost years of creative joy based on 'rules' or opinion. Make your own rules, and they can facilitate joy in the process.

Committing to finding joy in my creative process has allowed me to grow as an artist, have a job that I love and have the freedom to explore this way of living in other parts of my life too. We all have ideas or rules that no longer serve us and can be put aside in favour of our creativity. It's worth it, even if it feels a bit uncomfortable initially.

But before you feel like you need to never follow a rule again to pursue joy, please don't worry, this isn't joy boot camp. This isn't about only doing things you like and never putting out the rubbish again. It is about getting rid of the things holding us back. As with everything in life, the creative process can sometimes be complicated or tedious. I have found this to be far less often when prioritising joy. Even if you can identify and set aside one

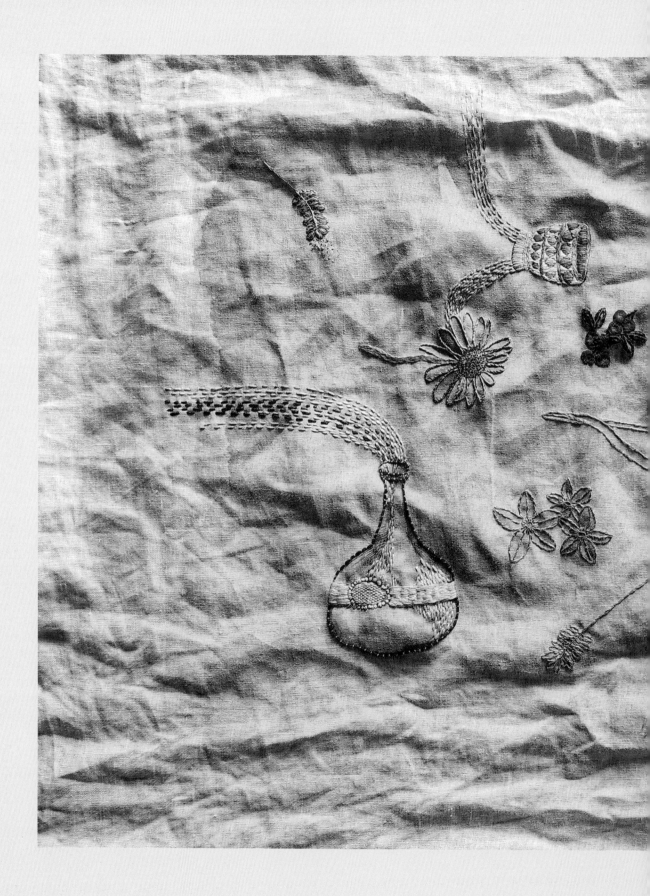

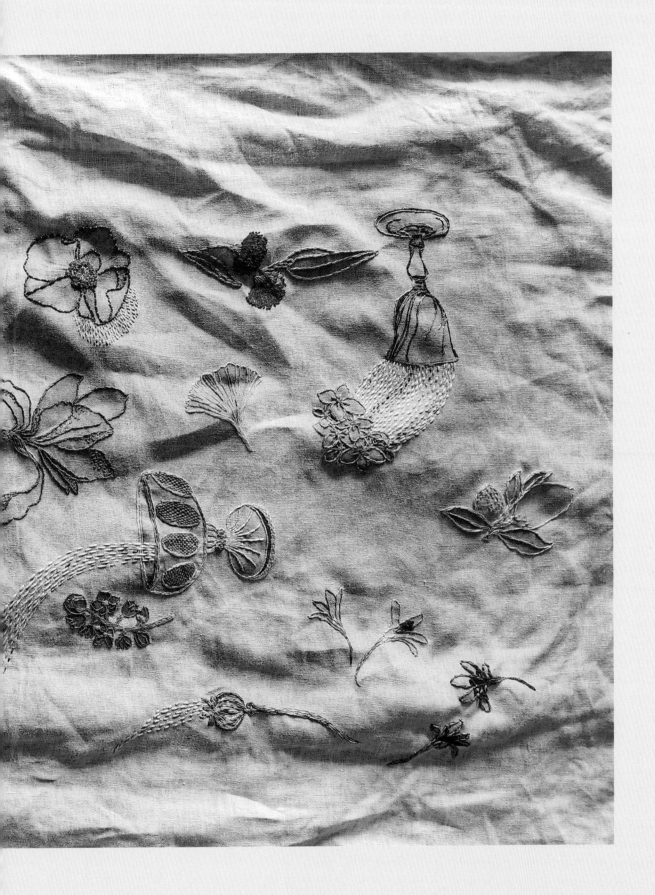

limiting belief, it will allow you to
notice what you enjoy and have more fun
when creating.

Having joy in your creative work is
often more straightforward than you
think. By choosing only colours you
like, noticing what interests you most
and forgetting the rules that make
creating hard, you can curate your
practice to look however you want.
Joy can be found in every part of your
practice. I find joy in flora, colour,
texture and detail, and the way I choose
to work with each element.

When I teach workshops, people often
assume I will know all the stitches
— but I don't. I only use around
six essential stitches, occasionally
learning new ones when I desire a
particular texture or style to aid my
storytelling. My favourite stitches
are split back stitch, French knots,
couching, Kantha, blanket and weaving.
These are the stitches I enjoy using.
The flow I can achieve using these
stitches allows me to focus on building
the image with colour and texture.

It is worth noticing what mark-making
you enjoy most and making it a part of
your regular practice. It doesn't limit
you, because you can learn techniques
any time, but to slog on with a process
that doesn't feel interesting to you
just because you think it's crucial to
master every stitch, is one of those
optional rules you might like to set
aside. Similarly, if you subscribe to
the idea that it matters what the back
of your embroidery looks like, I am here
to tell you that it very rarely does.
I like to say it's nobody's business
what's happening at the back.

On a practical level, my tools and
supplies are essential to allowing my
process to be joyful. I take note of

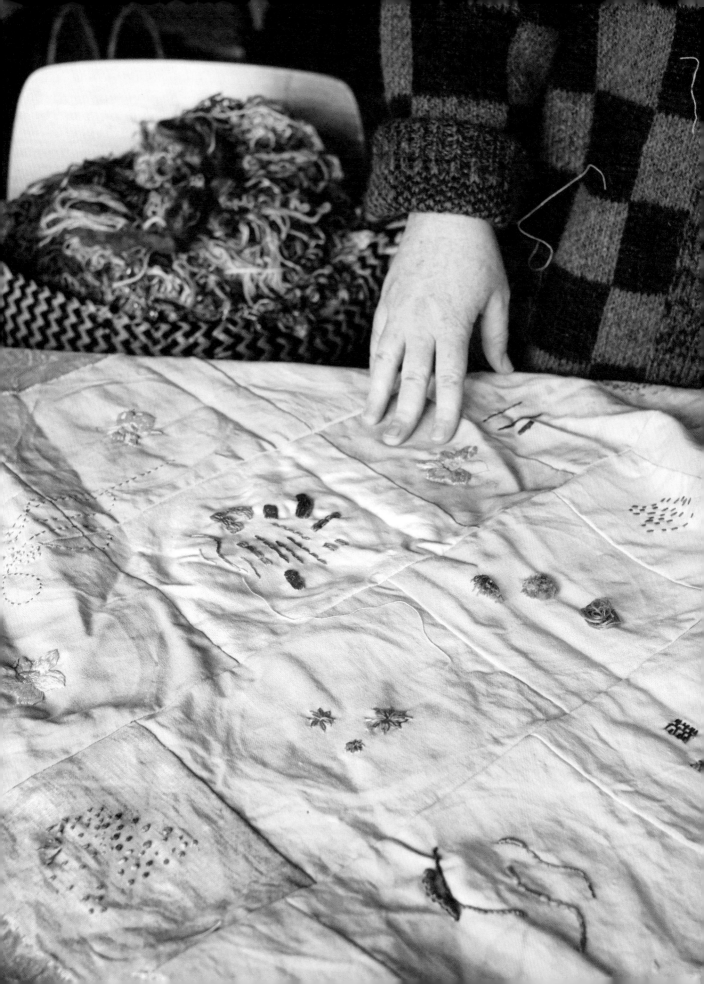

Joy Journey, 2022. I adore how
the back naturally becomes an
abstract version of the front,
both beautiful in their own ways.

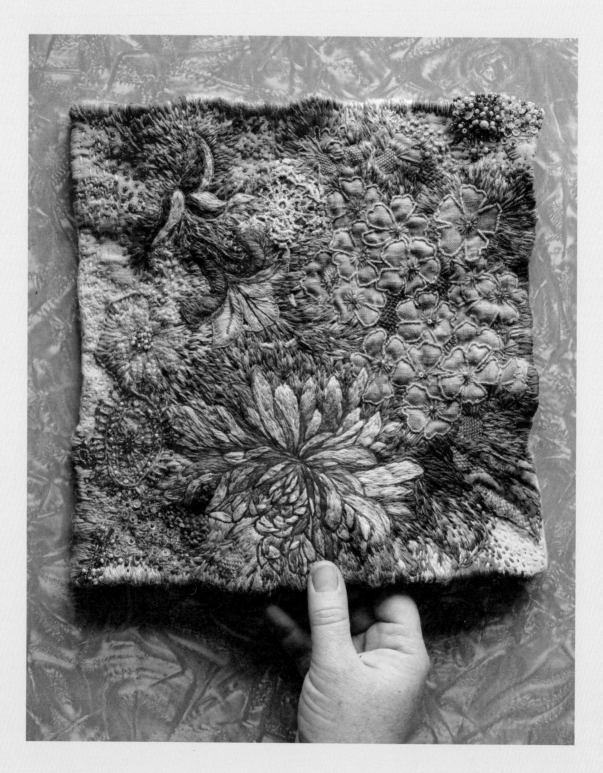

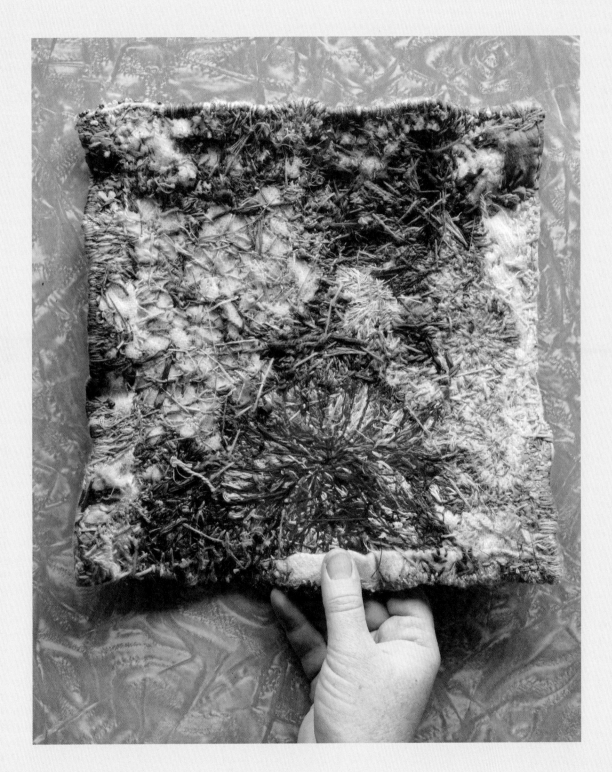

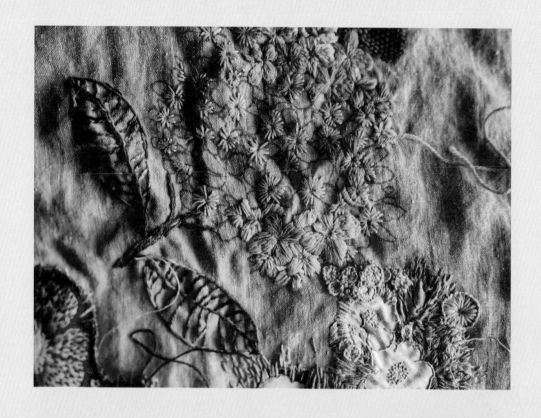

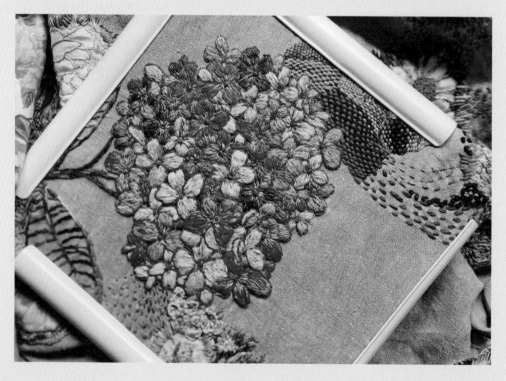

what needles, threads, textiles, frames and other supplies I find the best to use. They aren't always the most expensive but simply the ones that work for me. The chair, the light, the table and the temperature are all important too. You should be comfortable as you create. Your practice is much more enjoyable if you look after your body; move, stretch, take breaks. It's easy to forget this stuff if life is busy and time feels tight, but it is worth taking a moment to make these small accommodations for yourself.

I always have more than one piece on the go. Whenever I get bored, annoyed or lost, I can put that work down and start working on another piece. This ensures I bring a sense of enjoyment to all of my work and has become an excellent way to avoid overworking or losing my sense of direction. Most importantly it prioritises joy in the process.

Having a goal, mission statement, or set of values (that can change), can be an excellent way to weed out unnecessary processes, tools or techniques from your practice. My main goal is to create work that embodies the energy, joy,

inspiration and reverence I experience from nature. It is essential to me that each piece I create has been made with a sense of joy and adventure, so I am committed to constantly adjusting my process to maximise this. I regularly question whether the way I am doing something is the most joyful. The great thing about stitch is that as the work evolves slowly, you can take the time to notice what is enjoyable for you and what elements you could live without.

Intuition is an integral part of joyful creation. The more you learn to trust your gut when you create, the more you will know that there aren't any terrible mistakes, only redirections. Your creative soul knows what brings you joy, and if you can set aside the rules that don't serve your process, you might find that joy turns up more regularly in your practice.

There is this old story that artists must struggle, feel tortured or suffer for their work. Replace struggle with resilience, torture with vulnerability and suffering with courage. Creative work requires resilience, vulnerability and courage. Joy in your process

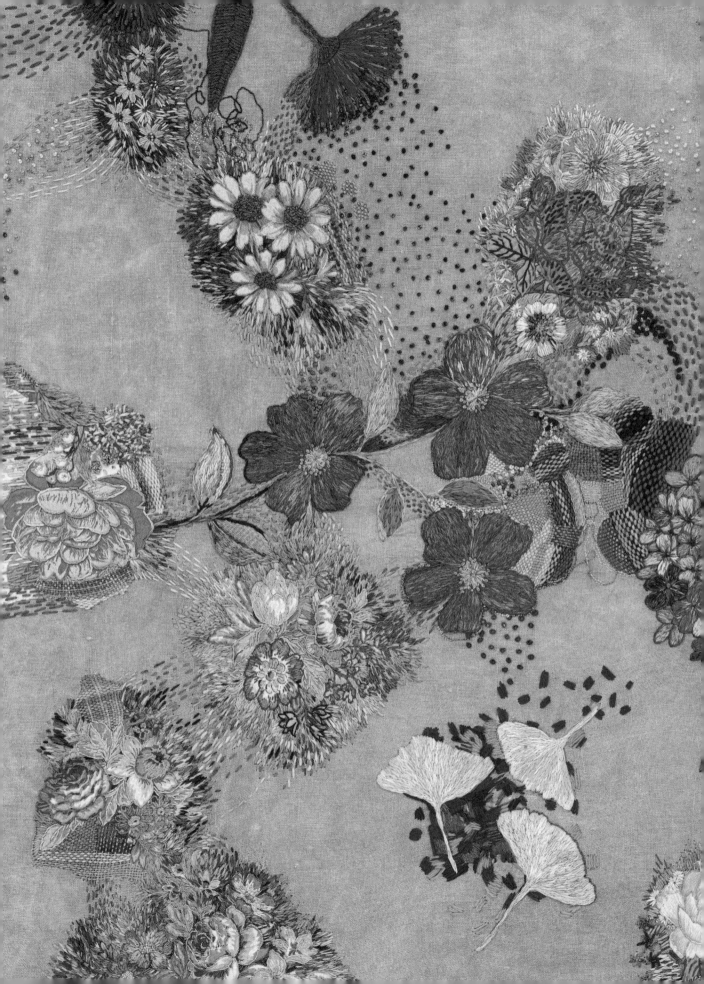

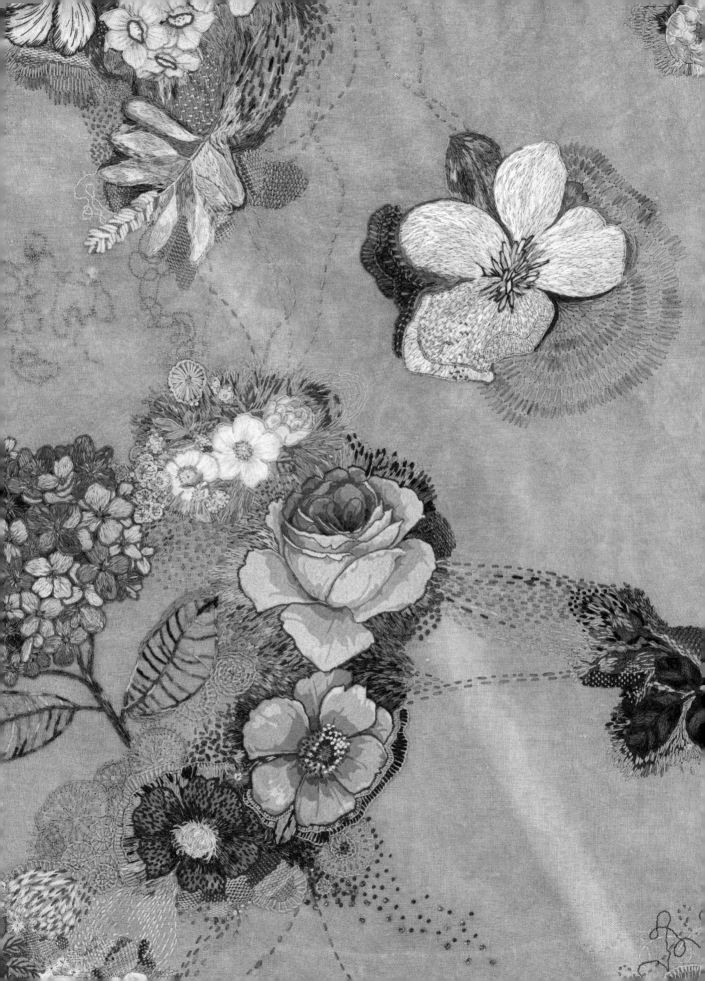

Collect the frayed edges of textiles and add them to a little 'tangle jar' for future use. My tangle basket revolutionised my sense of freedom when creating with thread.

doesn't negate challenges that require resilience, or storytelling that requires vulnerability or the courage to continue when you're unsure if you're on the best path. Instead joy looks like doing things your way, focusing on the things you love and leaving anything that doesn't serve joy by simply setting it aside.

The most significant joy-giving discovery of my entire career was seeing another textile artist doing a stitch demonstration, and as she did, she would reach down to a basket by her side. I'd see her dig into a tangle of threads, pluck and snip the one she needed. I had held the idea I wasn't a proper stitch artist because I struggled to keep my threads tidy. Being tidy when I create

doesn't come naturally to me. It had honestly never occurred to me that this was an option. What a revelation! I now have a large basket filled with the tangles of every project I've worked on for the past eight years. I use it when creating my artwork and enjoy rummaging through, plucking and snipping the right tone and texture as I work.

For me, joy is in the little things.

Whatever your joy is, bring it into your creative process in small ways so it can build and grow, overflowing into your daily life. Embrace the slow and note the things you like as you create. Commit to continue growing the list of things that feel good. Be patient and kind to yourself as you learn this.

JOY IN THE PROCESS ~ 147

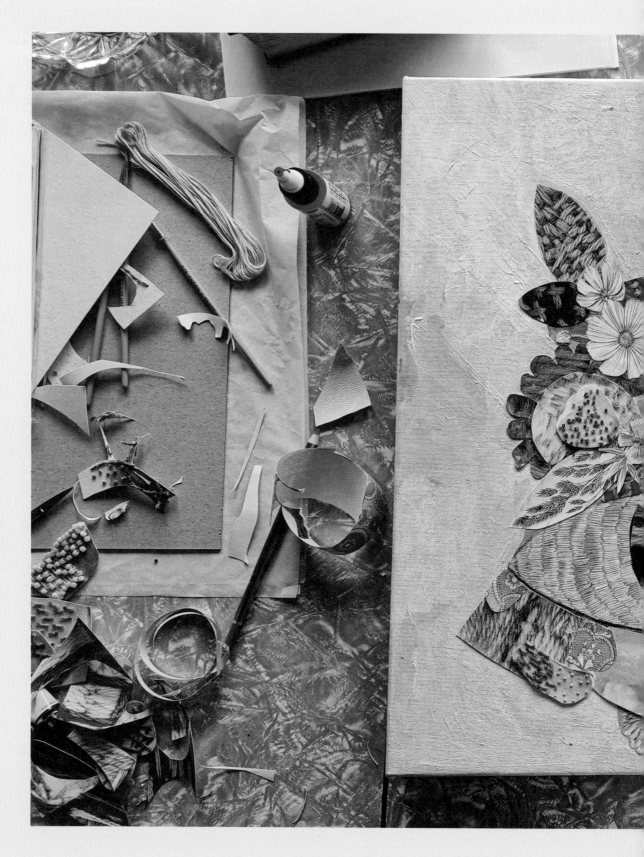

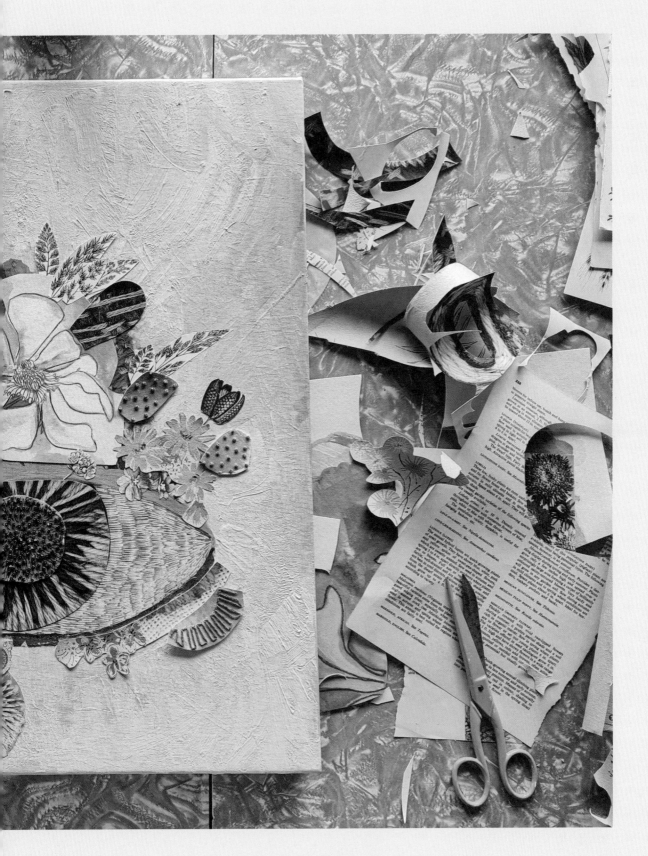

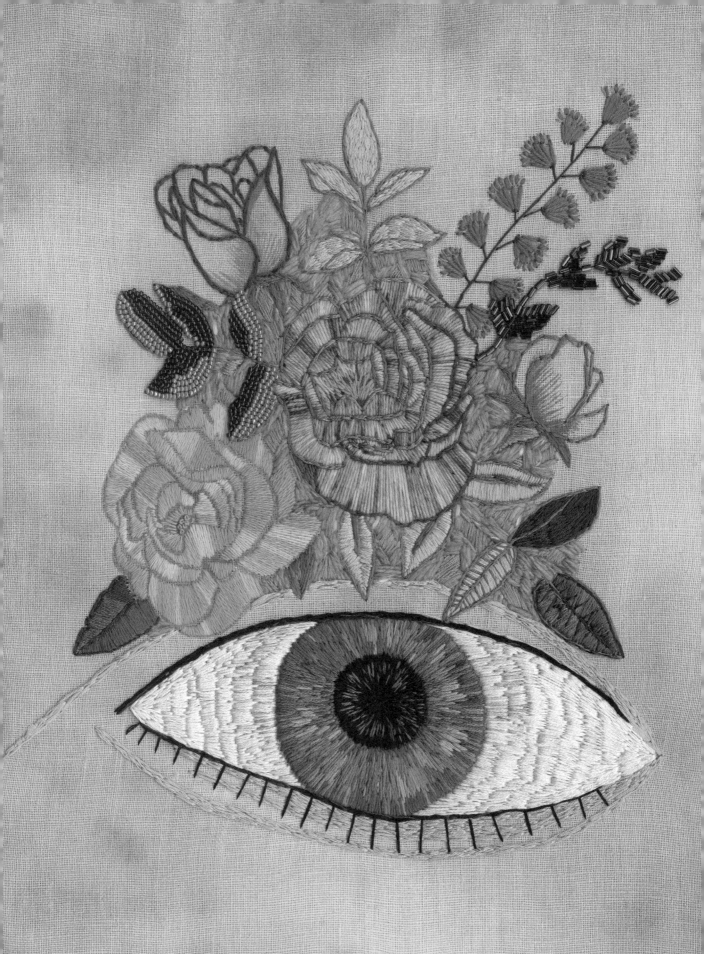

Previous: Collaging with prints
of stitched artworks and found
papers. Opposite: *Soul Garden*,
2016, limited edition print.

DETAIL GEEK

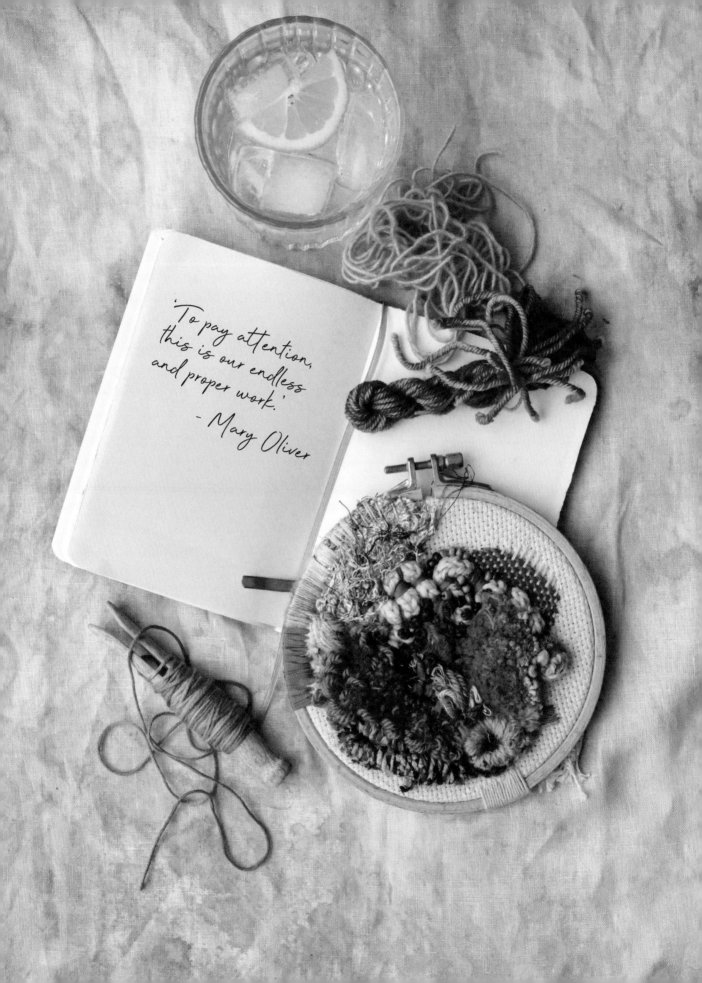

'To pay attention,
this is our endless
and proper work.'
— Mary Oliver

It is the detail that defines and refines your piece of work.

I'm such a detail geek that it is often much harder for me to *finish* an artwork than start one. A firm deadline can help, but working back in, and adding detail is the most inspiring and illuminating part of the process for me. It has become such a joy that it helps me ride the waves of uncertainty, and gets me through all the boring bits, as I know there is fun to come and plenty of 'aha' moments at that stage.

Attention to detail is separate from the far less enjoyable inner critic. Knowing you can add detail is empowering and should allow for a sense of freedom as you develop the base layers of your work to help your work fully form. One of the loveliest things about paying attention to detail with a spirit of joy and exploration, is that you remain in the moment with your work and allow yourself to live in the space of endless possibilities where happy accidents and a newfound trust for your creative intuition will occur.

Often my works look awkward until about 70-80 per cent of the way through the process. You might find the same and even notice that you don't often finish pieces, possibly because at around the 70 per cent mark, you feel like it isn't coming together and choose not to spend any more time on it. This is when you could put the work aside and come back to it with fresh eyes another day, breaking through that awkwardness and into something extraordinary. Many miss this lovely rewarding part of the process because they give up too soon. I encourage you to revisit some of your unfinished projects with a fresh perspective. If nothing else, know that in future, all is not lost as the going gets tricky. It is just time to put it aside … come back with fresh eyes and know that the last 20-30 per cent will bring it together.

Being a detail geek means I like to curate my supplies with joy, create my imagery inspired by nature, block in areas of colour with both paint and stitch and then work back in with stitching over my initial piece to add more information, colour and texture. This is generally in the form of borders, directional details and colours or textures that scatter throughout the work to emphasise some of the things I want to draw attention to.

For you, it could mean that too, or it might be as simple as paying attention to how the work feels. I am always ready

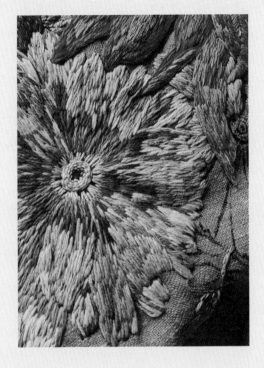

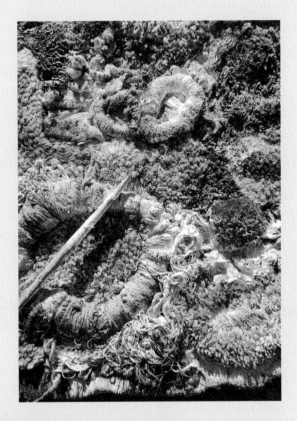

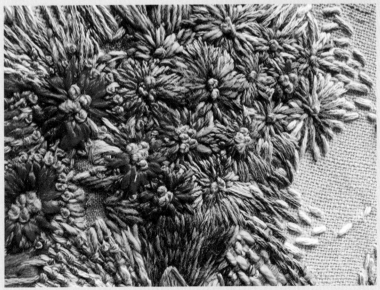

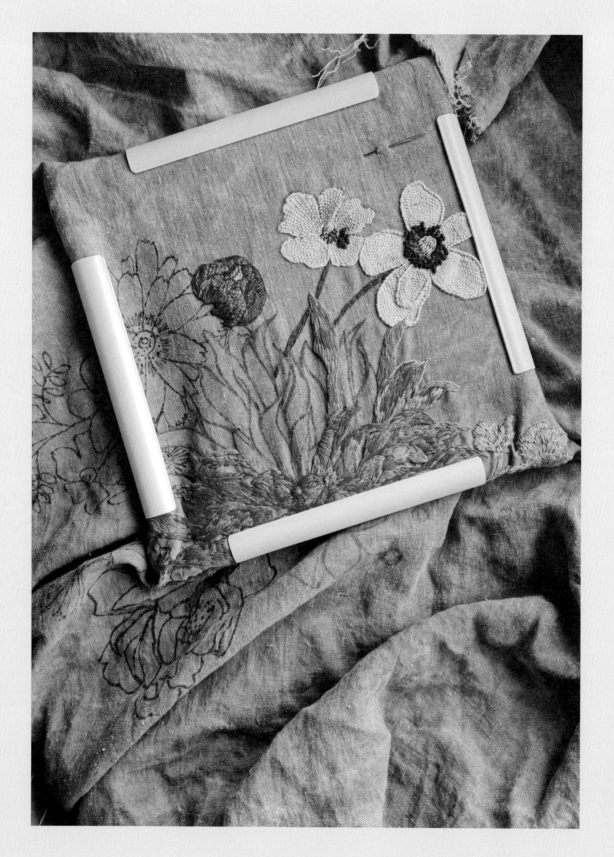

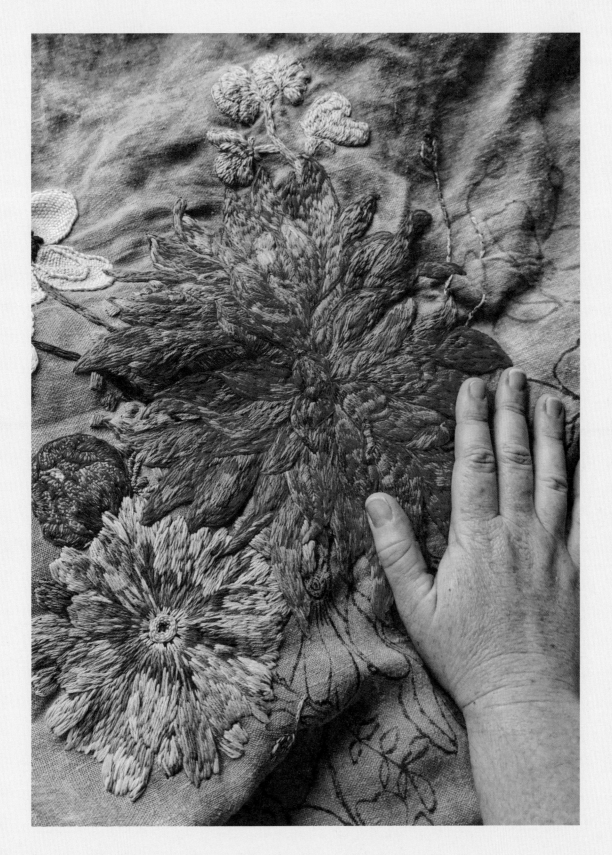

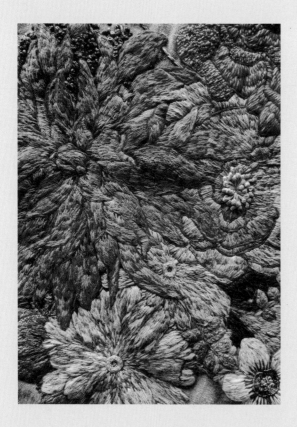

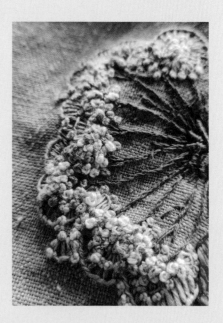

Summer Blooms, 2022, created to highlight favourite flowers and explore textures with weaving, French knots and a combination of threads including wool, bamboo cotton and stranded cotton.

to bring in more stitches as a remedy or to support my existing stitches. I've observed that much more traditional embroidery is less layered, which is fine as long as that is a creative decision you make because you want to, not because you think that's how it has to be done.

My painter's mind always approached stitches as an extension of painting. Hence, to communicate forms and bring more energy to the work, I think about blocking in base colours and then use detail to tell more of the story, which might be adding light, dark, illustrative or abstract marks. This isn't something I tend to plan but have developed through practice. My initial stitched works were much more paint than stitch, and my stitch was much more simplistic. However,

as I started stitching more, I would run into challenges — like maybe I had covered over the centre of a flower not noticing, or my simple long stitches weren't showing how the leaf or petals curled. These creative problems were not being solved by removing the stitches (I wouldn't say I like unpicking), but rather by working back over the top of the stitches to bring back what I felt was needed to revive the flora I was working with. The more I explored this, the more refined my sense of detail became.

Now it doesn't matter if my work is intricate or more straightforward, I still approach it with a detail-geek sensibility because I know it can be a few subtle additions that can shift a work from awkward to triumph.

Just as in noticing nature, we take time

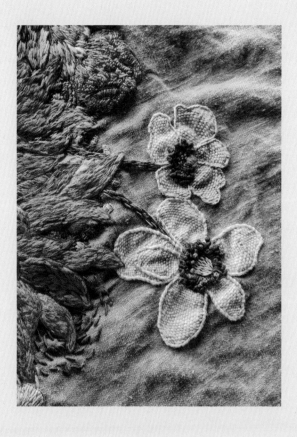

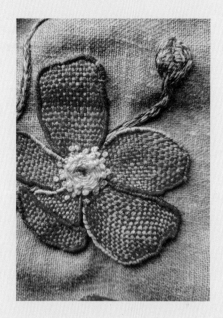

to observe what makes the forms we love so special. This translates into our stitching through the style of marks, the texture of the fibres and the energy we want to express. It doesn't have to make sense to anyone else, just to you. I love to make little scattered trails from flower to flower in lots of my pieces, sometimes using a Kantha stitch or scattered French knots; this is not an obvious representation of something I saw in the garden but rather an expression of the feeling of life and abundance.

If you're feeling stuck at the 70 per cent mark and unsure how bringing detail back in will improve the work, the first step is to set it aside for a few hours or days. Fresh eyes will bring a new perspective. When you view the work again, it might clarify what it needs.

Some of the details I commonly add to bring a disconnected work together...

Stitch back into the work using one colour.
It might be that this colour already exists in the piece or is a new wild card. Adding this colour to borders, details and the background can allow the eye to follow the visual more comfortably and create a sense of harmony.

Add a scatter of stitches or beads to the background in a similar colour to the fabric.
Sometimes you've created a beautiful flower that seems unintentionally suspended in space. Your instinct might be to add a stem or something

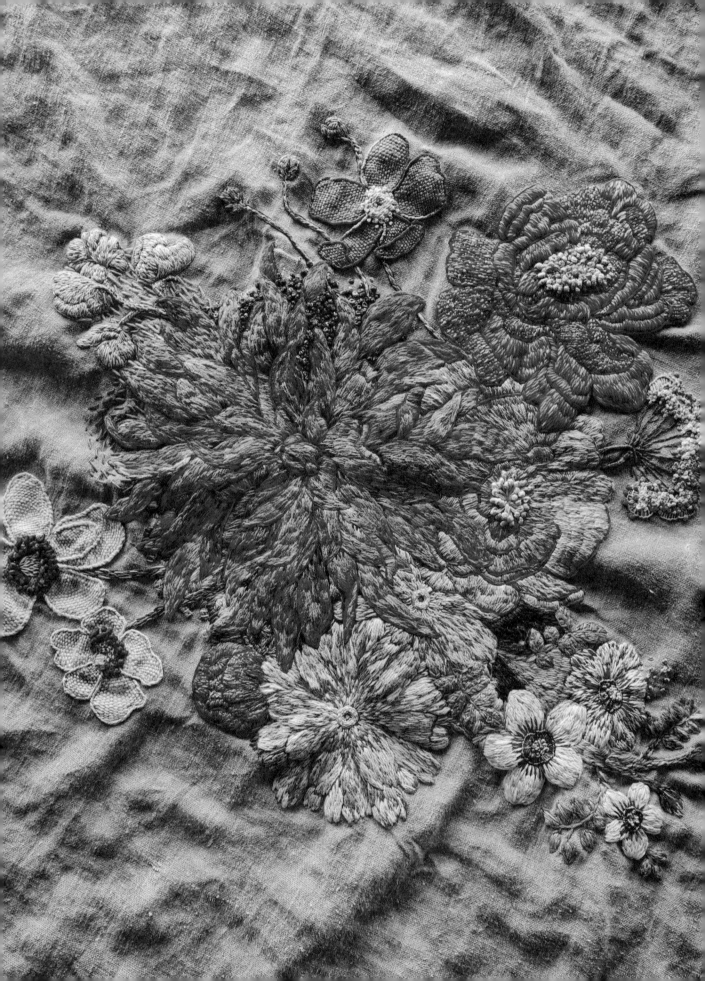

illustrative to ground it in place which could be a good option. The other is to cluster and scatter French knots of varying sizes throughout the background or add some patches of weaving, scattered beads or a directional Kantha stitch. Sometimes it doesn't need to be a literal interpretation of nature but rather a whimsical element that brings energy to the work.

Crop the work.
When you have been creating wild and free, the result can sometimes transition unknowingly in a new direction which despite being beautiful can create confusion. Sometimes you can end up with two works in one. Cropping (typically by cutting) to retain the area that feels successful will remove the area you are unsure about. And remember, nothing is ever lost. You can repurpose the area you've removed by bringing it into a textile collage or a textural piece in the future.

The same can work with expanding your area — you might start in a hoop but realise the work needs to grow to add it to a new piece of fabric in a larger frame and continue.

Smooth the lumps.
We love the texture, but sometimes as you're exploring it, there can be lumps and bumps that are less intentional and end up bothering you. This is not a call for neatness but rather an encouragement to leave those areas be while you're progressing through the work and know you can come back in later with more layers and detail to make the lumps disappear, or become a feature. I do this by using three strands of cotton/silk or other fine threads to tack down the stitches that bother me. You can make this look intentional by clustering your tacking stitches or adding them everywhere rather than just the lumpy patches.

Change colours.
Sometimes I find a colour I've chosen earlier no longer works. I'll work back over it with another colour and build up texture, or decide to commit and bring more of it into other areas of the piece. Often, if it's only in one place, it will stand out; you can balance the scales by bringing more in.

I have been known to throw caution to the wind and adjust the colour of a work by dying or painting over the entire piece. This often happens when I don't know what to do with it, and it is very much a gut feeling I have learnt to trust. It's not always a perfect science, but it usually works out well.

MAKE YOUR OWN RULES

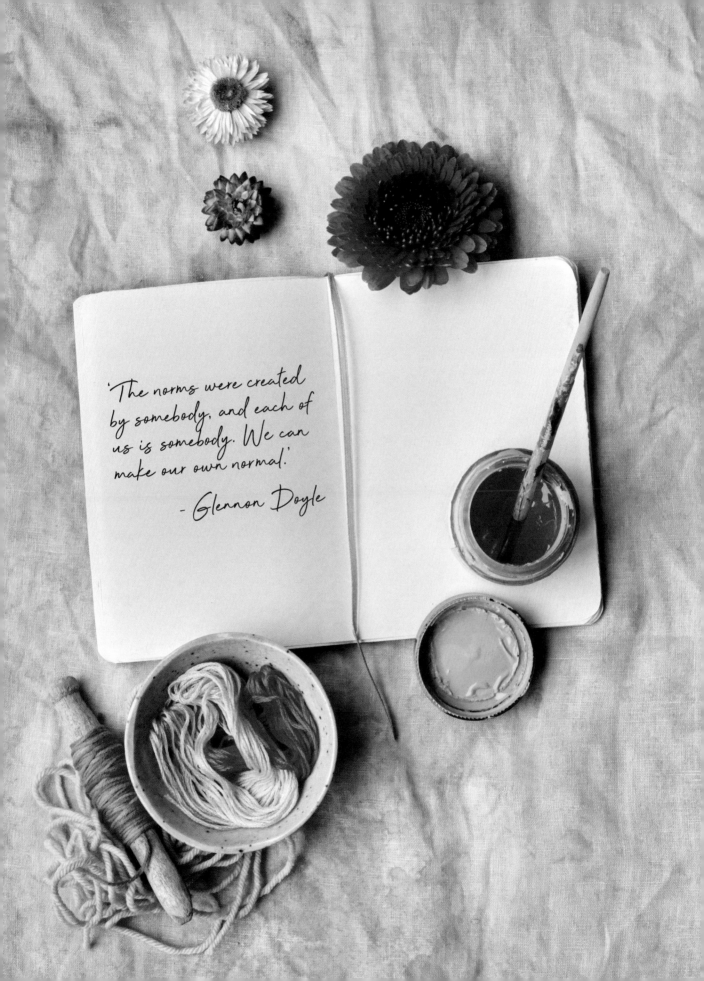

'The norms were created
by somebody, and each of
us is somebody. We can
make our own normal.'

- Glennon Doyle

Making my own rules for my creativity has helped me to innovate and grow as a creative but, most importantly, it has allowed me to embrace joy in the process.

It can seem such a simple concept but in reality, it is much more challenging as we are so conditioned by what we have been taught, and the stories we tell ourselves, that it can be hard to break through. But break through we must as making your own rules is not only liberating, it is a natural evolution of creating your own art practice.

Before you start creating your own, consider the old practices that hold you back. Understanding and knowing what they are so they can be set aside is important. Then decide on your new, more positive and uplifting rules. If the word 'rules' feels a bit loaded, think of them instead as 'design briefs' or 'governing concepts'.

Some examples of commonly held ideas around creativity that, through habit, can turn into rules:

✗ My work must be neat — if it's not, I have to stop and start again.
✗ I must always finish my projects — otherwise, I am wasting my time and resources.
✗ If it takes too long, I'm failing — I am not good at it if it takes ages.
✗ It doesn't look like a flower — why can't I make things that look just like the real thing?
✗ Why can't I make what I imagine — what I imagine is beautiful, and my work isn't.
✗ I don't know where to begin — I never come up with good ideas.
✗ I'm bad at this — obviously because of all of the above.

More positive thoughts to counter these:

√ Neatness is only required when I want it — I can stitch over things I don't like later.
√ I like to work on multiple projects to keep my perspective fresh — nothing is ever wasted because I constantly learn.

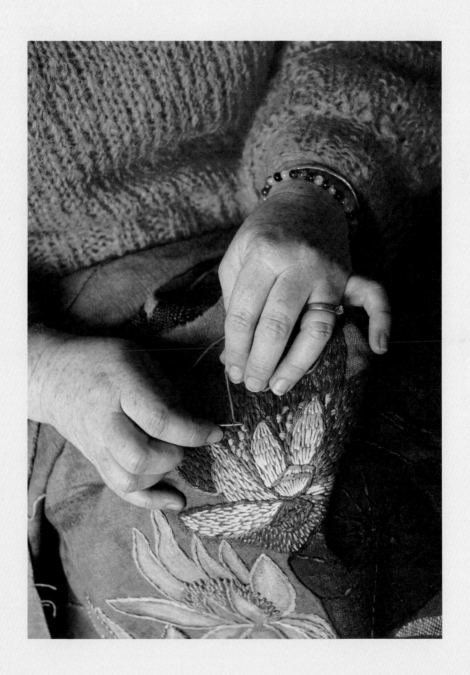

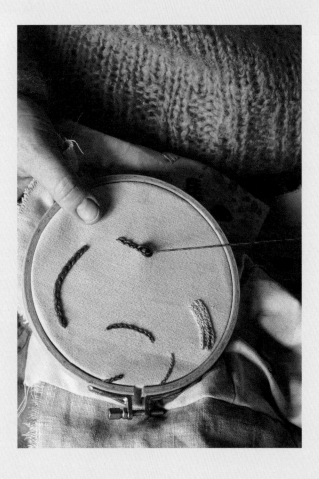

Creating simple concepts can help make beginning easier. Choose a colour palette, a piece of vintage embroidered fabric and start small.

√ I accept that stitch is time-consuming — allowing myself time to create is good for my practice and my wellbeing.

√ Flowers inspire me — I choose to try to capture their beauty using the skills I have.

√ The more I practice, the closer I get to what I imagine — my work is growing by the day.

√ Warm-up activities help to begin — warming up is an essential part of working in flow.

√ Starting with a simple design brief helps me create and stay on track — I can trust my creative intuition to guide me.

√ Every time I create, it gets easier — I know that creativity is a practice.

So many creatives — both beginners and those more experienced — tell me how they find it hard to start. Often one of the most productive things you can do is identify the areas that bother you and see if you can do things differently. Which in the case of making our own rules often comes down to shifting our mindset.

Practically this might be as simple as investing in a needle threader, or working with larger thread and needles with a bigger eye so that you don't have to struggle to thread your needle. Just because you have always done things one way, doesn't mean you need to continue along that path. There is no right way — just different ways,

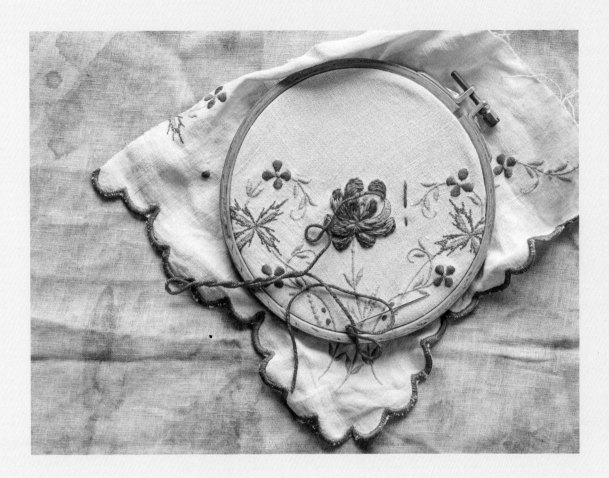

until you find *your* way. Ninety-nine per cent of the time, there is a simple fix to something that isn't flowing for you, but we often struggle on regardless. Seeking guidance or inspiration from others is a great way to open your eyes, and practice, to new ways.

One of the key things about creating your own rules is allowing the brief to change if need be. Being kind to yourself as you make, helps you to keep going. It is also often best to start with a basic project, and then as you create the story, your direction can slowly evolve. And remember — keep the 'joy in the process' front of your mind as you decide on your new set of guidelines.

Here are some tips for how I set up a few simple 'rules' that allow me to dive into projects …

Choose your size
Smaller is better if you're beginning or someone who likes to see results within days, not months.

Select your fabric
If you don't like designing your imagery, you can purchase designs from other embroidery artists or use printed material that has imagery you like.

Choose a colour palette
This can be inspired by your fabric or something completely different (these

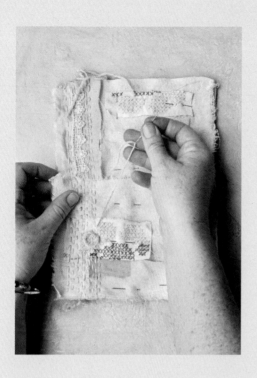

Using a neutral colour palette
can take the decision-making away
from your process and allow the
textures to tell the story.

are your rules, remember!). If you are
unsure I would typically start with 5-7
colours and only add more once you've
reached 70-80 per cent completion.

Give yourself a goal

This doesn't have to be the only
thing that guides your work, but it
is excellent to give you a jumping-
off point. It could be simple, like
colouring all of the flower's petals
using split back stitch or extending
your existing practice, like bringing
beading into 40 per cent of the piece.
Some folks like to write this down so
they can keep their design brief in
their project basket and refer to it.

Textile Collage

Gather neutral tones of various textiles
on a neutral base like a wool blanket
or other open-weave fabric. Choose one
thread colour in many textures, like
wool, stranded cotton, delicate ribbon,
pearl cotton and any other threads you
like. Bind the layers together using
Kantha stitch. You can change the
direction of the stitching or work in
parallel rows.

Stitch a Daisy

Choose a piece of linen and three
different 4ply colours of wool (I love
a silk merino blend) plus one stranded
cotton in any colour you like. You might
want to hand-paint some linen as your
base (refer to page 104 for how-to).
Either hand-draw or trace an image of
a simple daisy in the centre of your
fabric, taking care to check it sits
inside your size of hoop/frame. Stitch
the petals starting at the base of each
petal using split back stitch until the
petals are coloured in. Add a border
around the petals using a couching stitch
with one of your wools as the base thread
and your stranded cotton split into three
strands for the tacking stitch. Cluster
French knots in the centre of your daisy
using one of the wools.

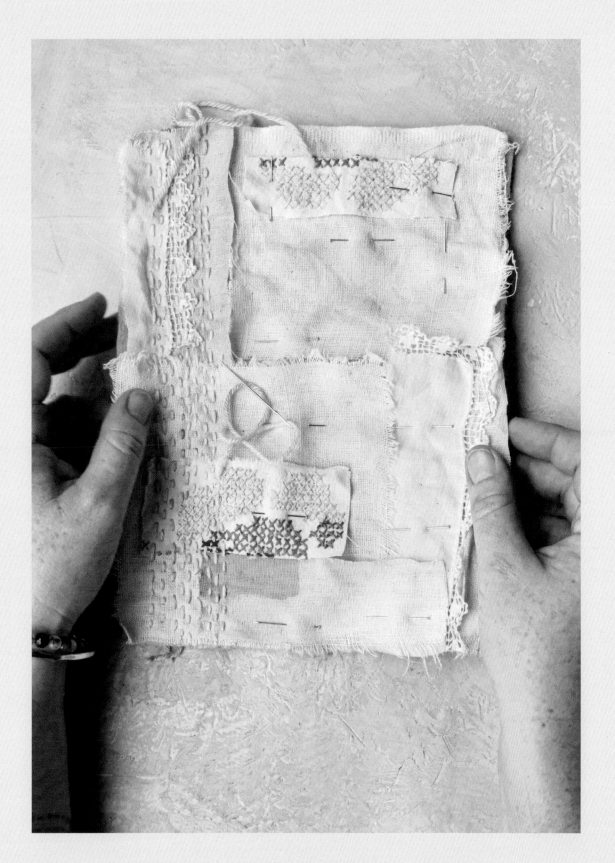

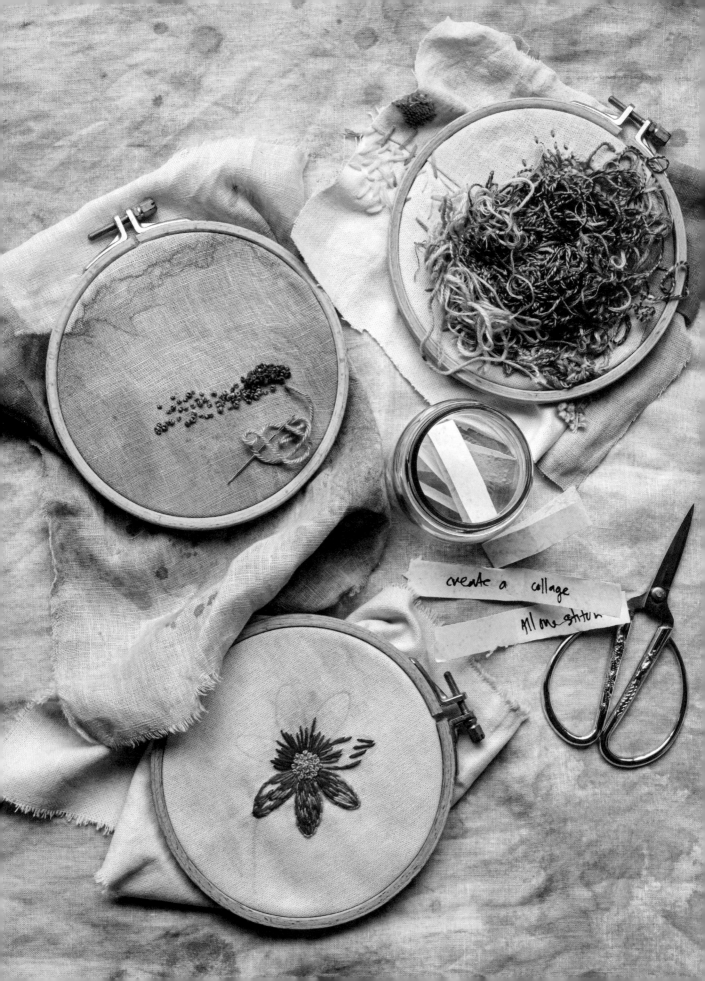

Lucky Dip, Stitch a Daisy, create a
French Knot Garden or drop a tangle of
threads onto some linen. All great easy
jumping-off points for a new project.

You can finish there or play further
by adding more flowers or abstract
background details like scattered seed
stitches in a similar colour to the
background fabric, or some Kantha stitch
running around the background.

Lucky Dip

Write a bunch of ideas on small pieces
of paper, fold them and put them in a
jar. Pick out an idea and use that as
the beginning of your project. Things
like only use one colour; stitch only
French knots; create using a type of
thread you've never used before; make a
leaf with only beads; outline stitch a
rose; cover a small area with different
colours of weaving stitch; make a Kantha
stitch rainbow; practise three stitches
for 15 minutes each; sketch from a still
life; paint linen. The list can go on
and on, and it is a beautiful way to
never find yourself staring at a blank
piece of anything without ideas.

Contemporary Stitched Sampler

If you haven't already started on one
of these inspired by earlier chapters,
having a stitch sketch page is lovely.
Mine is a constant work in progress. Go
for something that feels doable size-
wise and choose a linen or wool blanket
or layer a couple of pieces of fabric

like linen so that it is soft and easy
to stitch through. Randomly add stitches
to your sampler as a place to practise
each stitch. You can section it into
areas like a more traditional sampler or
allow the stitches to grow, wander, and
eventually merge. Do it your way. It is
for you.

Tangle Texture

Grab a tangle of threads and plop them
on your fabric. Stitch them down using
tiny tacking stitches (similar to a
couching stitch) in any thread you like.
Allow yourself to add other stitches
into the gaps and let them climb over
some of the mounds of thread. French
knots, weaving, colouring in, whatever
your heart desires. If it gets too
abstract, remember you can bring it back
together by working back into the entire
piece using only one colour.

French Knot Garden

Use a blanket, felted wool, hand-
painted, printed or plain linen as
your base in a small hoop. Stitch with
colours inspired by a small garden scene
using only French knots. I like to use
wool and stranded cotton for this, but
you can use any thread. Cluster the
knots to represent the plants. Think of
Monet as mark-making inspiration.

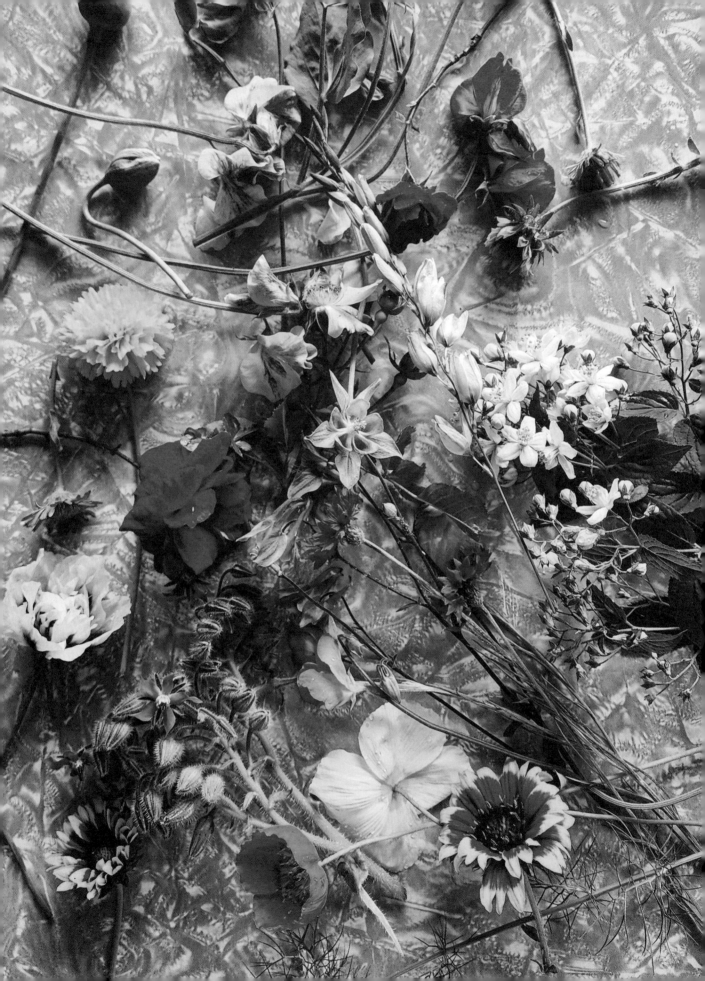

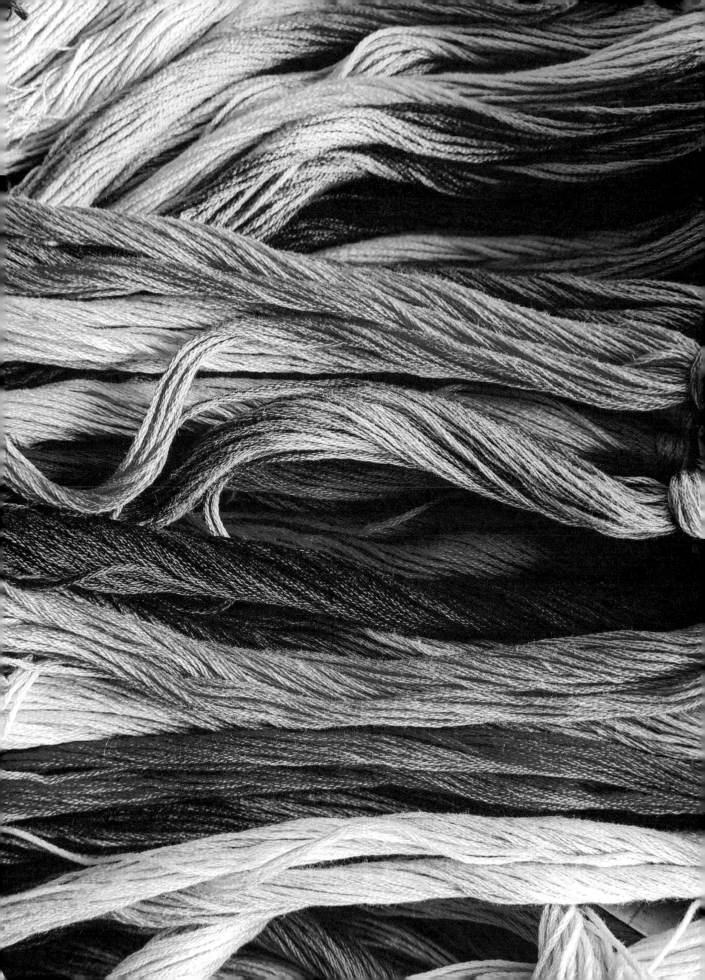

MEANINGFUL
MARK-MAKING

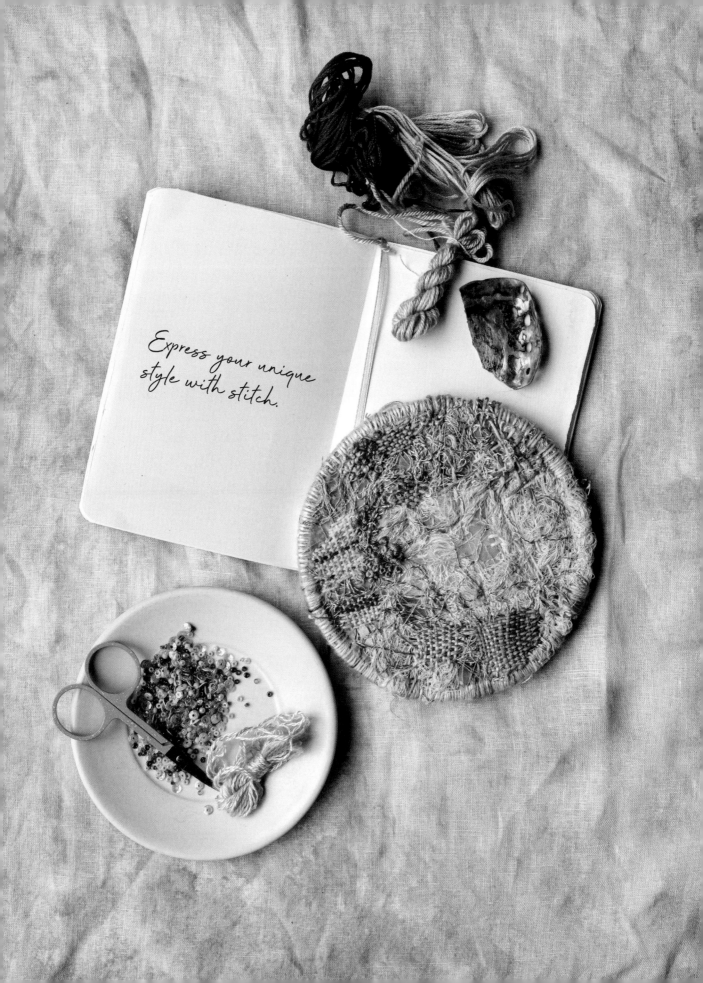

Express your unique
style with stitch.

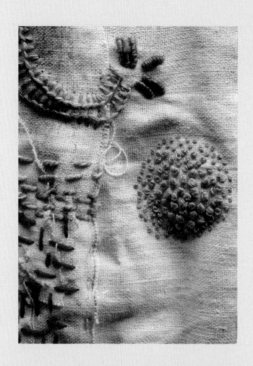

Top Left: Scatter of French knots in various sizes. Bottom Left: Blanket stitch in different directions. Bottom Right: Kantha stitch in a variety of threads. Opposite: Pointing at split back stitch, I use it in most of my work for colouring in.

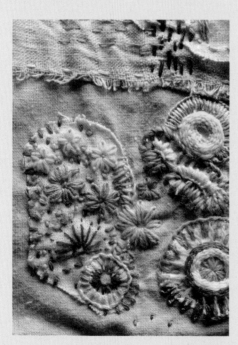

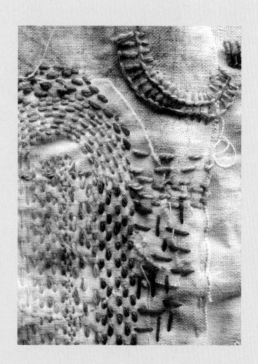

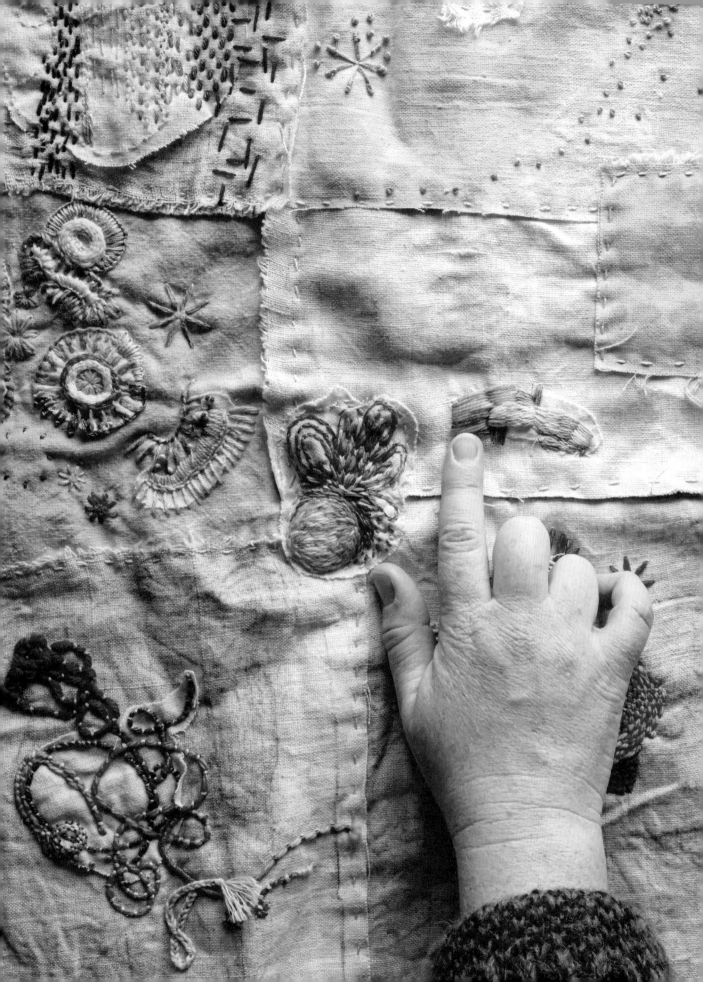

A collection of projects — I like to
work on multiple projects so that
when I'm unsure what to do, I can
put one down and pick up the next.

No matter where you are in the spectrum of stitch knowledge – beginner, hobbiest, regular stitcher – it is beautiful to try to bring a sense of meaning to your stitched mark-making.

I came to stitch with the brain of a painter and mixed media artist. I already felt I understood colour and composition, so stitch was another way to make marks and add texture to my work. Little did I know it would send me down a magical rabbit hole of fibre art.

I am grateful that I didn't seek any traditional guidance when I began and had little to no idea about embroidery, for it meant nobody told me I needed to follow any rules, like the length of your thread or that the back must be neat … I just played in the studio until I found the processes that worked for me. I naturally learnt a very long thread can get tangled or frayed. Initially, I tried to stitch through the heavily painted canvas and realised it was pretty hard on my fingers and the fibres. One day the penny dropped — painters paint on linen and crafters embroider on linen, so I played around to marry the two.

Lots of what I do, and how I approach stitching, is about using it to bring more colour and texture into my work. When I began, there weren't a million different YouTube tutorials or excellent online resources, and I had no idea what to google, even if there were. It was a foreign language to me that I learnt through intuition and play. I discovered there are many ways that the marks you make can bring meaning to your work. It doesn't always have to be complicated or clever; sometimes the simplest marks can be mighty.

If you had told me then that now I would be writing a book, teaching workshops and offering an online course, it would have been impossible to imagine, as I always associated those things with people with formal training and multiple degrees. I eventually came to realise that the years of exploring with a sense of freedom and deep curiosity in the studio is an unequivocal commitment to learning. This process allowed me to gather knowledge filtered through my unique lens. The more I stitched into my paintings, the more I understood that my process was unique and that being self-taught was an advantage. Most of all, it became apparent to me that my creative DNA had delivered this skill and that working in a contemporary way with a traditional craft was unique and worth sharing.

It brings me great joy to teach and share in person, online and now here in *The Untamed Thread*, this process that

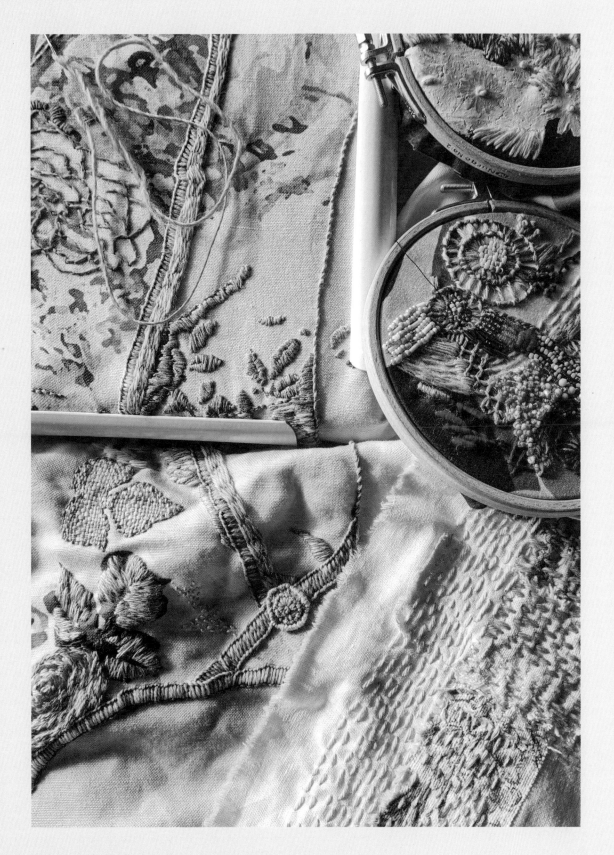

1.

is mine, but it is also for everyone.
Creativity is for anyone who wants it,
and the absolute best thing we can
do is share it. So here I am sharing
my favourite stitches and how I use
them to tell my visual stories about
nature. You might like to try them,
or it might inspire you to consider
approaching any mark-making differently.
I am aware I don't use a wide variety
of unique techniques, but what makes
my work interesting is the variety
of colour, texture and layering that
I use to expand these techniques, in
the directions that suit the forms
I'm working with. When I'm stitching a
delicate flower, I will seek out threads
that offer a similar texture or split
my thread to create finer stitches,
and the opposite is true when exploring
something much more textural.

What will make your mark-making
meaningful is using stitches you enjoy, in
colours and textures that make sense to
you and the visuals you want to create.

Learn why you chose a particular mark
for a specific area and what appealed to
you about doing it that way. It is what
transitions your work from a copy, or a
functional craft into an artwork, as every
mark you make reinforces the story you are
telling alongside all the other decisions
you make.

One of my favourite things when
workshopping is to see how we all
approach a process differently and how
like me, many make methods that work for
them. I encourage you to feel free to
do the same, while keeping your process
playful and joyful so that you trust your
intuition to do some of this work for
yourself. You will learn as you go rather
than always being entirely intentional.

1. Split Back Stitch
This humble stitch is the foundation of
much of my work and became a significant
part of my practice when the short-long
stitches I was using didn't cover enough
ground any more. I think of this stitch

2.

3.

as a colouring-in stitch and use it to block in colour and position my stitches directionally to communicate form.

For example, when stitching a petal, I will generally start at the base with split back stitch and travel in the direction of the form, curving or fanning the stitch as required. The key with split back stitch is that you always want to be coming back from above the area you want to fill in. That way, you can control where your needle enters the fabric from above and effectively create a circle of stitch from front to back. As you colour in, you want to bring your needle into the fibres of the stitch before from above each time. Back stitch is when you go into the hole of the stitch before; it becomes a split back stitch when you stitch back into the fibres.

2. French Knots
For years I attempted to do funny little knotty things to replicate the sweet little knots I would see on my collected vintage embroideries until, eventually, I was having tea with some wonderful ladies from the Nelson Embroiderers' Guild Extensions Group, and they generously showed me how to 'actually' do some stitches. What a game changer; since then this little stitch has become one of my favourites. I love it for the centres of flowers, clusters of texture or simply some scattered detail to communicate a sense of movement or energy.

My tip for mastering French knots is to place your hoop/frame on the table so you can use both hands, one to hold the tension of the thread and the other to use the needle. It can feel fiddly initially, but once you get the hang of it, you will have hours of fun.

3. Couching
This stitch was added to my repertoire when I found some fibres too thick to get through my linen, so I added them

4.

5.

on top and used little tacking stitches
to attach them. I liked the effect so
much that I started bringing it into my
work often to define lines and borders.
I find it winds beautifully around
curves and can be both a subtle or a
more robust outline by playing with
contrasting the colours of the base
thread and the tacking stitches.

It is a pretty easy stitch to master,
so a good one if you are beginning and
seeking a new stitch but need time to
develop confidence. Remember that the
base thread with couching will be the
strongest element and, ideally, will be
thicker than your chosen tacking thread.
I often use a 4ply wool as my base and
three strands of cotton or a single
strand of pearl cotton as my tacking
thread. Wherever you place your tacking
stitches is where your base thread will
sit, so you can always draw a line to
follow if there isn't a natural outline
already.

4. Kantha Stitch

As we explored in Embracing the Slow
(page 114), this stitch is a pleasure
to do for its simplicity, but I find it
also excellent for adding directional
marks to link the eye from one area to
another. Also known as a running stitch,
this simple in-and-out stitch is best
done with a long darning needle. I also
use my chenille needles for this.

5. Blanket Stitch

Traditionally, you would find this stitch
edging blankets or rugs. However, I use
it in varying ways to add texture. If
you play around with having your stitches
close together, the blanket stitch forms
a lovely edge that can look gorgeous to
add a ridge to define areas like leaves,
for example. Blanket stitching on top
rather than around the edge of the fabric
sometimes stumps people at the beginning.
If you remember that you always start
with a loop and work from top to bottom,

6.

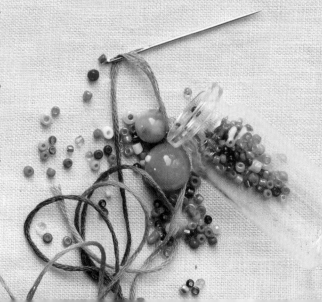

7.

catching each stitch at the top, it helps you get into the rhythm of it. The first loop always looks a little wonky. I typically return to the first loop at the end and gather it with a little stitch to even the effect if needed.

6. Chain Stitch

This is another lovely stitch to play with. I sometimes use it for line work but mostly use it to block in colour and add texture. By running the stitch in close parallel lines, you can create what looks like a knitted jumper texture, which I am very fond of.

Similarly to the blanket stitch, the chain stitch starts with a loop. You come up into the middle of your loop to create your next one by making another loop before going back down into the middle of the same loop and back up through the centre of your new loop and repeat. The last loop can be held down with a tiny stitch.

7. Weaving Stitch

This stitch brings me so much joy. Setting up a row of lines and then weaving back through them, alternating each way, brings fantastic texture and colour to the areas you add it to. It's a generous stitch that covers quite a lot of ground.

The trick with weaving is that your initial lines need to be at least a needle-width apart, and then when you begin to weave back through, you want

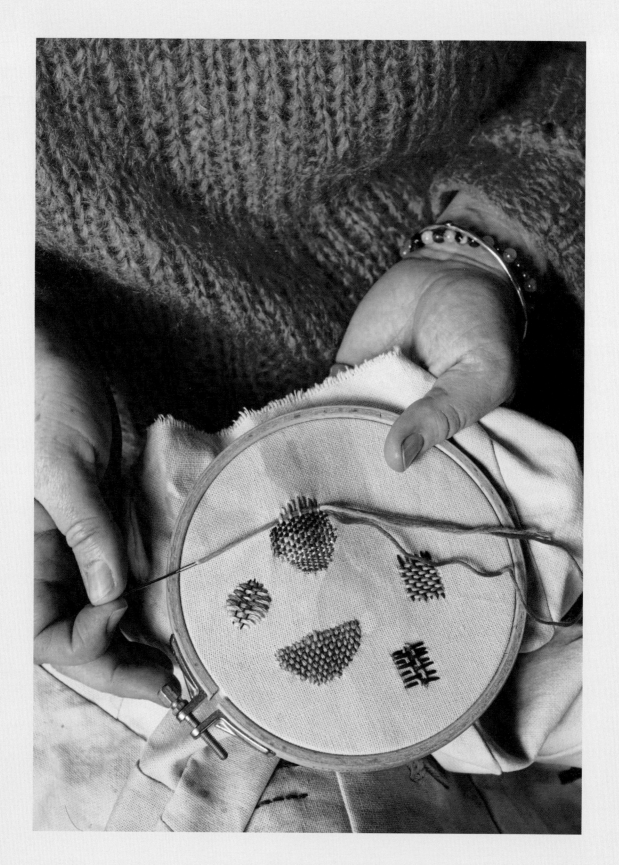

Weaving stitch using
different colours.

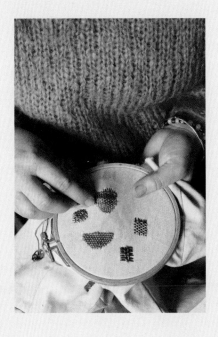

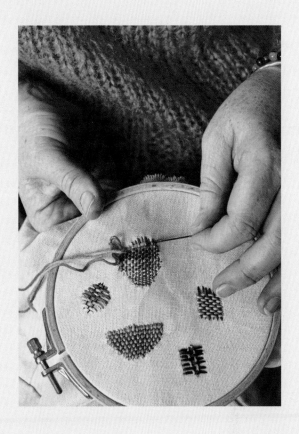

to come up through the fabric at one
end, preferably in the most significant
area, so you can start to establish your
pattern. You then weave your needle and
thread over and under your row of lines
until securing at the end by stitching
back down through the fabric. When you
are ready to stitch your next row, start
right next to where you just ended by
coming back up through the fabric and
weaving through the lines, alternating
the pattern. Where you went under, you
now need to go over and vice versa.

The only time you are stitching through
the fabric is at the start and end of
each row. Your baselines need to be a
needle-width apart at least to bring the
weaving together and create a lovely
checkerboard effect; you need to make
your weaving rows very close together.
It can help to use two different colours
when you're learning this stitch — one
for the base and the other for the
weaving — that way, you can see your
pattern and follow it in whatever shape
your weaving forms.

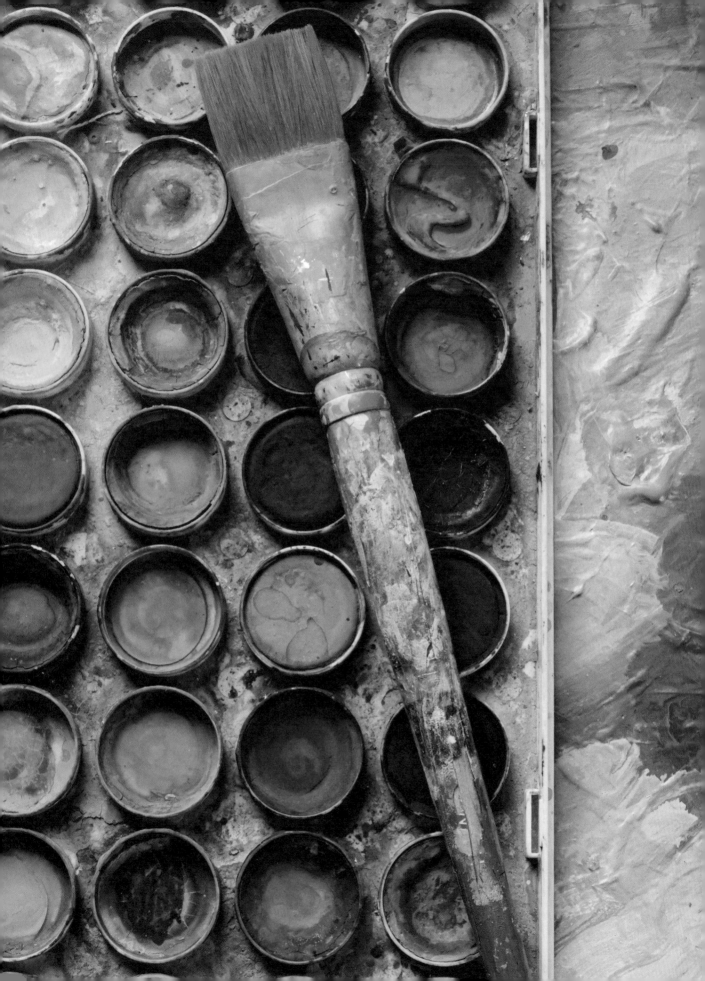

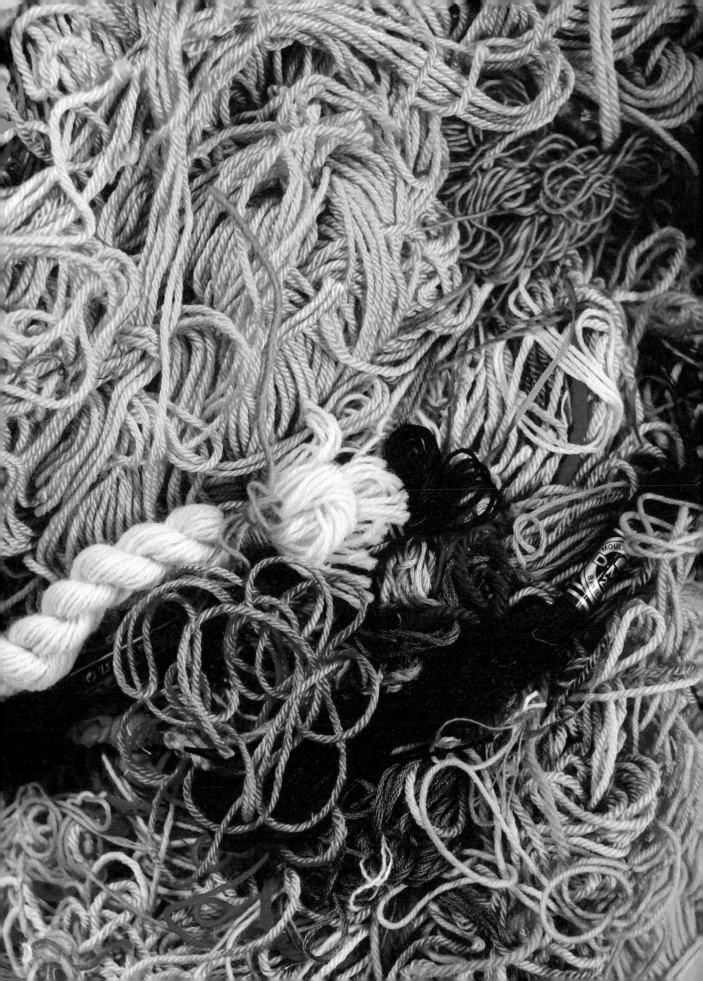

COLOUR WHEEL

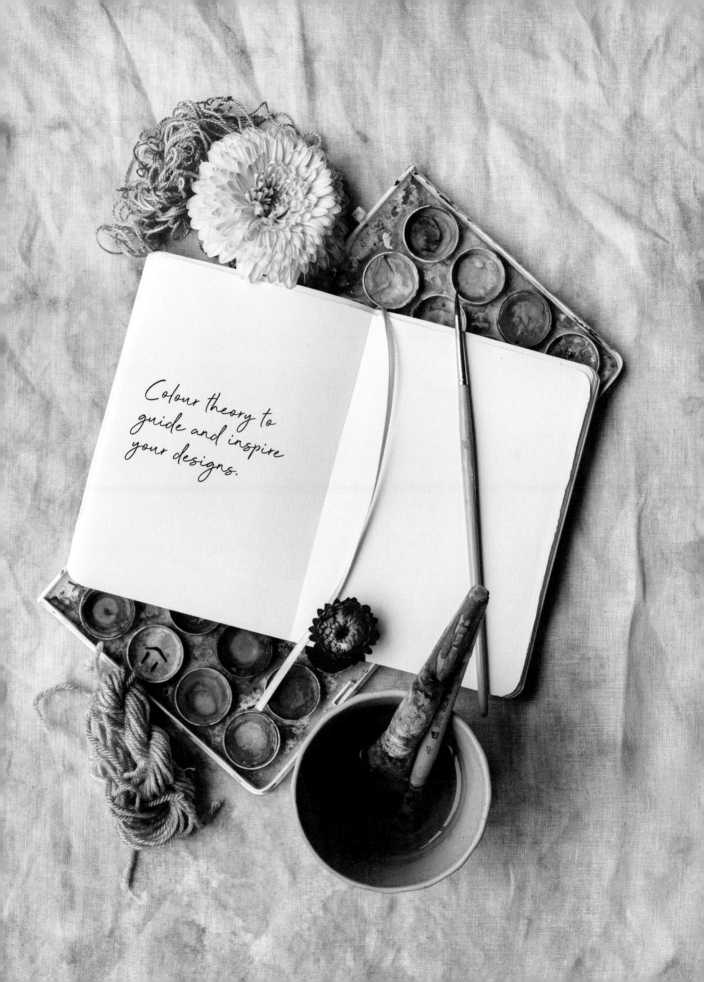

Colour theory to
guide and inspire
your designs.

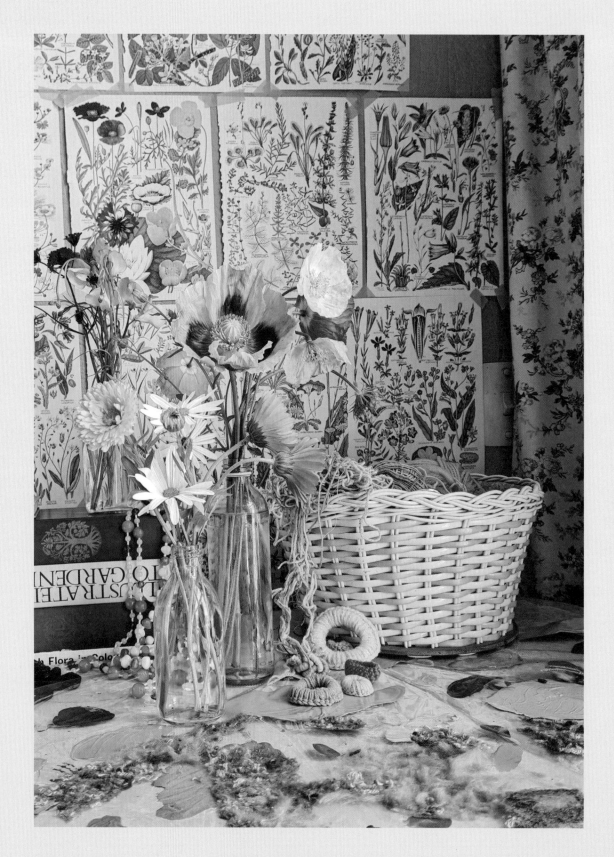

Previous Left: A corner of the
studio with a book page wall
collage. Previous Right: You
can never have too many threads
— wool skeins by Miro Yarns in
my favourite silk merino blend.
Right: The three true primary
colours; Red, Yellow and Blue.

The most important thing to know about colour is that you can't be wrong.

Yes, technically, there are colours
that 'go' together, but varied hues can
sway the balance swiftly, and really
what works best in terms of colour is
entirely up to you and your aesthetic.
What makes one person's heart sing can
be the opposite for another.

We all have an individual colour
palette, colours that we gravitate
towards. If you're unsure what yours
is, look around your home, garden and
wardrobe at the colours you choose and
enjoy. If you've been playing it safe
for colour in your environment for years
but want to expand and explore, your
creativity is a great place to do this.

For those feeling challenged by
creating their colour palettes, here are
a few basic colour guides that will help
you select a palette to work with when
designing your projects.

The primary colours are
Red, Yellow & Blue

You can mix two primary colours to make
secondary colours.
Red + Yellow = Orange
Blue + Yellow = Green
Red + Blue = Purple

You can then mix primary and secondary
colours to make tertiary colours, mixing
different amounts of each colour to
create differing hues.
Red + Orange = Vermillion
Blue + Purple = Blue-Violet
Red + Purple = Red-Violet
Blue + Green = Teal
And so on …

White and black are described as tones
and can be added to any colour to
lighten or darken them.

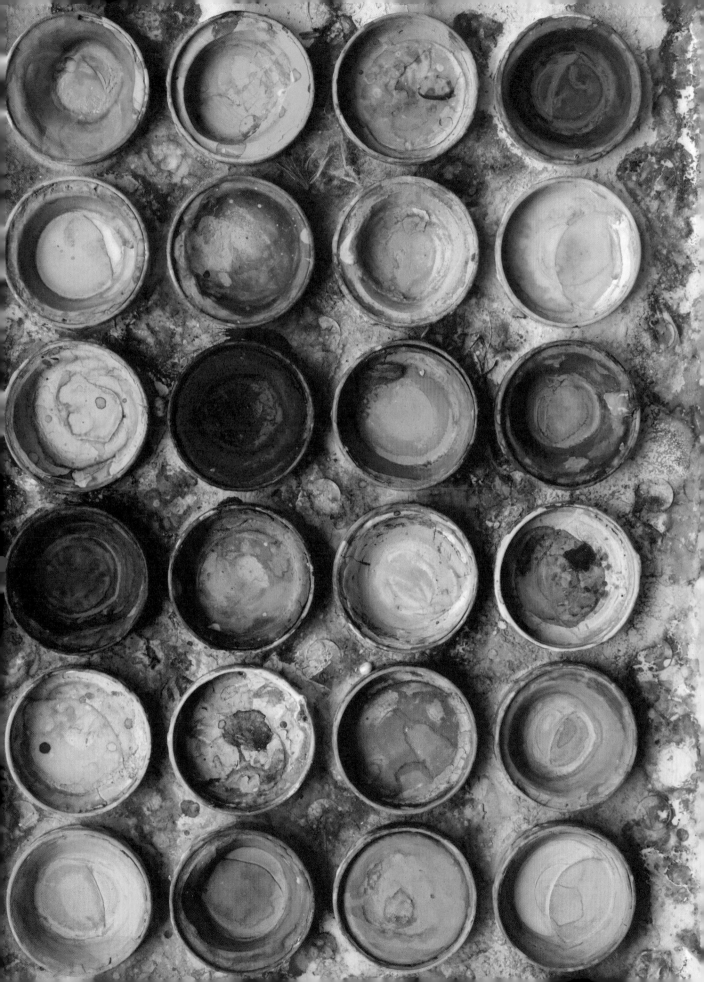

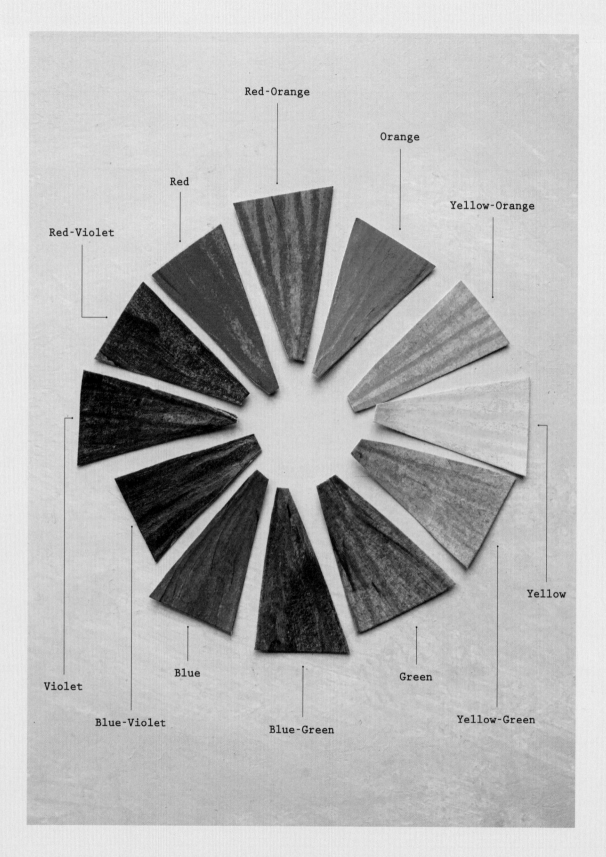

Red-Orange

Orange

Yellow-Orange

Red

Red-Violet

Yellow

Violet

Blue

Blue-Violet

Blue-Green

Green

Yellow-Green

When you look at our simple colour
wheel, the main points to note are that
colours sitting opposite each other
are generally considered complementary.
For example, blue and orange. Opposites
attract.

What is equally important to
acknowledge is that many colours
have strong associations, like red
and green for example, to me, ignite
notions of Christmas, so even though
they technically 'work' together, it
doesn't automatically give them a spot
in your line-up.

Usually, to find the colours I want
to work with, I use colours mixed with
tones; for example, I choose a pink and
pair it with a lime green. Red + White
= Pink and Green + Yellow = Lime Green.
So even though the colour story is more
nuanced, it does work with the basic
principle of colours sitting opposite
each other on the colour wheel. If you
are stuck there are interactive online
colour wheels that you can use as a
handy tool to determine which colours
complement a selection of colours.

The other thing to note about colour
is texture. You will notice in the
flatlays we have created that elements
of the same, or similar colours can
look quite different depending on
the texture. So it is always worth
considering texture when curating

your colour palette. Creating a colour
story is one of the most beautiful ways
to explore colour. We've done this in
a range of colours with elements from
the studio and foraged in nature. If in
doubt, nature will generally offer up
some lovely options.

A simple way to create a colour palette
from nature is to select your imagery
and break down the colours — if you are
looking at a pale pink rose for example,
it could be broken down into: 50 per
cent pale pink, 25 per cent pale shell
pink, 10 per cent coral pink, 10 per cent
yellow and 5 per cent mint green. This is
harder to translate into how many skeins
of thread you'd need as there are many
variables, including size and thickness,
but it gives you an idea of what colours
you'll need and that you'll need more
thread in pale pink than anything else.
If you wanted to take the same flower but

change the colour, you would apply the same theory by sectioning your chosen colours accordingly.

Once you are more confident working with colour, you can also bring in wild cards, like a hint of hot pink or neon yellow. It's okay to be playful and bold or muted and subtle; the key is to commit to the palette you select for the bulk of the work, then bring in other colours closer to the end to highlight specific details or bring the story together.

If in doubt, refer back to the simple colour wheel and look at what colours sit opposite each other, then expand on that by using different shades or tones of that colour. For example, if you choose orange and blue, you might select rust and navy.

I wanted to include palettes that communicate a colour story and show how colour and texture can create energy. We know there are colour concepts that can be complementary, but there is also feeling attached to colour. It can aid your storytelling to create colour palettes that appeal to your personal aesthetic and are sensitive to the story you're telling with your work. I've chosen some words that spring to mind when I look at each palette; you might think something entirely different when you look at them, and that is the beauty of colour and our own colour stories. Some of our thoughts around colour are

universal, and many are unique.

Each colour palette could be applied to a project, or you could take elements to create a new collection of colours. Like in so many areas of the creative process, there isn't a clear right or wrong, and the more you play and explore colour, the more you will become sensitive to subtle changes in hues that can make a big difference to your work. Create your own colour stories with foraged flatlays and supplies. It can be fun to combine inspiration for subject matter with the threads you love.

The Soft Palette — gentle, subtle, whimsical and light

The Warm Palette — inviting, uplifting, autumn harvest, sunshine

The Cool Palette — calm, serene, lakeside, moonlight, cool dip

The Greens Palette — fresh, inviting, lively, grassy, new

The Pinks Palette — romantic, deep, wine, opulent

The Neutrals Palette — refined, contrast, textural, rugged coast

The Earthy Palette — natural, warm, embracing, fireside

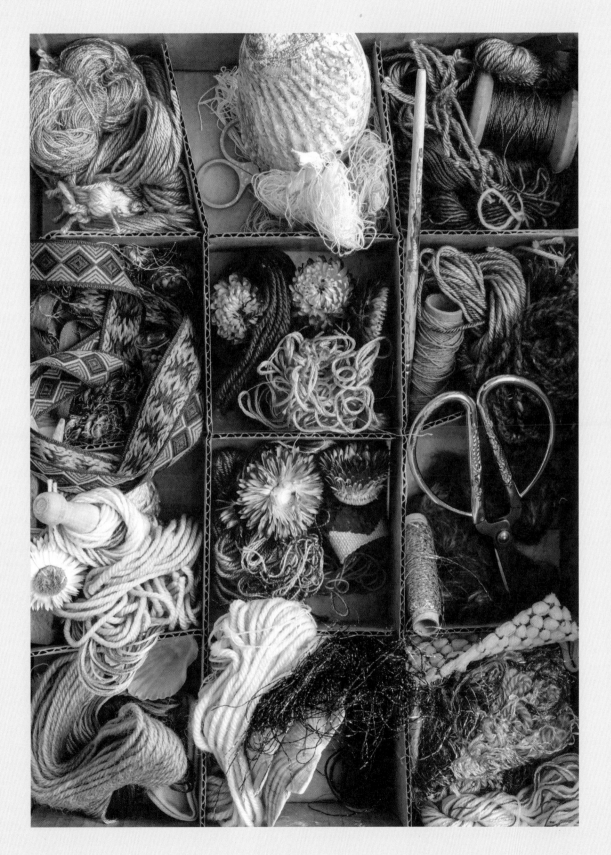

IVORY
LINEN
BLUSH
CREAM
CARAMEL

Soft

gentle + subtle + whimsical + light

SAND
MAUVE
LEMONADE
NUDE
PEARL

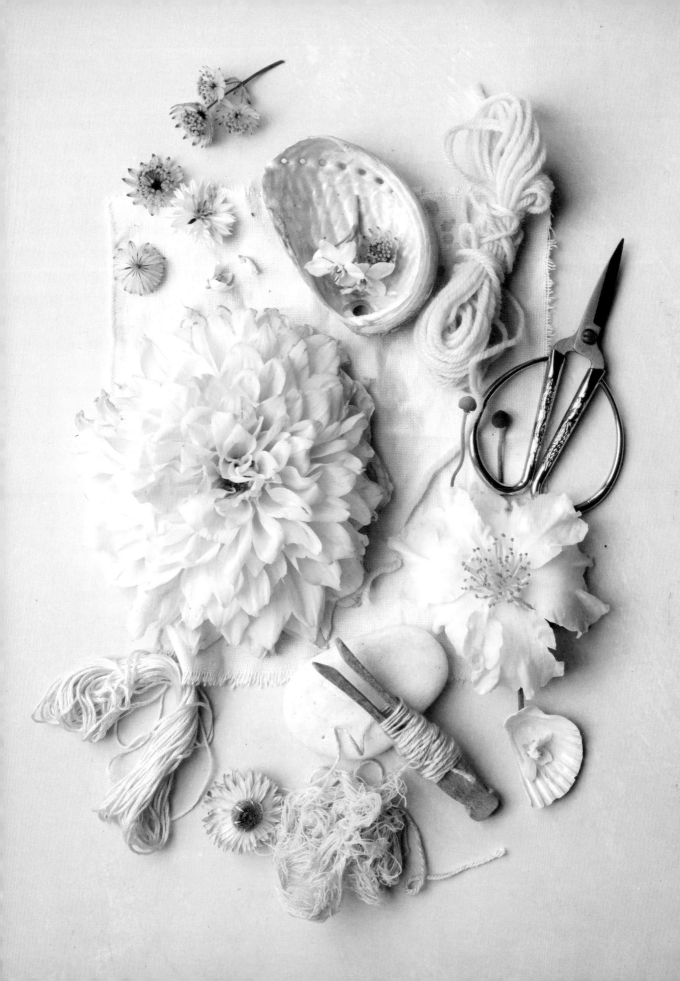

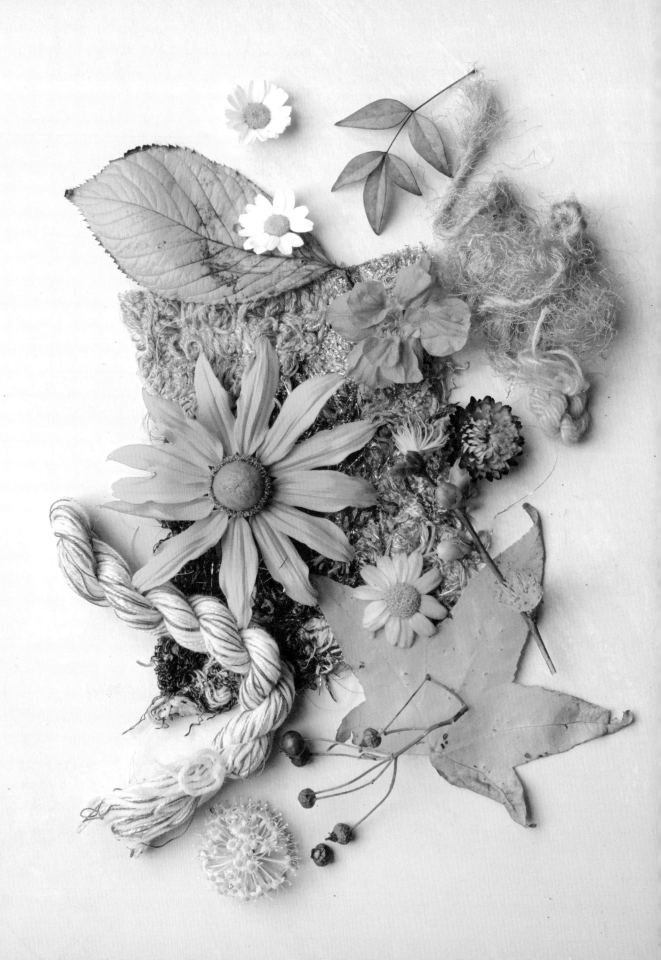

CORAL
MUSTARD
BUTTER
SUNFLOWER
GOLD

Warm

inviting + uplifting + autumn harvest + sunshine

AMBER
GINGER
TANGERINE
RUST
HONEY

DENIM
COBALT
CORNFLOWER
TURQUOISE
NAVY

Cool

calm + serene + lakeside + moonlight + cool dip

AQUA
SKY BLUE
LILAC
AZURE
BABY BLUE

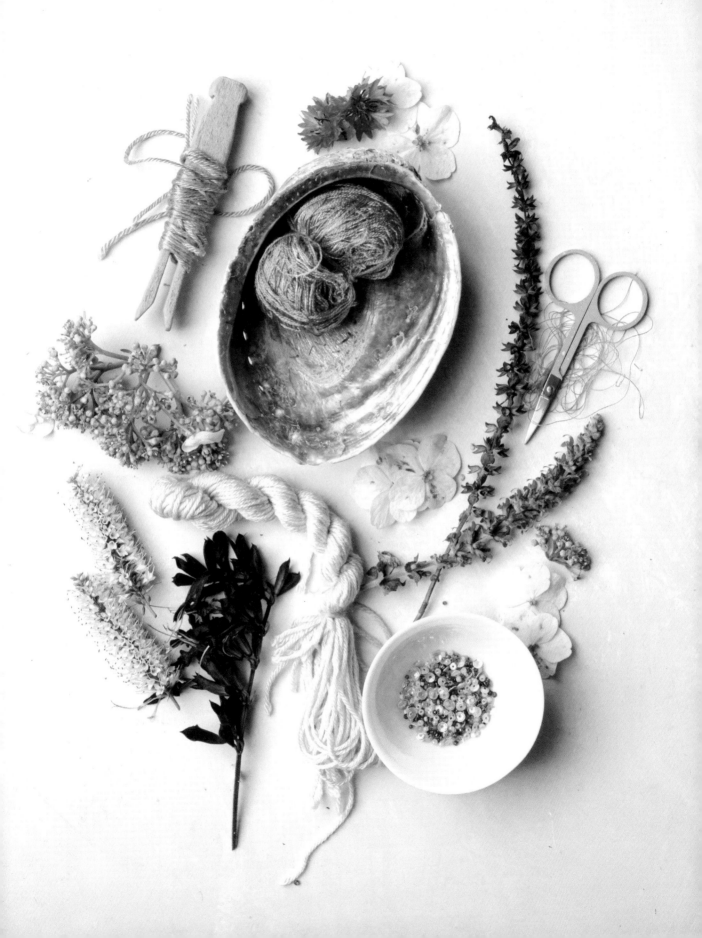

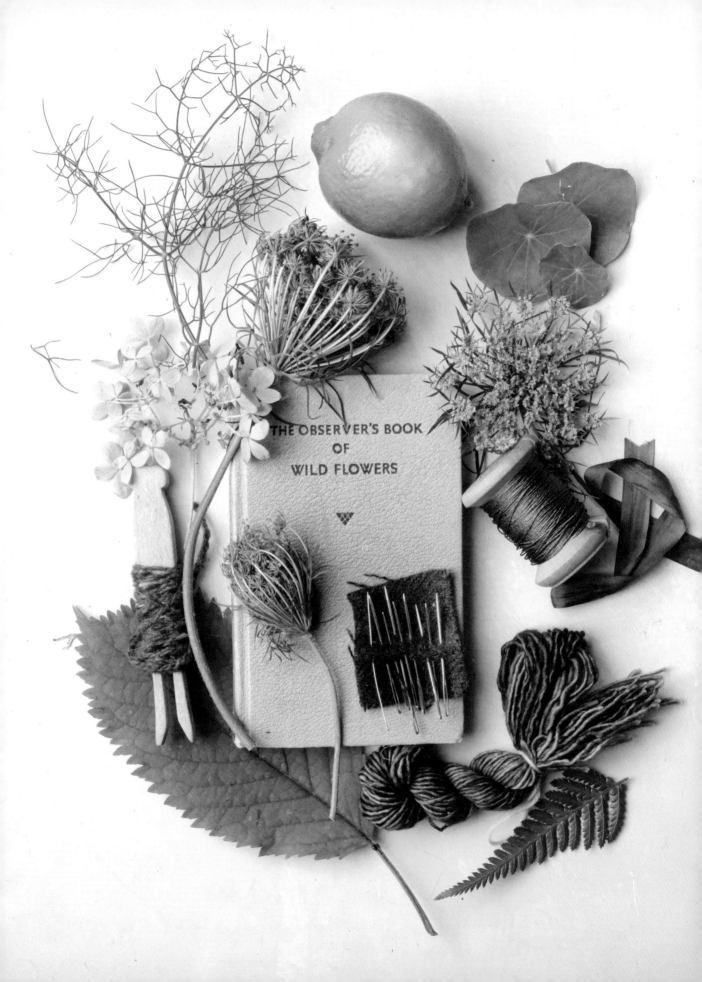

MINT
FOREST
CHARTREUSE
EMERALD
SAGE

Greens

fresh + inviting + lively + grassy + new

MOSS
LIME
OLIVE
PISTACHIO
JADE

CORAL
HOT PINK
WATERMELON
BUBBLEGUM
GRAPE

Pinks

romantic + deep + wine + opulent

STRAWBERRY
BURGUNDY
MAGENTA
ROUGE
FUCHSIA

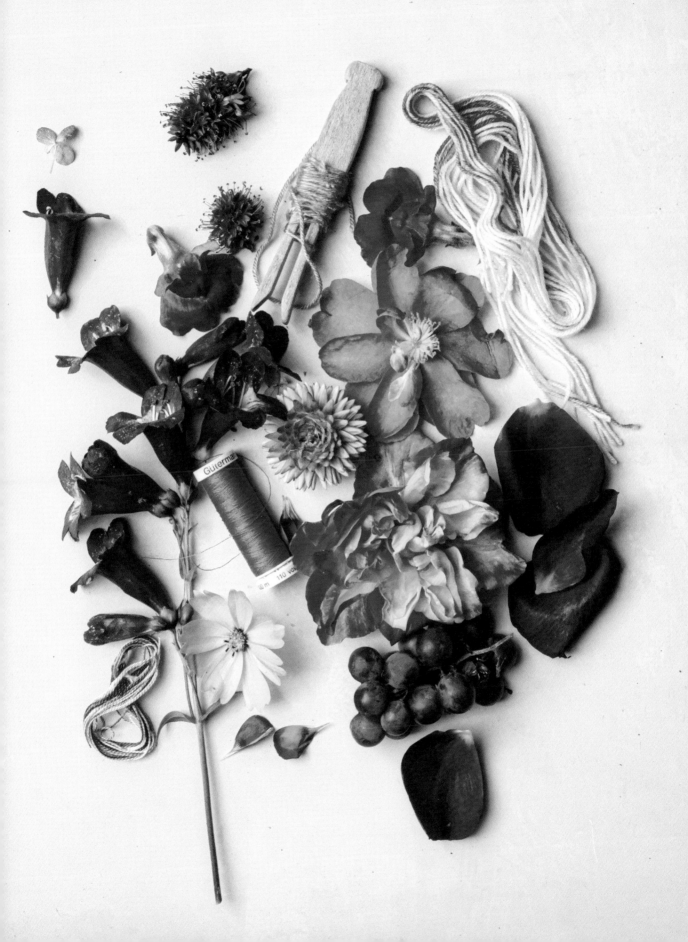

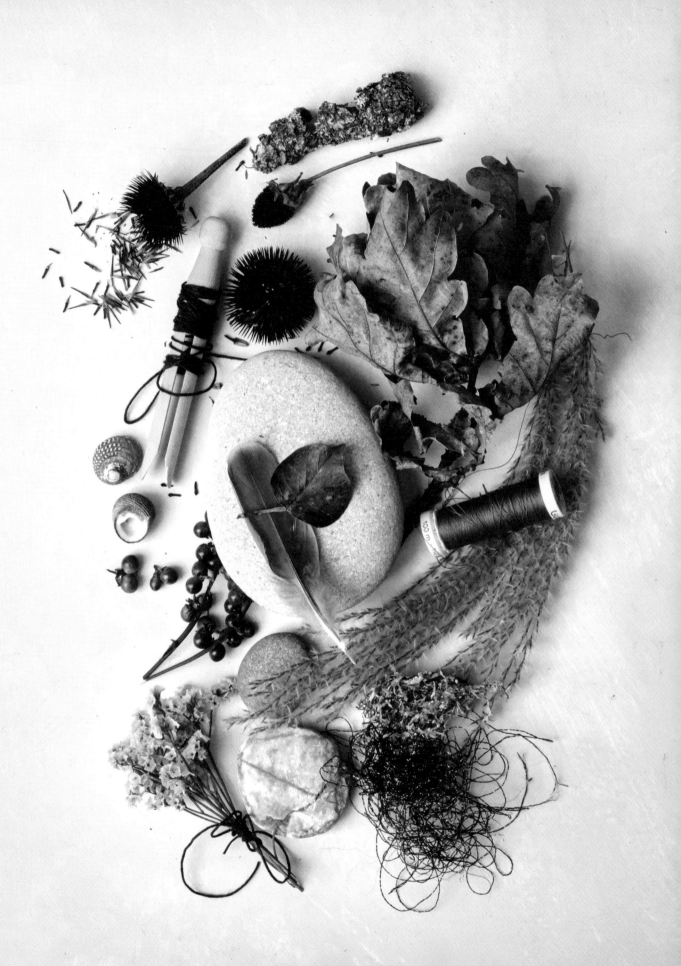

SMOKE
CHARCOAL
TAUPE
PEWTER
CLOUD

Neutrals

refined + contrast + textural + rugged coast

STONE
GRAPHITE
SILVER
SLATE
ASH

RUST
BRONZE
CHESTNUT
OCHRE
TAWNY

Earthy

natural + warm + embracing + fireside

CHOCOLATE
CINNAMON
AUBURN
COPPER
TOFFEE

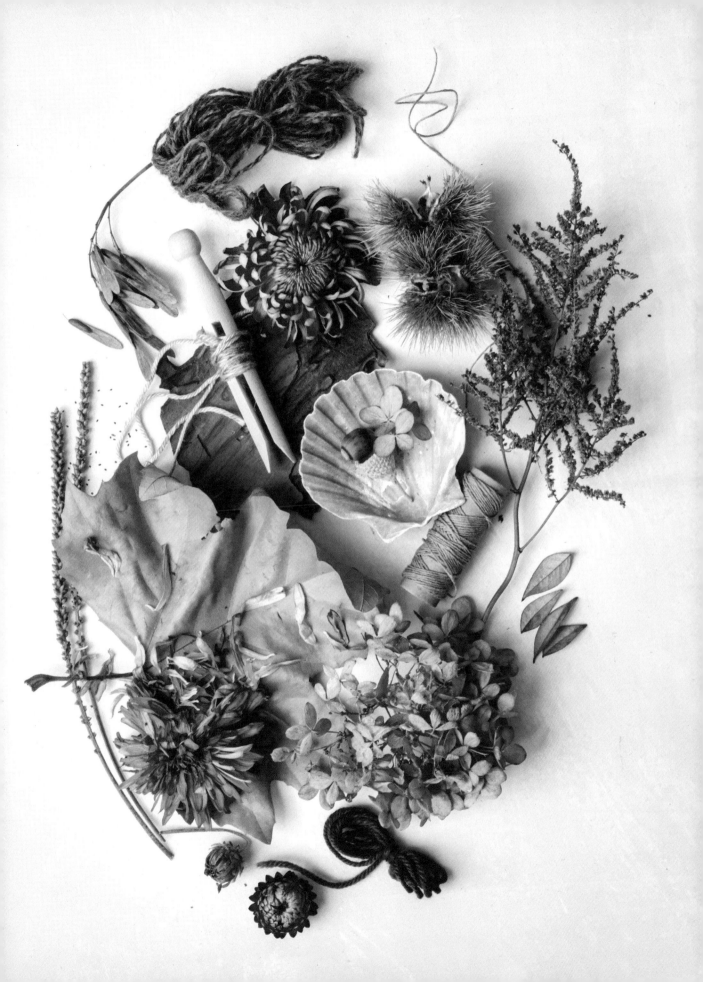

Textures from the forest — lichen
and leaves bring inspiration to the
threads I use. Opposite: Smoothing
a cut skein of 4ply merino wool.

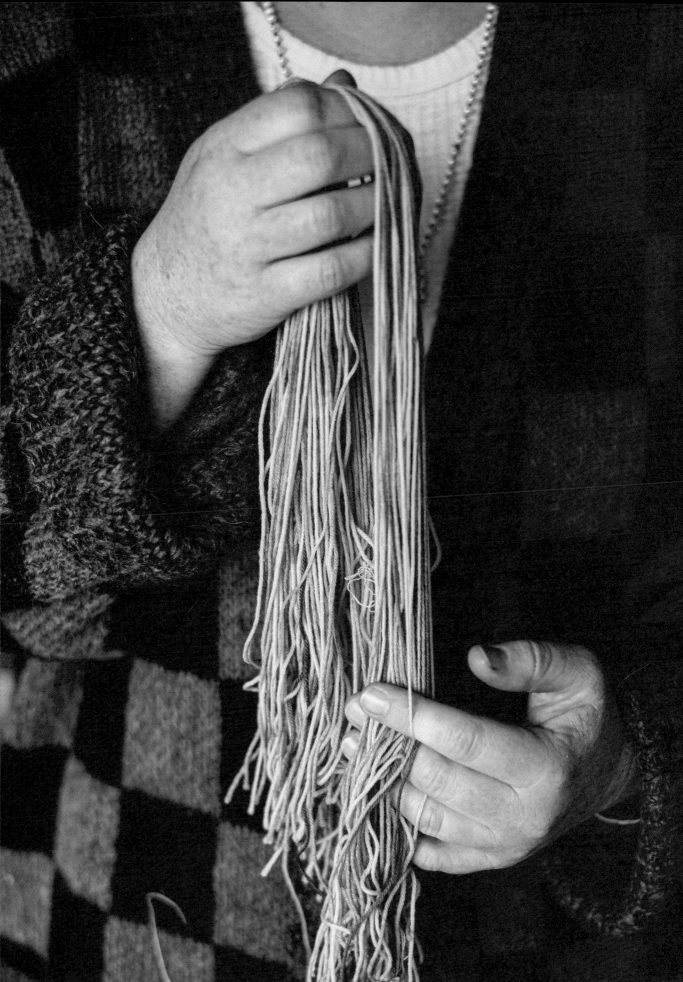

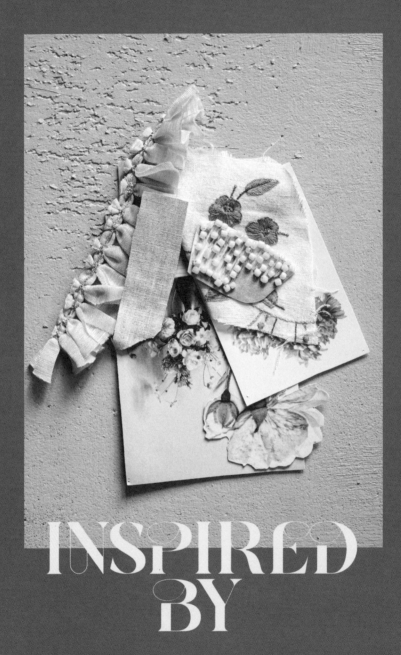

INSPIRED BY

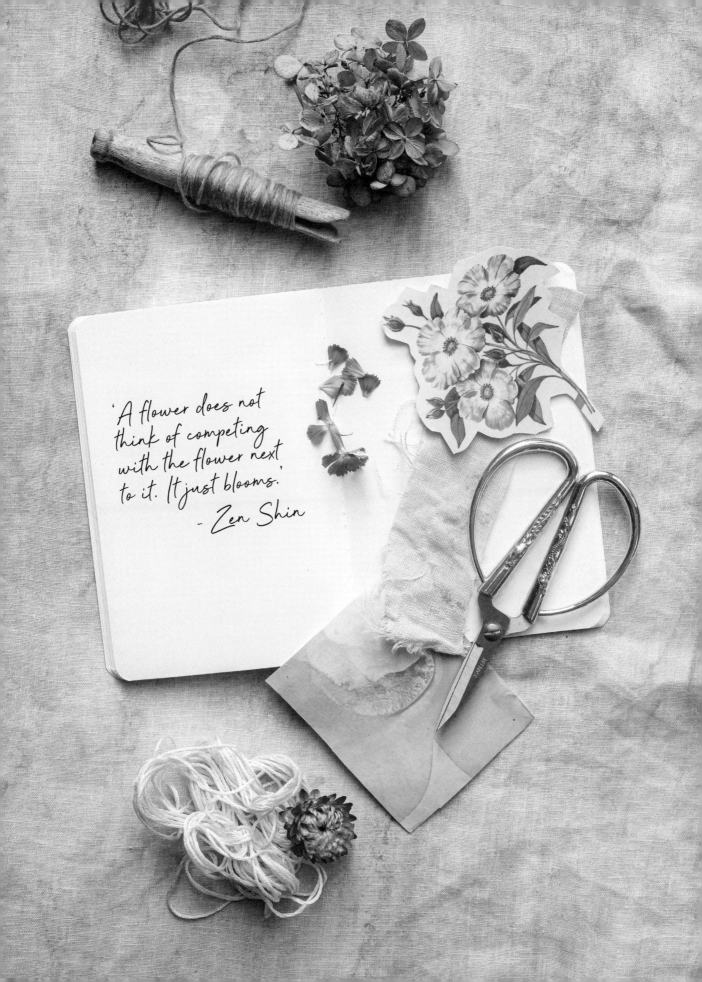

'A flower does not think of competing with the flower next to it. It just blooms.'
- Zen Shin

Gathering inspiration is a natural and essential part of the creative process.

But here's the catch — the real work is digging deeper into what the inspiration is leading you to. Like treasure hunting, the things we are drawn to are often clues that bring us closer to our unique creative process and style. Often when you're learning, it feels safe to borrow someone else's designs, ideas and instructions. This is normal as long as you use this inspiration to help you *grow* in your learning phase, for it gets problematic to use other people's concepts as your own. This isn't just an ethical issue in terms of copyright, but the impact it has on your journey to finding *your* way. We all need inspiration, and it is often argued that there is nothing original, but even with all of the beautiful inspiration in the world, you can make original work if you cultivate an awareness of who you are as a creative — a concept we have explored throughout this book.

Inspiration is beautiful, joyful and worthwhile but it provides the jumping-off point, not the result. If you are working in a symphony with your true self, your creativity will be so unique to you that even work that has essentially been done before will hold your signature.

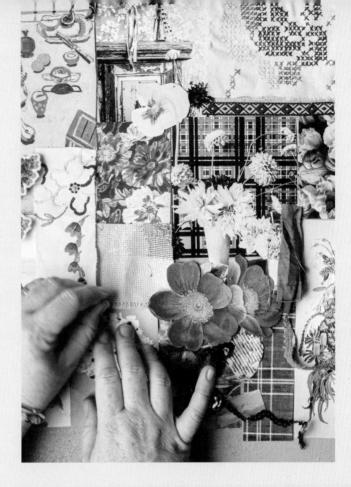

Creating a mood board is a lovely
way to spend time with the things
you love, and learn why they
connect to each other.

Many sources inspire me, and while I
find other fibre artists' work enjoyable,
I don't tend to seek much inspiration
from them. This is because I find drawing
inspiration from other creative processes
inspires me to be more innovative with
my own. As we have established, I am
inspired by nature, colour, texture,
fibre … and outside of my natural
environment my favourite way to gather
inspiration is through books and browsing
online. Couture, gardens, surface pattern
design, visual art, craft, object, art
and music all feature heavily on my
Instagram and Pinterest feeds.

An excellent way to gather inspiration
for a particular project, or to explore
different ideas, is to create a mood
board of imagery, either online using
Pinterest or an editing tool like Canva,
or as a physical board of collated
imagery and elements.

Rather than write at length about the
people and things that inspire me, I
have collated a visual representation of
various mood boards I have created. Enjoy
this celebration of creatives, concepts,
people, places and spaces. Each curated
with a sense of joy and admiration.

Give it a go, surround yourself with
inspiration and allow it to feed your
creative spirit.

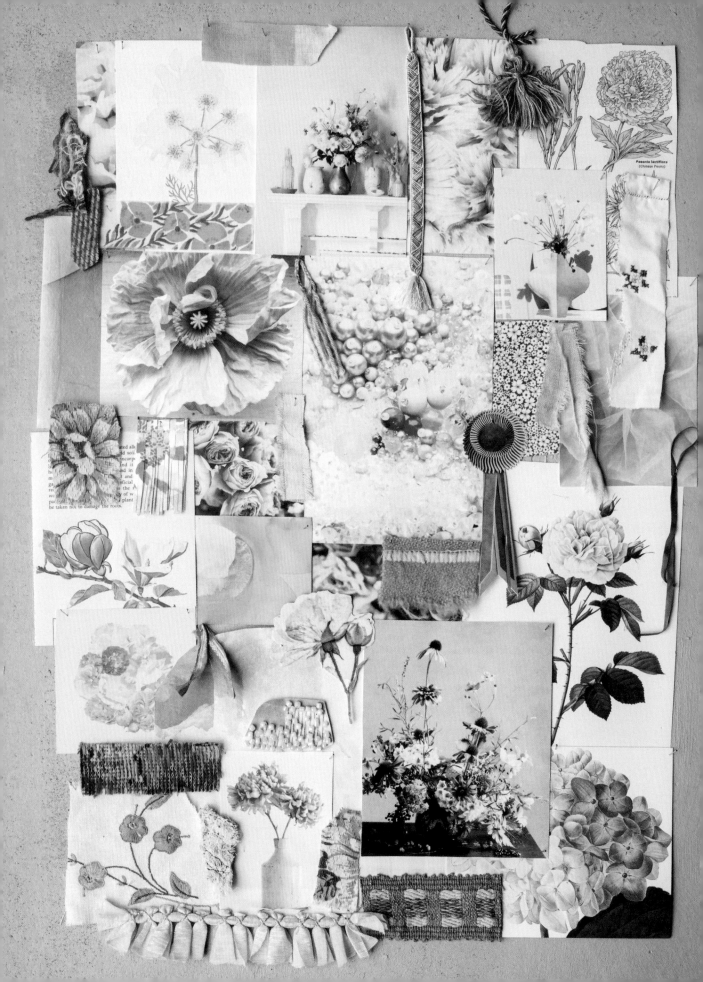

Here are two curated collections of images, and elements that inspire me. Patterns, colours, forms, textures and processes, that when brought together as a group, create an energy that can tell a story and encourage new ideas.

Left:

Warm

pinks & greens + textures & flora

An assorted collection, including items from:
Julia Atkinson-Dunn, Stylist and Floral Photography
Alexander McQueen Couture
Leila Sanderson, Poppy Photograph and Textile Rosette
Louise Meuwissen, Beaded Artwork
Susan Christie, Ceramic Art
Liberty London, Textile Print
Katherine English, Floral Art

Next:

Cool

reds & blues + patterns & flora

An assorted collection, including items from:
Kate Vella, Painting
Amanda Holland, Stylist
Liberty London, Textile Print
Ann Wood, Paper Botanicals
Susan Christie, Ceramic Art
Leila Sanderson, Poppy Photograph
Julia Atkinson-Dunn, Floral Arrangement
Jane Guthleben, Painting
Leila Sanderson, Textile Rosette

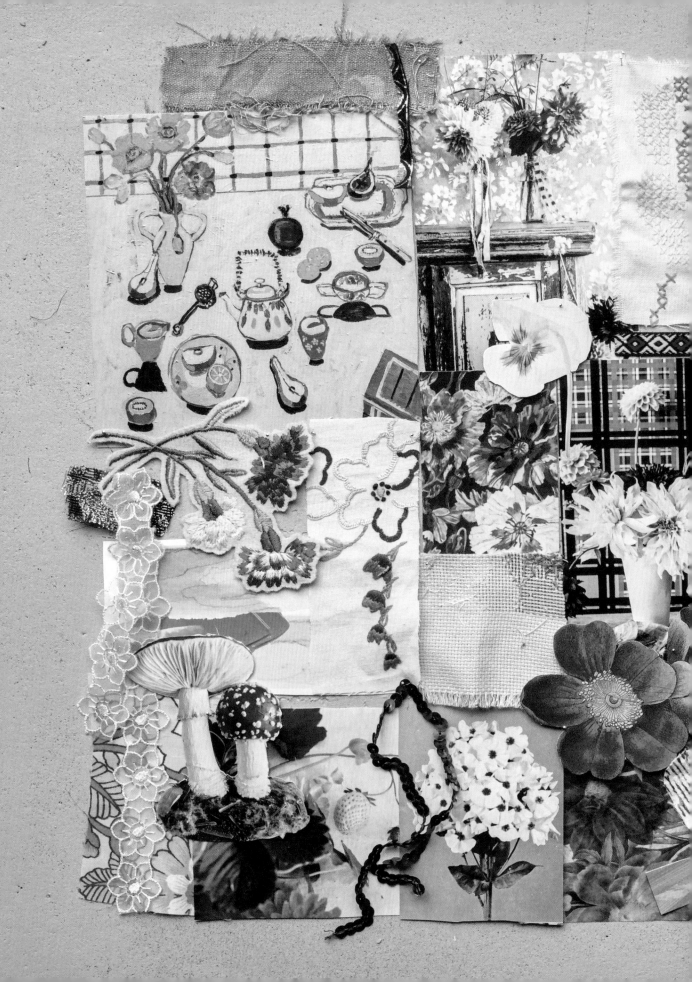

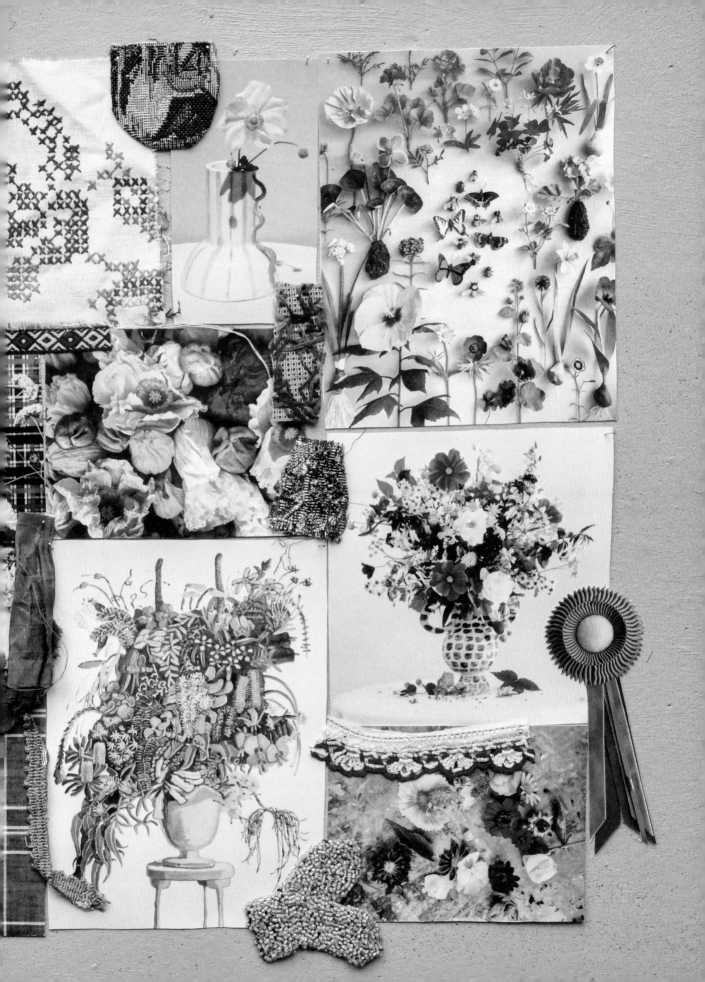

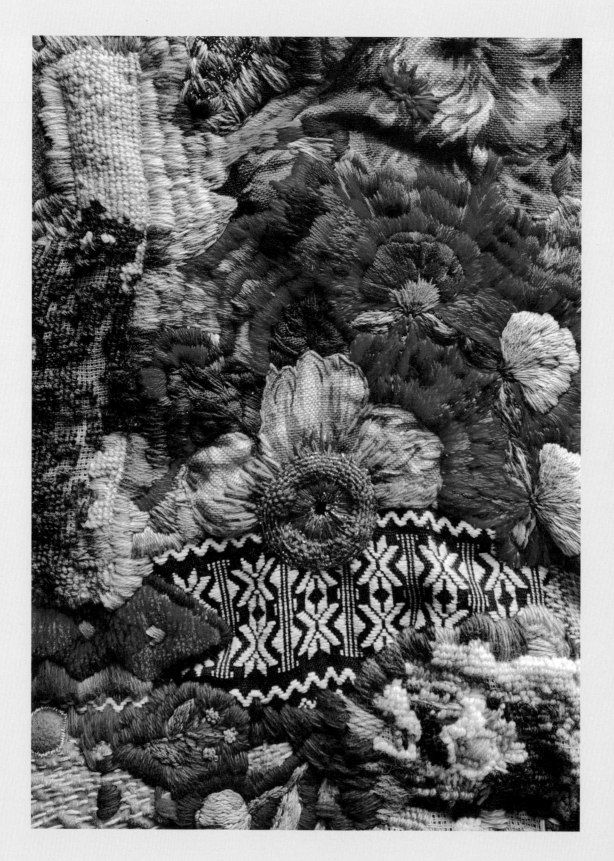

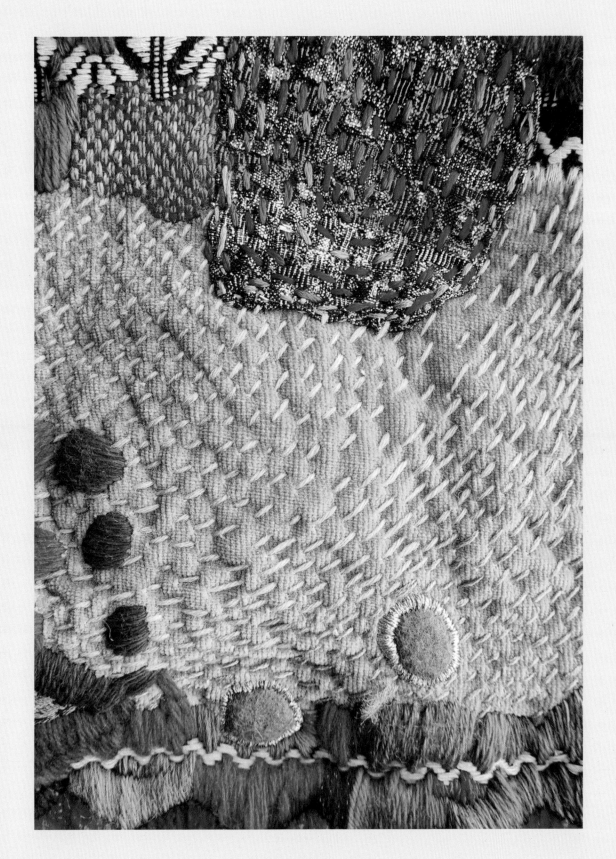

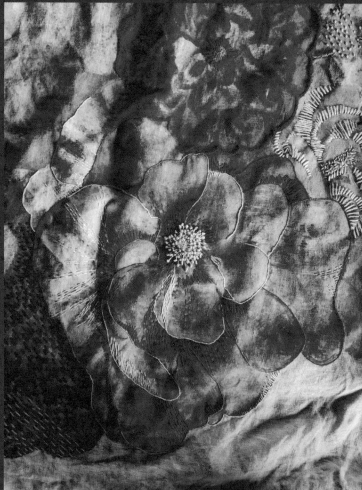

HONOURING
THE STORY

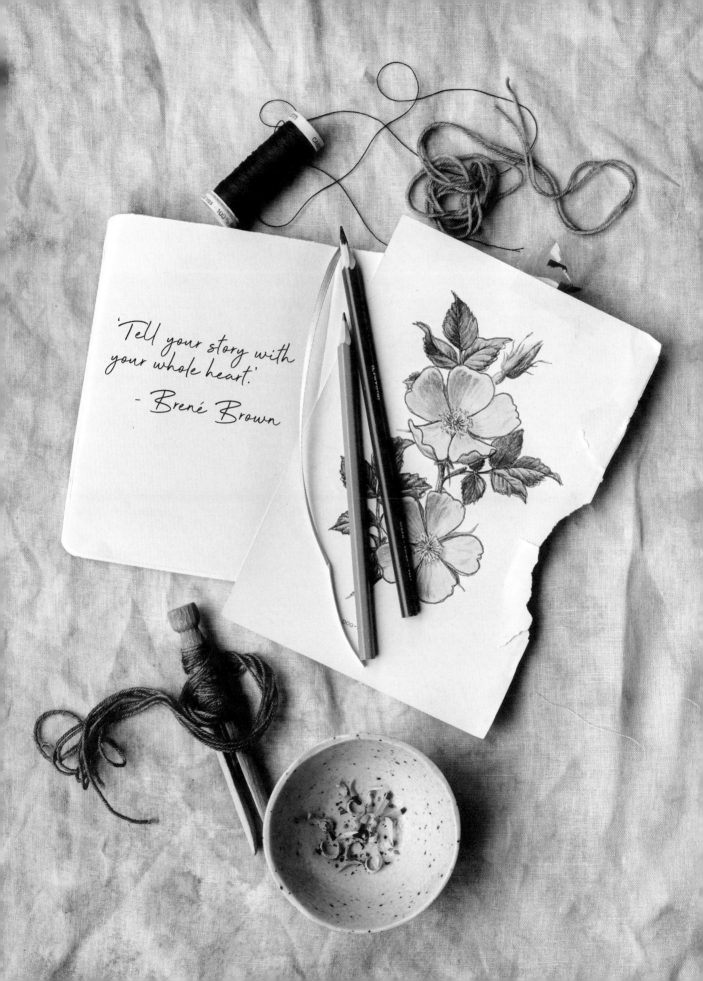

'Tell your story with
your whole heart.'
— Brené Brown

Art can be both simple and profound, complex and shallow; most of all, it can match the curtains and still matter.

For a long time, I didn't call myself an embroidery artist, a fibre artist, or even an artist because it all felt too loaded, like I had to take a position and hold a course that I wasn't sure would ultimately represent who I am. It turns out I didn't know myself. All I knew was that I was creative and aligned with the feeling of being a maker. I'd worked in the corporate world, become a mother, made some weird stuff, and moved to the country. For so long, I pursued creativity but wasn't willing to sit with what I loved or acknowledge who I was without art, parenting, or a job title.

When I finally embraced my sense of creative spirit, I started to understand the true depths of my desire to create and began to care much less about labels or definitions. It was a letting-go that led me to my true story: one about feminine resilience, nostalgia for a time that I had never lived in, and synergy with the ways of nature. Zero street cred, maximum authenticity.

Today I call myself a contemporary fibre artist. Not because I need a title but

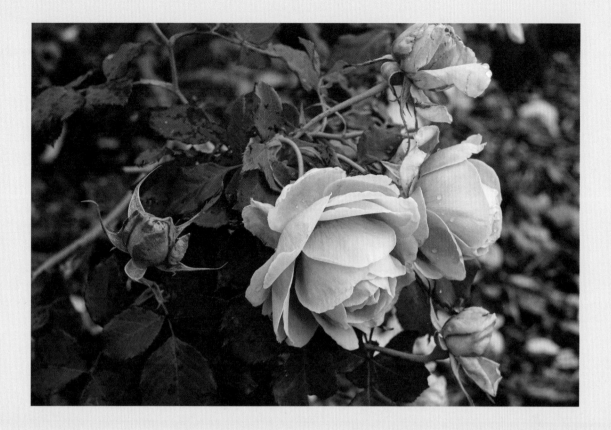

because it helps people get a taste of
what I do most days. I have no attachment
to that title or any other. I am a
creative soul, the vessel for creativity
from generations past to flow through and
become re-embodied. I've said before that
if I could see my soul, it would be made
of flowers. My purpose isn't to be the
best or brightest at anything but to be
a vessel to create, grow and share.

 There was a time when I felt like
telling stories was just an annoying
thing that artists did to try and be
clever, usually to the exclusion of
90 per cent of the viewership who felt
completely baffled by lofty, complex and
hard-to-follow statements printed on

Opposite: Choosing how to honour your work
can be as simple as signing it on the back or
framing it to take it from craft to art piece.
Above: Garden rose, inspiration for *Rosie*, 2019.
Pages 222 & 223: A textile collage using found
textiles layered with a variety of stitches
that connect one piece of fabric to the next in
creative and playful ways.

gallery walls. That was until I realised that, like it or not, everything we do creatively, and otherwise, tells a story. And that stories help us feel connected, however simple or lofty they may be. So, I started to embrace my story; the intergenerational stories I learnt, and the broader stories that impact us culturally and environmentally. I allowed my true self, my creative soul to shine through.

Stories are in everything: colours, textures, subject matter, composition and intention. Every element tells a story, so why not allow our voice to be heard in the way we would like it to be by noticing what we are naturally drawn towards and considering what that says.

Initially, I started to be more intentional about creating with an underlying concept. This could be as simple as a season, a flower or a colour. The main benefit not so much that other people could understand or access where I was coming from, but that it took quite a lot of the random dead-end paths out of the creative process. You see, I'm not a sketcher or a planner, so I like the work to grow (somewhat) organically as I go along. This could mean that, ultimately,

my finished results were like an entire semester of learning on one piece of fabric. Growth-wise this was interesting but meant it often came out as quite a confused and convoluted piece.

Once I began to embrace the idea of adding a simple concept to the beginning of my process, it helped me as if it was a mantra to guide me. A concept brief like: subject (roses), scale (large) and colour (pink) would provide me with a launch pad to explore without being creatively stifled. Essentially, while not a fully formed story, it ensured I didn't unintentionally wander off-track into weird and wild territory.

As I practised this more often, I noticed that I would gather stories as the work slowly evolved. When researching rose imagery, I'd be reminded of a rose we had in my childhood garden in Arrowtown, Central Otago, Aotearoa New Zealand. I can still smell it. I can see the view down the river valley, opposite where it was planted and remember sitting on the tiled patio in the sun with my cat Tigger, surrounded by the scent of that rose — feeling a sense of peace. The title of that work would become *River Rose*. Another was called *Wild Roses*,

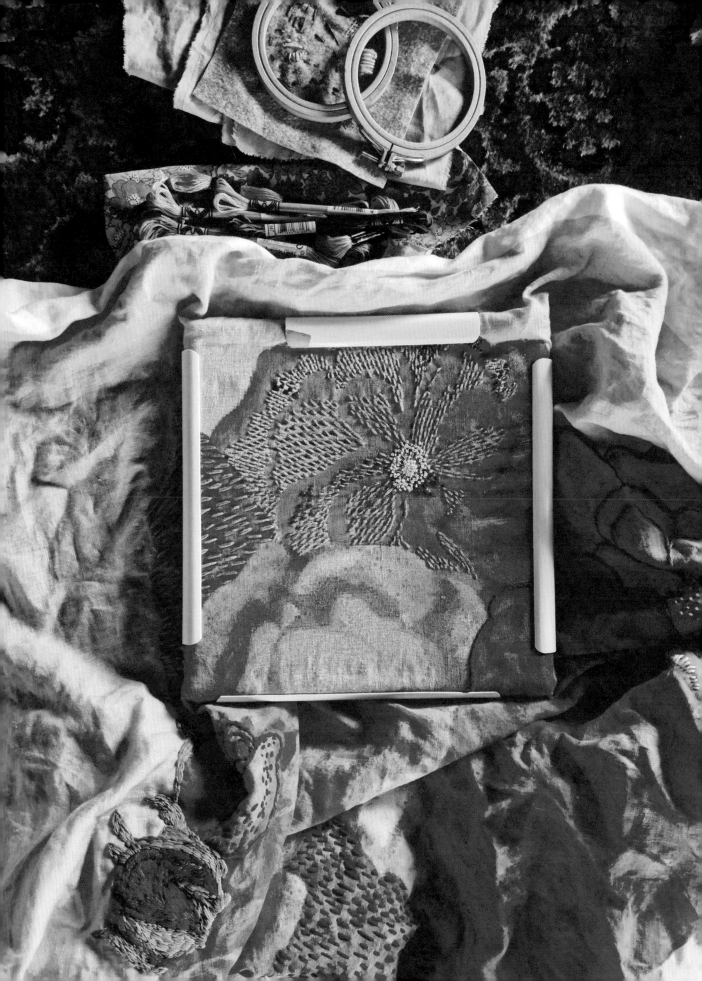

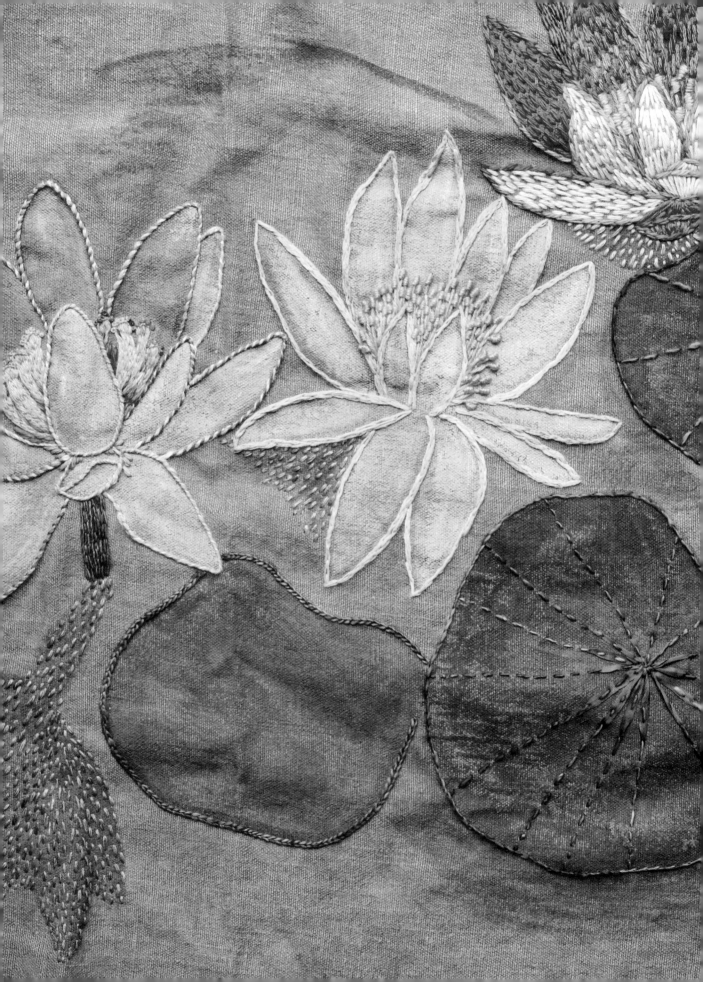

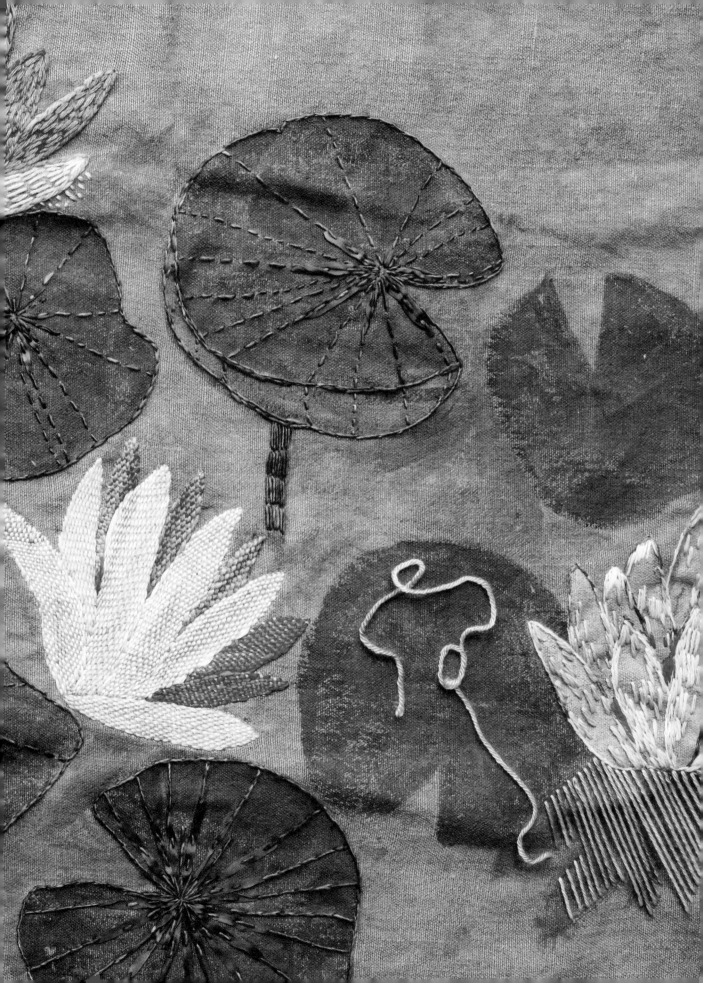

The centres of flowers
and intricate details are
endlessly fascinating to me.

which reminded me of riding my horse through the rosehips over the Crown Range in Central Otago as a girl. I noticed that most of the things I gravitated towards were connected to fond memories or positive feelings and, on a deeper level, linked to my love of nature.

Gradually these experiences built upon each other to help me explore stories not just as a concept, but in the materials I choose and their associations. I use a lot of wool in my work, not only because I enjoy the texture but because it feels comforting. There are links to growing up in rural Aotearoa New Zealand surrounded by merino sheep, farming and undoubtedly to the handcrafts I have always treasured. It eventually dawned on me that we are all connected but don't always feel it. So many of us seek connection.

By sharing your true loves, passions, quirks and whimsy, you allow others to resonate with those things, creating a connection that leads to a growing community with a beautiful ripple effect. The story doesn't always need to be told in words — sometimes it is about allowing yourself to acknowledge simple elements and being intentional about the supplies you select, or the subjects you embrace. You can tell a visual story that is not only a joy to create, but brings joy to those who engage with it.

Even if you never say it, simply by creating you are an artist. You tell a story by making design decisions and showing someone your work. Each time you share, you permit someone else to, so if it feels a bit confronting to get deep and meaningful about your work, you might consider it a service to your wider creative community. Whatever makes you feel able to do it, even in small ways, is lovely. We start revolutions when everyone has the chance to understand that their story matters, to share their story in whatever way feels accessible to them and to keep connecting. Those reading this book are kindred spirits — we are connected by the collective energy of what we are drawn to.

Now that we've explored the more spiritual side of storytelling and its virtues, I want to leave you with some practical ways that can help you to honour your process and share stories in gentle ways. The most important thing to

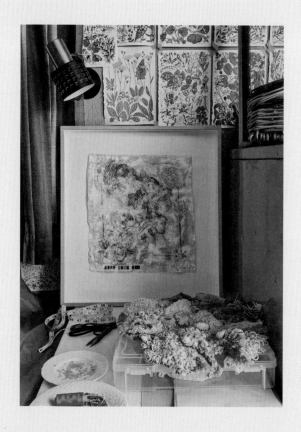

My textural fibre rock pools are
created using a combination of punch
needle, hand-built soft elements,
hand-stitching, beading and painted
clay pieces with some textile scraps.
Next Left: The Marlborough Sounds,
New Zealand. Next Right: *Blue Pool*,
2022 — fibre rock pool with paint and
ink, beads, clay and found textiles.

remember is that you don't have to have a
fully formed story to begin creating. As
you start to make and your work evolves,
so too will the story. Your story matters
as much as anyone else, so be brave and
honour all of your creative work with the
truth behind your creation.

There is no right or wrong decision here,
it's about sharing your work but doing
it in a way that honours your effort,
celebrates your creativity and inspires
others. Baby steps are significant.

Display work in different ways in your
home or as a gift. Simply taking your work
out of a hoop and putting it into a frame
can change how it reads, and moves it
from the craft space into the art space.

Make things with practicality in mind.
Sometimes you might feel more confident

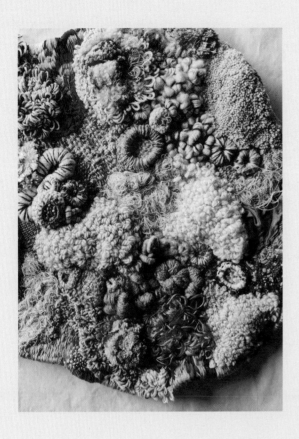

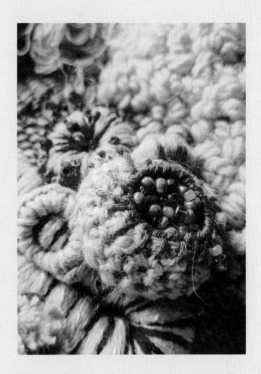

about your work being 'out in the world' in the form of a tote bag or a journal cover.

Gift your work with a stitched signature — a title, your name and the year is an excellent way to mark an occasion and leave a trail for future generations. It could be on a separate card, or the back of the work. You might not see the importance of what you've created, but your family or community might appreciate having access to it in the future.

Keep a photo album, physical or in the cloud, of your creative work, the process, your inspiration and any stories you want to share.

Join a local art/craft/fibre group and consider joining in on one of their group exhibitions.

Share on social media. Wouldn't it be a wonderful world if social media was filled with creativity? Remember, to take good-quality pictures of your work you need to use a good light source, preferably natural light out of direct sunlight, and that social media often operates in particular formats like squares, so set your frame to the shape you work with. Being on Instagram has been a beautiful way for me to connect with like-minded creative kindred spirits around the globe and has often felt like a good space to share my visual stories.

Start each work with an intention. It could be a simple concept brief, a word or a piece of inspiration. Write it down to remind yourself of it regularly. As you create it will guide you.

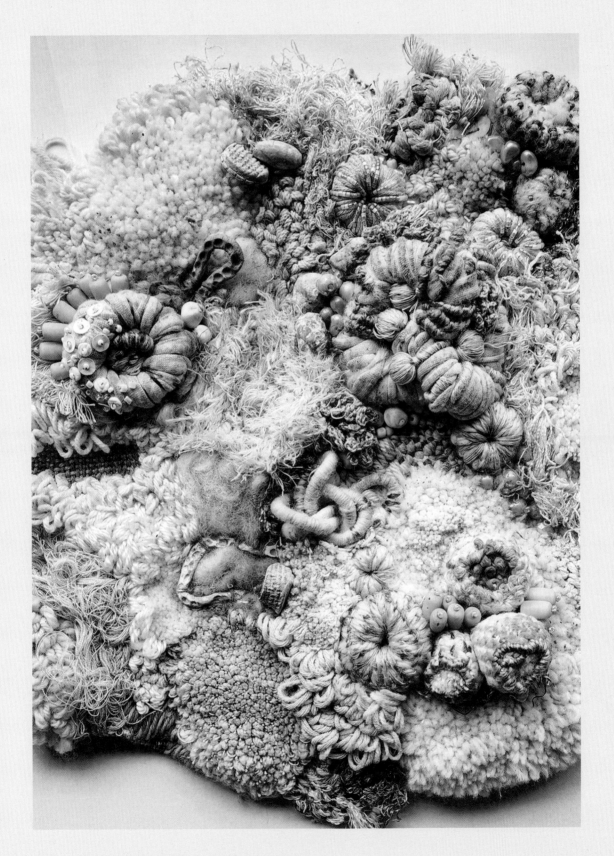

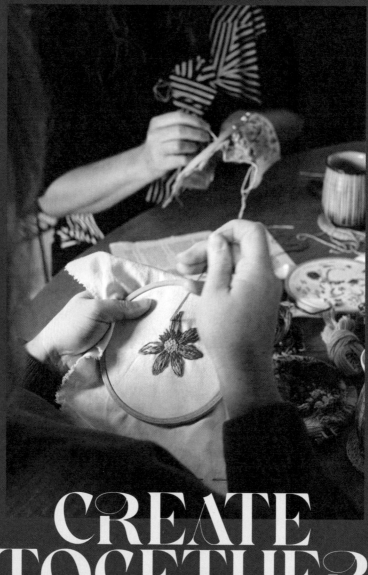

CREATE TOGETHER

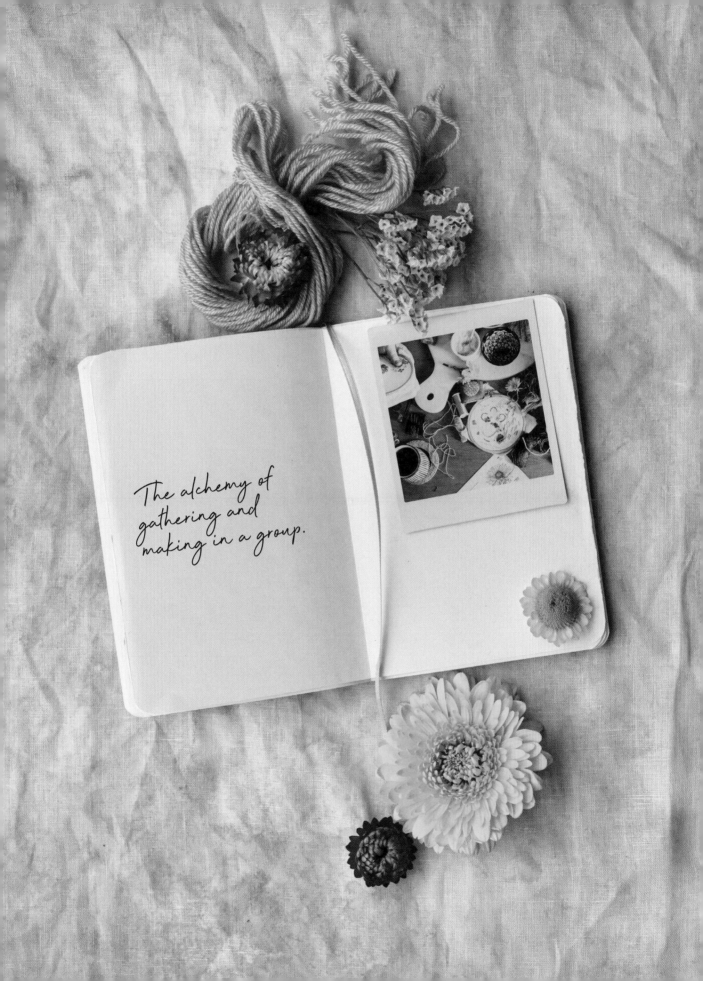

The alchemy of
gathering and
making in a group.

Creating together lifts your
spirits and brings a deeper
sense of joy, knowledge and
resource to your practice.

Gathering to create is where the true magic exists.

This can be so overlooked as an essential part of our creative process. We think we must carve out time to be alone, to be quiet, to reflect and pluck our ideas out of the ether. At times this is true, but most of the time, it is about balance. I find my best work occurs when I'm not trying so hard. Having a cuppa with a friend and stitching while you talk, joining a group either in person or online to share ideas or participating in workshops are all great ways to learn and make connections with folks that love some of the same things as you.

I don't know why we've isolated ourselves so much when we know that togetherness feels lovely.

Most people find they are more motivated, feel more confident, and learn new skills more quickly when they regularly gather to create with others. It takes a village and, in our era, the village can take many shapes — both in person and online.

I have been pleasantly surprised by the depth of the connections I have made with fellow creatives across the globe via Instagram and my online course. They are genuine and kind and allow me to learn and grow through connection without a sense of limitation due to my location in the Upper Moutere Valley, a tiny

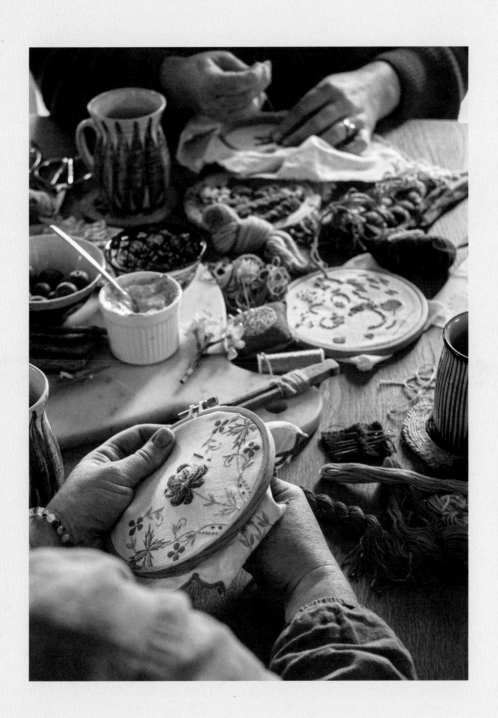

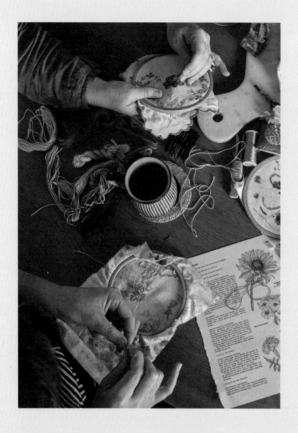

village in rural Aotearoa New Zealand.
When it comes to online groups, I find
the best ones will often be very clear
about what they offer as a community.
They may ask you to answer some questions
to join and require you to agree to some
pre-defined but reasonable guidelines.
These groups tend to be more curated
and safer to share your ideas, with
administrators who moderate the content
so you can enjoy supportive comments and
make genuine connections. The loveliest
connections I have made have grown slowly
and organically via commenting on fellow
creatives' work on social media and
eventually messaging each other. I have
found the creative community very kind
and supportive when you proceed with love
and kindness in all your interactions.

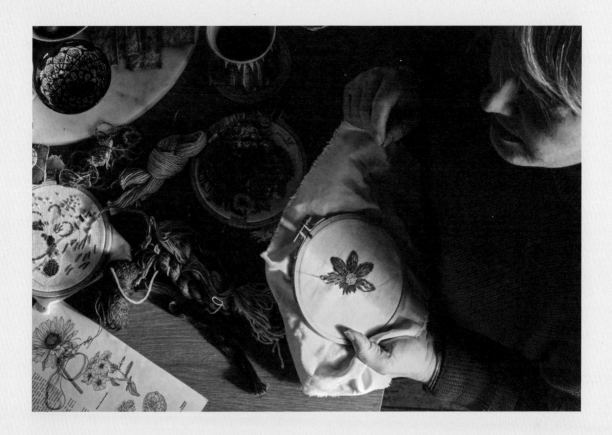

I think the key to making contact online is to interact as if you were in the same room; it takes a little more effort but is generally much more rewarding.

However, nothing can ever replace the pure alchemy of being together around a table, sharing tea and creating. One of the easiest things to do is join an existing group. A common misconception regarding stitch is that your local embroidery guild is only for very neat, traditional stitchers. I have found here in Aotearoa New Zealand that most local guilds have what they call an extensions group or a contemporary group. These people are often a mix of new and long-time stitchers who make an incredible, diverse range of fibre art and are generally very helpful and generous in their knowledge sharing. If you don't want to limit yourself to stitching, you might like to join a local art group or creative fibre group. That way, you can work with more mixed media alongside others doing the same. Many groups have a 'bring your project' type session that is an excellent way to continue with your current work in company.

Sometimes you might need to try a couple of groups or visit the same group more than once to find your people. Don't give up, it is so worth it. This isn't about making friends (although that is often a fantastic by-product), it is about the invaluable exchange of ideas and knowledge, and having a day, time and space locked in to create alongside others.

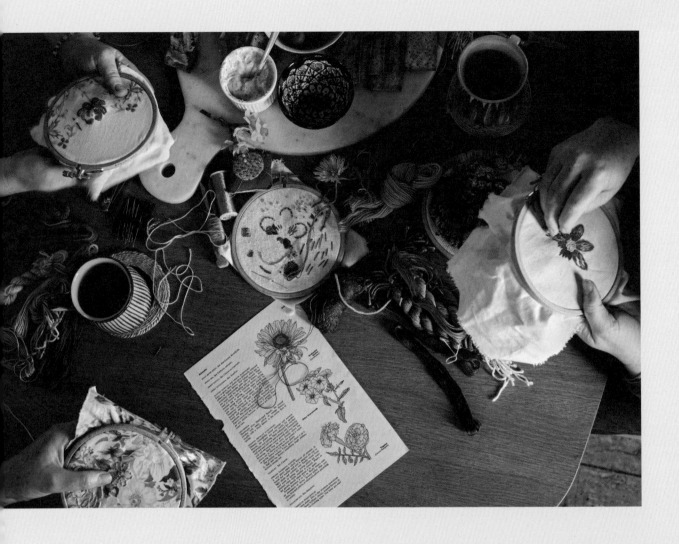

When you choose to learn something new by gathering in a room of strangers and prioritising your creativity, it can feel vulnerable. This is where the magic is because you are never the only person in the room who feels that way. With so many creative souls in one space, different souls start to recognise each other as if they've met before and establish bonds that gift you the confidence, support and connection to keep creating.

This is a big part of why I teach workshops, not so much to share my knowledge (although I do love sharing), but to facilitate a safe space for folks

to gather and create surrounded by love and kindness. Over the years, I have witnessed the lasting impact a workshop can have on someone's life path; this isn't about me — it's about the people who come with open hearts and a willingness to reclaim time, energy and resources to support their creativity. This is a gift you give yourself.

I often say at the start of a workshop that 'while we don't know it yet, we are all kindred spirits'. Within minutes of the workshop starting, often in a room full of strangers, I hear the most beautiful connections being made, at first gently, then progressively as numbers are shared and plans made to create together again in the future. I have never facilitated a workshop that I didn't love. It never fails to humble me with how genuinely kind and giving people are and how much we all have to contribute to sharing. I always go away with new skills and a full heart; it is never a one-way street.

If going out and meeting new folks in a new space and learning new things feels a bit much, you could start a little more gently. Invite a couple of friends for a craft afternoon once a month or join a casual gathering like a bring-your-own-project drop-in session at a local café or library. One of my favourite things

to do while I create is chat with a dear friend on the phone, often on speaker phone, so that I can use both hands and we can fix the world over tea without having to leave the house.

It's proven that creating and sharing your creativity permits others to do the same. That ripple effect radiates into households and communities, spreading wellbeing and connection. It is a beautiful gift that we can all share so please don't sit at home feeling creatively stuck and unsupported; it is the worst feeling and easily remedied by connecting with a fellow creative.

TOOLS, TIPS & LINKS

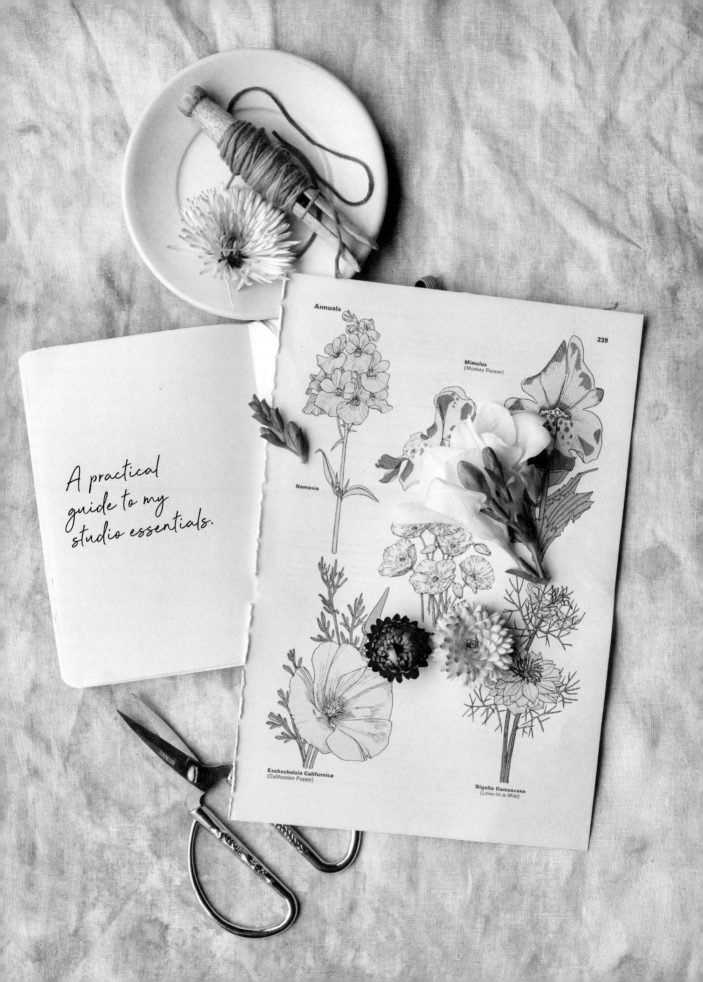

A practical
guide to my
studio essentials.

Annuals

239

Mimulus
(Monkey Flower)

Nemesia

Eschscholzia Californica
(Californian Poppy)

Nigella Damascena
(Love-in-a-Mist)

NEEDLES
FABRIC
THREAD
FRAMES
BEADS

To help you explore
mark-marking I have
compiled notes on the
supplies I love and my
top tips for making it
creative and joyful.

Plus, I've added some handy websites
should you like to do some online
learning or inspiration hunting. Use
materials you already have or borrow
things to try before investing if
you're unsure of what might work well
for you. Ideally, support your local
independent craft or fibre art store or
purchase directly from the maker.

PAINTS & PENS
INKS & DYES
IMAGERY
GADGETS
INSPIRATION

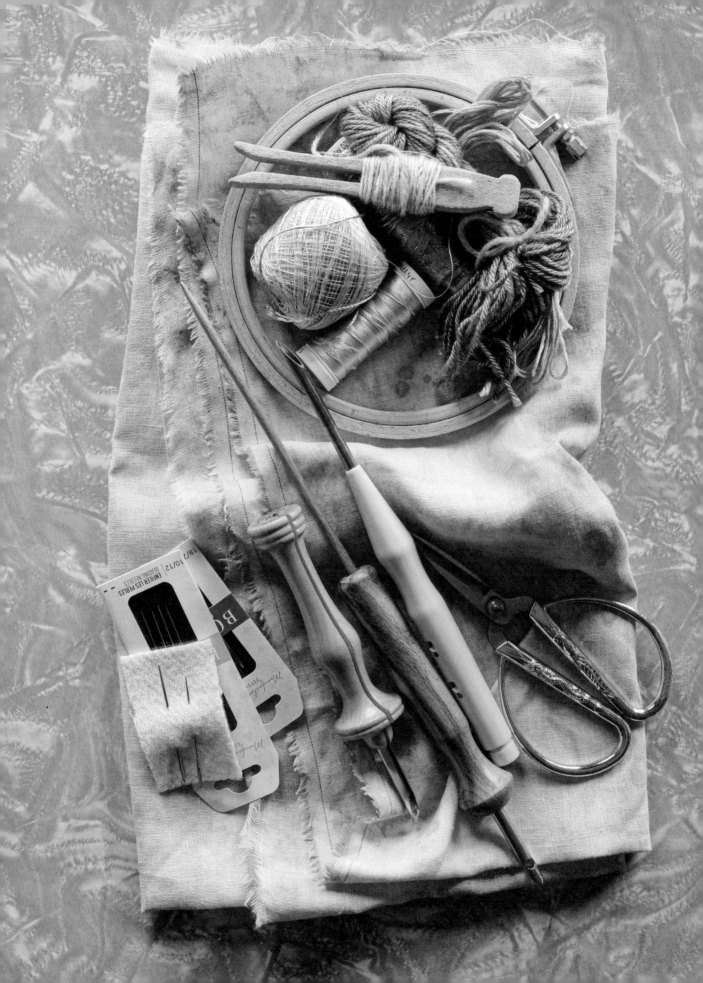

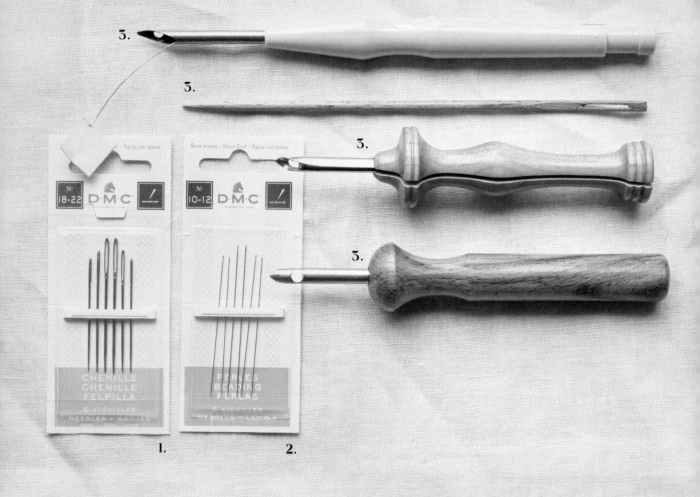

NEEDLES

1. Chenille needles sizes 18-22. 18 is the bigger size and excellent for 4-8ply wools. Size 22 is great for 3-6 strands of stranded cotton.

2. Beading needles sizes 10-12 are ideal for seed beads. I use sewing machine cotton thread in fun colours, or you can get specialist invisible beading thread.

3. Punch needles — there are lots of different sizes and brands available. Depending on your creative goals,

research or ask your local craft store for guidance. I use an adjustable punch needle that fits 8ply wool and works well with monk's cloth.

Tip
The needle paves the way for the thread. If you find it hard to pull your thread through your fabric it would be worth trying a larger needle. If it is still hard to pull the thread through once you've upsized your needle, you may need to look for a fabric with a more open weave, like linen.

Left: Collecting frayed textile
fibres to use in textural works.
Below: Wool blankets as a base
for a textile collage.

FABRIC

+ **Linen or a linen cotton blend** is
excellent for various stitch projects.
It fits well in most hoops or frames and
generally has a weave that will allow for
up to 8ply wool to be stitched through it
as well as fine threads. There is a large
range of linens available — I generally
use a medium-heavy weight.

+ **Woollen blankets** or felted wool fabrics
can also be lovely and soft to stitch.
While they don't always sit so well in
a hoop, they generally work fine in a
frame. It is perfect as a base for a
textile collage and great for people who
prefer to work without a frame or hoop.

+ **Monk's cloth** is a soft cotton open-
weave fabric that is great for chunkier
punch needle projects. I use it as the
base for my rock pools. You can also use
hessian, but it can be a little rough on
the fibres.

Tips

*Visit second-hand stores to find great
quality old woollen blankets, linen
clothing or sheets. Wash them and cut
them up for your projects. As you cut
or tear your fabric you will end up
with lose strands of thread — collect
these and pop in a jar to use in
future projects. I like to use mine as
additional texture in my rock pools and
moss works by simply selecting a tangle
of the collected fabric threads from the
jar and tacking them on to the fabric
with tiny stitches. They provide instant
texture with zero waste.*

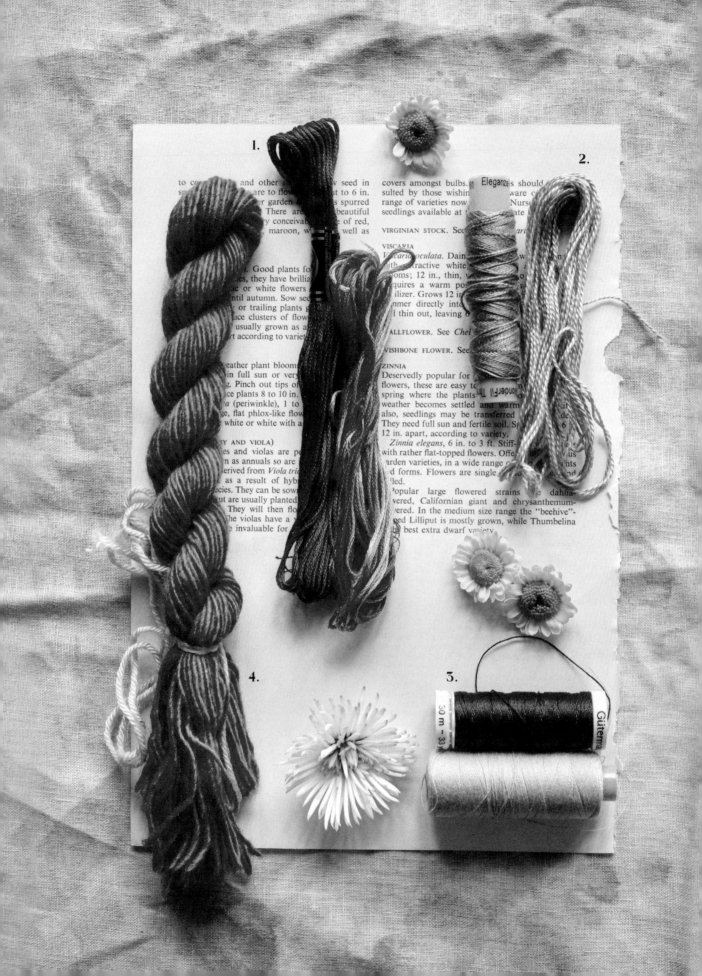

THREAD

1. **Stranded cotton** (or floss) comes in various brands and colours. You can use the strand as it is, or split it into three or fewer strands to work finer.

2. **Pearl cotton** is lovely for details. This thread is like a fine, smooth rope that comes in different weights.

3. **Cotton sewing machine thread** — I use this for beading, sometimes in bright colours that will peep through any tiny gaps in the beads. You can get an invisible nylon thread for beading if you prefer not to see colour.

4. **My favourite thread is wool**, a 4ply silk merino blend for stitching and 8ply merino for punch needle. Most 4-8ply wools are great to stitch with.

Tips
Hand-dyed and variegated threads and wools are beautiful. You can also stitch combining fibres like a 4ply wool with a strand of pearl cotton.

There are often two tubes around a skein of stranded cotton — the top usually has the brand information, and the bottom has the colour code. You want to pull your thread from the colour code end for it to come out smoothly. Also, it can be handy to snip a short length of the colour off and tie it around the colour code tube. That way, if you run out and want to order online, you can use the colour code. Hand-dyed threads often come on a paper card; you can do the same to keep a note of the colourway for reordering.

Second-hand stores often have a great range of threads. To check if they're still good to use, you can pull out a little strand and give it a good tug. If they have gone brittle with age, they will snap in your hands and likely break as you stitch.

Knitters' ends of ball wools are often gifted to the second-hand store and are lovely for stitchers.

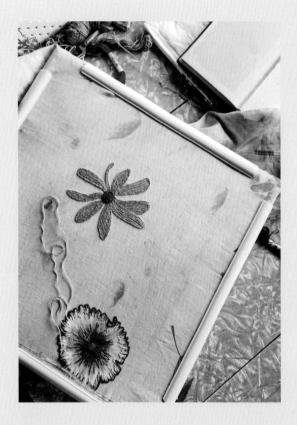

FRAMES

Plastic snap frame (above) — these frames
are plastic pipes that fit together at
the corners in a square or rectangular
shape with plastic grip clips that hold
your fabric in place. They come in a
number of brands and sizes. I like them
for more significant projects as I can
move the frame around my fabric and find
it's pretty kind to any stitching it
needs to grip over as you move around.
They also handle a thick fabric like
wool a bit better than a hoop.

Wooden hoops (opposite) — there are
loads of brands and size options. I use
Nurge Beechwood Hoops, in a 15 cm size,
for our small project kits.

Tips
*I like my fabric to be drum-tight in a
hoop or frame. Having your fabric tight
helps you to manage the tension of the
thread as you stitch and prevents the
fabric from gathering. If you find your
fabric slips, you can wrap masking tape
or long strips of cotton around the
inner ring of the hoop or pipes of your
snap frame. Wrapping provides more grip,
especially against a plastic frame, to
prevent the fabric from slipping.*

*If you find a hoop hard to tighten by
hand, you can use a flathead screwdriver
to tighten and loosen the screw at the
top of your ring.*

*If you prefer to work without a hoop or
frame, you might want to back your fabric
with a woollen blanket to help stabilise
it. Play until you find something that
feels comfortable for you.*

My personal preference is to use a
plastic snap frame (left) for most of
my work; hoops (right) are also great
and can be ideal for smaller projects.

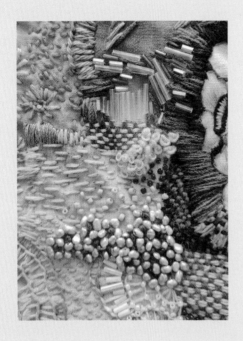

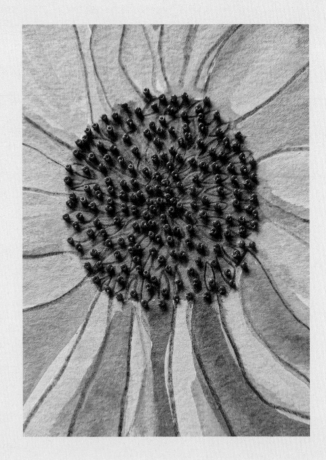

BEADS

Seed bead is the general term for any small round bead. Seed beads come in different sizes. I use sizes 8-12, which measure approximately 3 mm down to 1.7 mm, but honestly this varies all the time depending on the supplier. 2 mm seed beads will generally work in your size 10-12 beading needles.

Sequins. Again, a variety of sizes and styles are available.

Tip
My favourite way to source beads is by cutting up second-hand necklaces. If you are new to beading, I recommend finding the sizes and styles you like in a specialty bead or craft store before ordering online. Once you know what sizes and styles you want, it's much easier to tell what you're getting when you order.

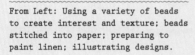
From Left: Using a variety of beads
to create interest and texture; beads
stitched into paper; preparing to
paint linen; illustrating designs.

PENCILS & INK PENS

You can get erasable, water-soluble,
heat-fading and more. I use a basic lead
pencil or a ballpoint pen to trace or
draw imagery onto my fabric.

PAINTS & PENS

Acrylic Paint — I use Golden brand or
any water-based acrylic house paint test
pots. Natural paint companies have more
eco-friendly options. I add water to my
paint before I paint onto linen, so a
little goes a long way.

Textile Paint — FAS is a commonly used
brand that can colour fabric and still
leave it fairly soft and flexible.

Textile Inks & Dyes — I use these less
often. There is a vast range available
and it's good to check if you need to
use anything to help the dye absorb
(like salt) and how to set the fabric
once it dries. Sometimes this is as
simple as a hot iron once dry.

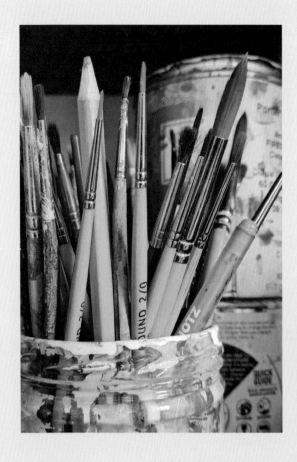

You can paint linen or paper
with any water-based paint; this
gouache is one of my favourites
for illustrating flora.

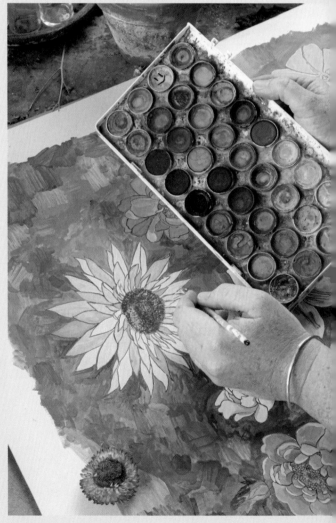

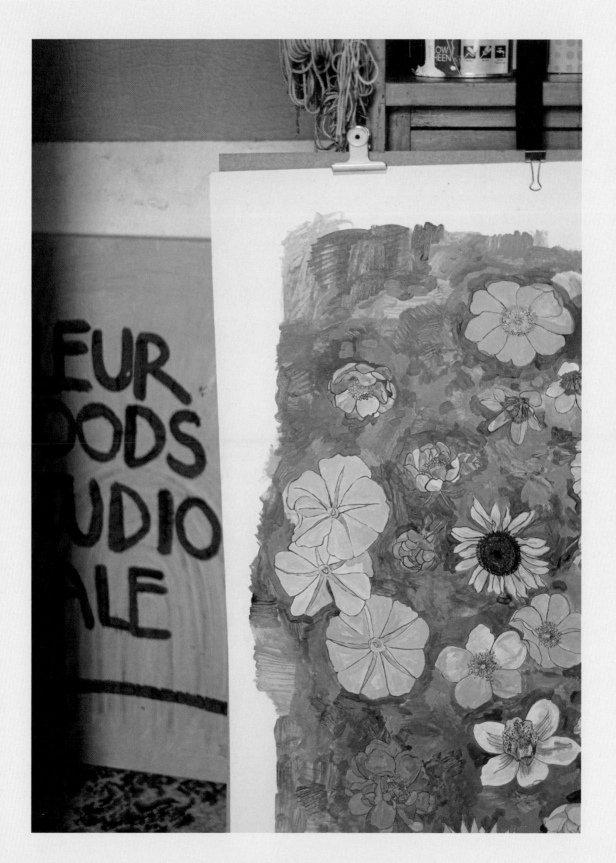

IMAGERY

Old books from the second-hand store are a great source of imagery to trace onto your fabric, and you can purchase many simple images or patterns online.

A note about tracing — you can tape your image to a window using washi tape and then tape your fabric over the top, making sure the image fits in the area you want to stitch. I always leave at least 5-10 cm of fabric around the edges to ensure I can move my hoop around the image if needed. Trace through using a pen or pencil.

If the material is too dark to see through, you can use carbon paper sheets or quilter tracing paper to lay on top of your fabric. Place your image over the top and draw with firm pressure over the outlines of the image to transfer it onto the textile.

Tips
Most imagery is fine for personal use; if you're unsure if an image is okay for your unique project, get in touch with the creator and ask. If you plan to create work to sell, your imagery needs to be made by you. That could be a photograph you print and trace, a drawing, or painting by observation. Loads of embroidery projects and imagery can be purchased to download and print, but these are generally strictly for personal use and great to use as practice.

You can also use magic paper to print imagery onto, then stick it onto your fabric and stitch through before washing the excess paper away. I don't use this, but many stitchers love it.

If you feel confident to draw or paint your imagery onto fabric, go for it! Textiles love to absorb water/paint so I tend to mix my acrylic paint with water so it is slightly more fluid, but then use a dry brush to paint details onto the fabric. If the paint is very thick it is hard to stitch through. This is very much a trial-and-error process, so worth playing with until you land on a technique you like.

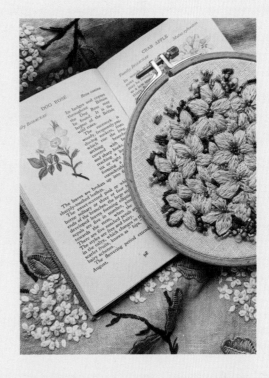

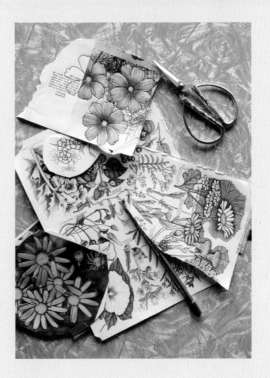

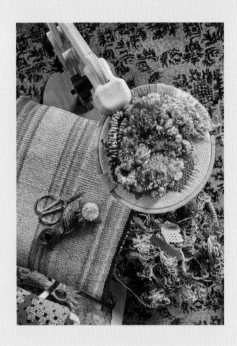

Above: At times I use a hoop stand to
help my posture. Right: A decent pair of
fabric scissors is key. Next Left: This
spot on the porch is the perfect place
to sip and stitch. Next Right: Hydrangea
flowers from the garden.

GADGETS

I wish I had known about some of these
sooner, and while I don't use many, I
do love …

Beading needle threaders. These come
in a range of options. You might want
to try them before you buy so visit
your local craft store or ask friends
if they have one you can try.

Fabric scissors. LDH is a brand of
scissors I have found to be great but
there are many varieties and while most
work well, the key with fabric scissors
is to only use them on fabric.

Hoop stand. Sometimes you need to
adjust your posture. A stand can be
a great tool to hold your hoop so you
have both hands free and can adjust the
height and angle to ensure you are not
putting strain on your neck or back as
you stitch.

Daylight lamp. Mine is tall but
lightweight with an adjustable long
wand of light. I like to have it on the
brightest setting day or night to help my
eyes as much as possible. Daylight lamps
are ideal because they are bright but
don't cast a deep shadow as you work.

INSPIRATION

A few websites I visit often

Gather inspiration and get links on Pinterest. I've created an inspiration and resources board, especially to complement this book —
pinterest.nz/fleurwoods/
the-untamed-thread-by-fleur-woods

Join me for my online course Joyful Embroidery
fibreartstaketwo.com/
courses/fleurwoods

Art inspiration online and in your inbox
createmagazine.com
mymodernmet.com
thejealouscurator.com/blog

Collect Imagery
biodiversitylibrary.org
is an open-source digital collection of a wide range of botanical imagery that is free to download.

Explore Gardens
annespencermuseum.org
botanicomedellin.org
en.uit.no/tmu/botanisk
gardenconservancy.org
kew.org
nparks.gov.sg/sbg

Fibre Arts Community
embroiderymagazine.co.uk
embroiderynz.co.nz/
 extensions
fiberartnow.net
fibreartstaketwo.com
royal-needlework.org.uk
textileartist.org

A few of the many, many artists that inspire me

Amelia Dennigan, Thread Painter
acrunyc.com

Ann Wood, Artist
woodlucker.com

Beci Orpin, Designer & Maker
beciorpin.com

Bisa Butler, Artist
bisabutler.com

Cayce Zavaglia, Artist
caycezavaglia.com

Christin Geall, Floral Artist
cultivatedbychristin.com

Colleen Southwell, Artist & Garden Maker
thegardencurator.com.au

Danielle Krysa, Artist
instagram.com/
daniellekrysaart

Evie Kemp, Creative
eviekemp.com

Hattie Molloy, Floral Artist
hattiemolloy.com.au

Katherine Throne, Painter
katherinethrone.com

Kelly Wearstler, Designer
kellywearstler.com

Dr Lisa Cooper, Floral Artist
doctorcooper.com.au

Louise Meuwissen, Artist
louisemeuwissen.com

Madeleine Stamer, Artist
madeleinestamer.com

Mary Jo Hoffman, Artist
stillblog.net

Mary Walker, Poet
marywalker.co.nz

Rachel Burke, Artist
shoprachelburke.com

Ronni Nicole, Artist
ronnicole.com

Glossary

Air Dry Clay — a soft, versatile clay that cures with air.

Beading Needle Threader — a small tool that assists with threading your needle, available in a variety of designs.

Colour, Primary — a group of colours — red, yellow and blue from which all other colours can be mixed.

Colour, Secondary — can be created by mixing two of the primary colours, for example, red + blue = purple.

Colour, Tertiary or intermediate colours are made by mixing a primary colour with a secondary colour, for example, blue + green = teal

Flatlay — an arrangement of objects on a surface photographed or observed from above.

Frame — often square or rectangular, a frame can fasten the fabric taut while you stitch.

Hoop — commonly round and made from wood or plastic, an outer circle with a screw to tighten and an inner circle are placed together to sandwich fabric and hold it taut while stitching.

Hoop Stand — an attachment to connect to your hoop or frame that allows you to adjust its position with the goal of making it easier to sit comfortably while you stitch.

Monk's Cloth — 100% cotton basket weave cloth designed with a plain weave to allow yarn to easily pass through the check pattern.

Needle, Beading — typically a long, straight, very fine needle with a small eye to allow the fine thread to pass through the hole of small beads. They come in a variety of sizes to suit the size of the bead being used.

Needle, Darning — a long, straight needle with a large eye generally used with embroidery thread or fine wool for mending.

Needle, Punch — a tool used to create thread loops on a woven fabric. The punch needle tool generally has a long or adjustable needle length, a hollow stem or ridge to place thread, a bevelled point and a large eye.

Seed Bead — a generic term for a small bead used for embroidery or jewellery.

Skein — a loose ring of thread or yarn that can be wound into a ball or cut to length.

Stitch, Blanket — traditionally used to reinforce the edge of thick materials, like a blanket. It can be seen on both sides when used around the edge, or the same process can be applied to the top of the fabric to create patterns and designs.

Stitch, Chain — a series of looped stitches that form a chain-like line or pattern.

Stitch, Couching — yarn or another material is laid on the surface of the base fabric and fastened with small tacking stitches.

Stitch, French Knots — a technique of wrapping the thread around a needle and securing it to form decorative knots.

Stitch, Kantha — also known as running stitch, a simple form of over and under long — short stitches with gaps between each stitch. It was traditionally used to bind layers of soft textiles by rural women in Bangladesh and Eastern India.

Stitch, Split Back — a stitch where the needle entirely circles the fabric, always coming back to the stitch before and entering through the fibres of the thread of the previous stitch. Commonly used for outlines and blocking areas of colour with thread.

Stitch, Weaving — often used as a darning stitch. The threads are layered in parallel lines both horizontal and vertical. The thread is woven over and under in alternating rows to create a checkerboard pattern on top of the fabric.

Vignette — a small scene created to draw or photograph. A collection of objects arranged with a central focus.

Washi Tape — a multipurpose paper type of masking tape that has a low-tack adhesive and is easy to tear. Originally made in Japan from handmade paper.

Wool — 4ply vs 8ply. 4ply wool (or yarn) is made of 4 threads spun together to make one strand, often known as sock yarn. 8ply wool/yarn is made of 8 threads spun together to make one strand, also known as double knit. The ply of a wool/ yarn or thread refers to its thickness. The general rule is the bigger the number, the thicker the thread.

To my village ...

The most heartfelt gratitude to you, the reader, to all of these folk, and too many more to list.

Tonia Shuttleworth, for inviting me to be part of the Koa Press family. This creative collaboration with you has been a dream come true in more ways than one.

Lucinda Diack, for being willing to wrangle my ramblings and still honour my voice. A true art.

Belinda O'Keefe, my appreciation for your attention to detail knows no bounds.

Anne and Keith Grantham, for raising me with the knowledge that you can do anything your heart desires.

Lily and Saffron Woods, for being the best gift of my life. I love you.

Cameron Woods, the true champion of my work, my greatest supporter, best friend and my love.

Miranda Goddard, the right hand and left brain for my left hand and right brain, I am so glad our paths crossed.

Jillian de Beer, Julia Atkinson-Dunn, Evie Kemp, Madeleine Stamer and Angela Truscott, my friends, colleagues and mentors — your wisdom and generosity is inspiring.

Louise Douglas, Luella Raj, Joanne Costar, Jessica Hanson and Pip Brett, I am forever grateful to you for giving me a leg up at the start.

Kris, Alice and Debs, my soul sisters. Every kind soul who has supported me and my practice in so many different ways over the years.

It really means the world.

Thank you.

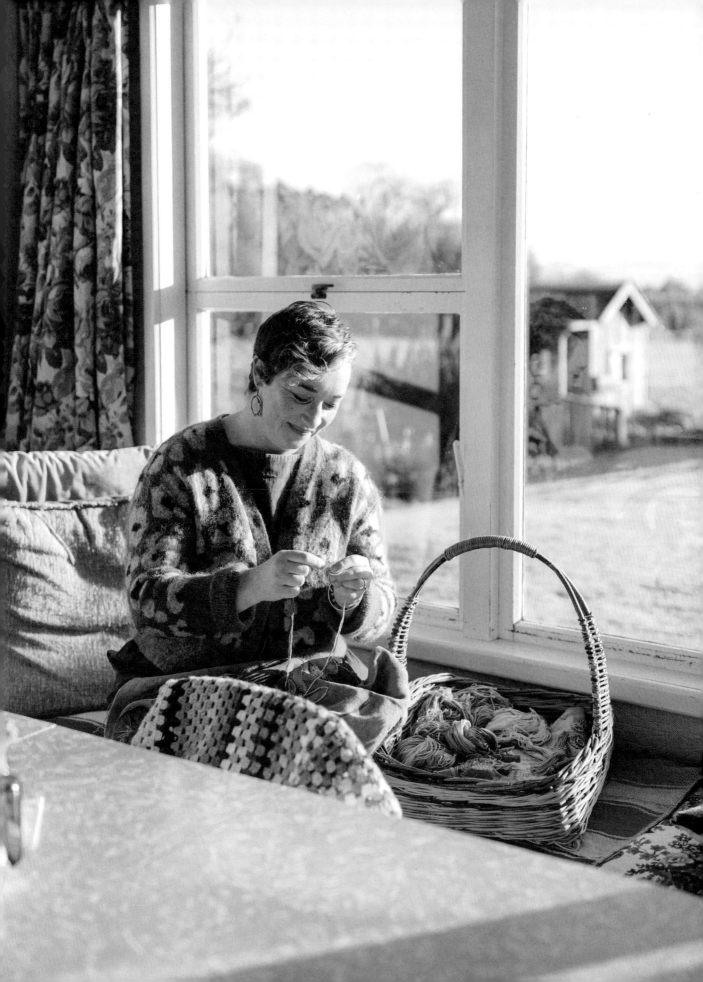

Opposite: A view from the carport door into our little world, George (the Labrador) always ready to say hello. Below: Oakleigh, our sweet little rental cottage on our friends' (the Hyatts) family farm in the Moutere Valley.

KOA PRESS

Published in 2023 by Koa Press Limited.
www.koapress.co.nz
@koapress

The Untamed Thread
ISBN 978-0-473-67976-7

10 9 8 7 6 5 4 3 2 1

Publisher and Director: Tonia Shuttleworth
Editor: Lucinda Diack
Proofreader: Belinda O'Keefe
Designer: Tonia Shuttleworth
Photographers: Fleur Woods @fleurwoodsart
& Tonia Shuttleworth @toniashuttleworth,
except pages 7, 269, inside front cover &
inside back cover © Ariana Leilani

A catalogue record of this book is available
from the National Library of New Zealand.

Printed in China by 1010 Printing.